African Americans
OF
CANTON
OHIO

African Americans
OF
CANTON
OHIO
TREASURES OF BLACK HISTORY

NADINE MCILWAIN AND GERALDINE RADCLIFFE

THE
History
PRESS

Published by The History Press
Charleston, SC
www.historypress.com

All images not attributed are courtesy of and donations by family members and other
Canton citizens unless otherwise noted.

First published 2019

Manufactured in the United States

ISBN 9781467141369

Library of Congress Control Number: 2018966270

A percentage of the royalties from this publication is donated to the Stark County Alumnae Chapter of Delta Sigma Theta Sorority Inc. Scholarship Fund.

We began this project knowing that we were contributing to the beginning, not the ending, of this story. There is a definite need for more research and more writing. Therefore, we dedicate this book to all of Canton's citizens, knowing that we are passing the torch and praying that our spark will ignite a flame.

CONTENTS

FOREWORD

Every city has hidden tales of unknown, unheralded people who helped to build it. This book contains a wealth of such stories and the accomplishments of people from all walks of life, whose lives of courage, determination and excellence are finally being told. Their examples of success against tremendous odds are still relevant and still very much needed.

In a community where local history has always been valued, this excellent book changes things.

—Charita M. Goshay

ACKNOWLEDGEMENTS

*W*e acknowledge God in all our ways, and He has directed our paths. For many years, we have heard and shared stories, experienced events and met people who have a wealth of information about the African American experience in Canton. Those experiences always ended with the statement, "Someone should write a book!" That request did not go unheard. We acknowledge the efforts of several individuals and thank them for contributing to this history, including Melvin (Frog) Howell, Dr. Norma Marcere, Apostle Gilbert Carter and local Stark County historians Herbert T. Blue and Edward Thornton Heald. Thank you Lois DiGiacomo-Jacobson for convening our committee and for knowing that "for everything there is a season." Thank you to all of the contributors for informing our work by chronicling your stories of struggle and triumph. Thank you for granting us interviews and for pulling shoe boxes from under beds and out of closets and opening safe-deposit boxes to share pictures, articles and news stories. This story could not have been told without the assistance of Judy Sessions Jones and Brenda Lancaster Baylor—thank you. Thank you Charita Goshay for writing the foreword to this book and for never saying "no" when asked to support the community. Thank you Taylor Matthews for fifty years of capturing the beauty of early Canton through your lens. Thank you George Lemon Jr. for your time and energy used to obtain many of the current photographs. Thank you Brian McKelley for assisting with processing our images. Thank you Jeaneen McDaniels for providing expert legal advice and consultation. Last but not least, thank you to The History Press and John Rodrigue, acquisitions editor, who patiently guided us through this project.

LIST OF CONTRIBUTORS

Bruce Allison
Rita Barrett
Edwin and Kathy Baylock
Brenda Lancaster Baylor
Robert and Hortense Bobbitt
Connie Calhoun
Elder Gilbert Carter
Selma B. Coleman
Marion and Emma Conner
Colleen Curtis-Smith
Will Dent
Lois DiGiacomo-Jacobson
Doris Edwards
Robert Fisher
Allison Goshay
Charita Goshay
Lovie Hailey
Ronnie Harris
George Hogan
Virginia Jeffries
Jimmy and Peaches Jenkins
Don Johnson
Elizabeth-Burton Jones

Mabel Jones
Beverly Jordon
Pat Byrd Kennard
Judith Barnes Lancaster
George Lemon Jr
Hundlean Maske
Taylor Matthews
Brooklyn McDaniels
Jeaneen Jaye McDaniels
Edna McIlwain
Floyd "Randy" McIlwain
Laura McIntyre
Shirley Inman McReynolds
Willie Paul Milan
Michael Miller
Lewistine Holloway Moore
Darlene Moss
Mari Alistine Victoria Thompson Moss
Monty Pender
Helen Potillo
The Repository
Judy Sessions-Jones
Gwendolyn Singleterry
Betty Mack Smith
Corey Minor Smith
Erma Smith
Fredricka Early Stewart
Vera Cole Thomas
Marilyn Thomas-Jones
Cherrie Turner
Vince Watts
Jennifer Wells
Bertha Bailey Whatley
Janet Chenault Williams
Carol Wright-Harris
Malik Zahir

A FEW FIRSTS IN CANTON'S AFRICAN AMERICAN HISTORY

Early 1800s: Prior Foster is the first black man to settle in the Canton area.

Pre-1865: David Hall is first black man to settle in Canton. He worked as a miller at Canton City Mills.

1907: Esther Archer is born.

1920: Dr. J.B. Walker becomes the first black physician in Canton.

1921: The Canton Urban League is founded by Dr. John B. Walker and others.

1934: J.L. Brewer opens Southside Pharmacy.

1936: Leila Greene, 1932 McKinley High School valedictorian, number one in her Howard University class, postgraduate work at Radcliffe College with Phi Beta Kappa honors, is offered a position in Canton City Schools to teach elementary school but turns it down, as the job was not commensurate with her educational level and skills.

1946: Clearview Golf Club in Osnaburg Township is designed and built by William Powell.

1948: Esther Archer becomes the first black woman elected to a municipal office in Ohio.

1949: Dorothy White is hired as Canton's first black teacher.

1956: Ira Turpin is appointed assistant Stark County prosecutor.

March 1964: The Reverend Martin Luther King Jr. visits Canton and speaks before 3,500 during a "Freedom Rally" at Canton Memorial Field House.

1967: Stark County resident Renee Powell becomes the second black woman to join the Ladies Professional Golf Association.

April–June 1968: A series of ten seminars on "The Profile of the Canton Negro" begins at Malone College.

December 1969: Odes J. Kyle Jr., thirty-eight, is the first black to serve on the Canton City Board of Education.

1972: Ira Turpin is elected to common pleas court, the first African American elected on a county-wide basis.

1973: Gerry Radcliffe, RN, is the first neurological nurse specialist in Stark County.

1974: The Canton Fire Department hires its first black firefighter, who resigned two weeks later. A second black firefighter was hired in August 1975.

December 1980: Canton City Council passes a law mandating fair and equal housing regardless of race, color, creed, religion, national origin, sex or handicap.

1981: A federal judge approves an agreement that requires more blacks and women to be added to the Canton Police and Fire Departments over the next ten years.

1983: Ira Turpin is elected to the Fifth District Court of Appeals—highest elective office of any African American in Ohio.

1984: Nadine McIlwain is elected to Canton City Council representing the Sixth Ward.

1987: Jeffrey S. McDaniels is hired as the first African American financial consultant at Merrill Lynch Pierce Finer and Smith in Canton.

1988: Jeaneen McIlwain McDaniels becomes the first African American assistant law director for the City of Canton.

1989: Virginia Jeffries is elected to an at-large seat on the Canton City Schools Board of Education. She was the first black woman to win a citywide election.

2001: Nadine McIlwain is elected to an at-large seat on the Canton City Schools Board of Education.

2004: Bruce Allison becomes the first black captain in Canton City's Police Department.

2007: Marva Jones becomes the first black woman to serve as interim superintendent for Canton City Schools.

2009: Jeff Talbert is appointed superintendent of Osnaburg Local Schools, resigned one year later to become the assistant superintendent at Cleveland Heights–University Heights School District. Presently, he is serving as the superintendent of Alliance City Schools.

June 1, 2010: Fonda Williams is named deputy mayor.

2010: Andrea Perry becomes first female safety director for the city.

2011: Ida Ross Freeman and Lisa Gissandaner are elected to the Canton City Schools Board of Education, joining Nadine McIlwain.

2013: Adrian Allison becomes the first black superintendent of Canton City Schools.

2016: Corey Minor Smith is elected serve a term on Canton City Board of Education.

2017: Thomas West is elected as the first African American state representative from the Forty-Ninth District.

2018: Corey Minor Smith is elected as the first African American to win an at-large race for Canton City Council.

2018: Canton City residents are represented by four black city council members: Madam Majority Leader Chris Smith, Corey Minor Smith, Nat Chester III and Kevin D. Hall.

2018: Chris Smith is chosen to serve as majority leader for Canton City Council.

1

WRITING CANTON'S BLACK HISTORY

If a race has no history, if it has no worthwhile tradition, it becomes a negligible factor in the thought of the world, and it stands in danger of being exterminated.
—*Carter G. Woodson*

sk yourself this: Do the citizens of Canton and Stark County recognize the contributions of local blacks? How many know that Esther Archer was the first black elected to Canton City Council? How many know of the late Dr. Norma Marcere, who after gaining her teaching degree, was informed by the Canton superintendent, Jesse Mason, 'I will never hire a colored teacher as long as I am superintendent of Canton City Schools. Go South!'"

This question was asked in an opinion editorial by Ron Ponder and Rabbi John Spitzer. If the answer to this question is NO, it may be because much of our historic past has neither been recorded nor preserved. The editorial added the following comment: "Historically, the history of the Negro was hidden not only from him but also from the rest of society. That history was not mentioned in textbooks, mainstream media or anywhere else. Negroes had no idea how productive they had been to society, how many contributions they had made, and how they, too, could be brilliant people."

Prior to the civil rights movement of the 1960s, black history education in the United States focused exclusively on the enslavement of Africans. The tragic epic depicting the enslavement of Africans in the United States

should not be discarded or minimized, but it should not be the sum total of the written history of Africans in America or African American generations. It is our belief that young people need a firm and true foundation of their history as human beings upon God's earth; their legacy as Africans with many unique cultures; a long, significant past; educated leaders; and major contributors to the history and progress of all humankind.

Ponder and Spitzer concluded by asking another question: "Has knowledge of black history made a difference?" They answer their own question: "Bruce Allison, the first black lieutenant and captain in the Canton Police Department, attributes part of his success to Officer Guy Mack, a respected black Canton police officer who lost his life in the line of duty. He was a hero and an inspiration to Allison." There are many heroes and inspirations to be discovered in Canton's black history. But what remains of the people, events, buildings, neighborhoods, churches, social arenas, businesses, parks and recreational centers have significance in our lives and the lives of our children only through the memories and recollections of our elders.

This volume captures a portion of those memories and recollections. Ultimately, this effort will resurrect only the head of our historic body; the torso and its extremities will remain buried until uncovered by future historians.

Efforts to chronicle Canton's African American history exist through the efforts of individuals too numerous to name here; however, a few notables deserve special recognition. The *Canton Black Book* was printed in 1977 by the Canton Black History Week Committee using a grant from Canton's Black United Fund. This publication included an overview of Canton black history, some famous firsts in black Canton, a listing of black agencies and a number of biographical sketches. Additionally, the book included a listing of black organizations such as churches, businesses and social clubs.

Elder Gilbert Carter authored an autobiography, *Cast Down Your Bucket Where You Are: My Midia Experience in Stark County.* Dr. Norma Marcere tells us the story of her first eighteen years growing up in Canton in her autobiography, *'Round the Dining Room Table,* and continues her story in *The Fences Between.* We are indebted to these individuals for filling in some blanks. Pictures of Cherry Avenue businesses and other Southeast Canton places of interest are featured in Melvin Lee (Frog) Howell Jr.'s *Memories of Cherry Street, Southeast Canton.* The Stark County Library sponsored an oral history project that recorded the memories of many African American senior citizens. Edward Thornton Heald and Herbert T.O. Blue included minor

references to African Americans in *The Stark County Story* and *History of Stark County*, respectively. Finally, the William McKinley Presidential Library and Museum yielded several newspapers articles.

Many black social organizations and several black churches have preserved their histories, although no one work contains a compilation of these histories. Brenda Lancaster Baylor entrusted us with the photographs, newspapers and program booklets that her mother, Charlotte Lancaster, and her mother's sister, Betty Danzler, saved over a lifetime. Gerry Radcliffe, in collaboration with the William McKinley Presidential Museum & Library, sponsored several exhibits recognizing the photography of Taylor Matthews and saluting the contributions of the county's African American hair stylists.

Although we salute past efforts, we recognized the need for a written history of African Americans in Canton. We solicited information from community members to document this story. Contributors submitted stories about family members, favorite teachers, mentors, unsung heroes, neighborhoods and social organizations. These contributions guided the direction of our work. We began by asking who were the firsts? In other words, was it possible to authenticate the first African American teacher, principal, barber, beautician, business owner, police officer, firefighter, postal carrier, Boy Scout leader, Girl Scout leader, politician, social worker, nurse, doctor, minister, lawyer or homeowner in Canton? We began the lists and discovered that firsts did not encompass the range of African American history we wanted to share. Thanks to the many contributors, we expanded our scope to include professionals, schools, medical personnel and other representative groups. In honor of the many families whose stories are included and those whose stories are not told, we present this volume as a beginning of the story, not the end.

2

THE EARLY YEARS (1800s)

*C*anton was the first city platted and settled in Stark County. Generally recognized as the founder of the city, Bezaleel Wells, a surveyor from Steubenville, laid out the first plat and sold lots in 1806, although the accepted year of the city's birth is 1805. Wells recorded the plat and named it "Canton" to honor his childhood hero, Captain John O'Donnell. O'Donnell purchased a plantation in Baltimore and named it the Canton Estate, commemorating the first cargo to arrive in Baltimore from Canton, China.

E.T. Heald lists Prior Foster, "a Negro who settled in Pike Township," as the first African American to settle in Stark County.[1] Although Heald does not record the year Foster first arrived, he wrote that he "married a white girl in 'Oberly Corner,' Canton in 1811." That any record of Prior Foster exists is probably due to the marriage of his son, George Foster, to another white woman. Since marriages had to be performed by justices of the peace or ordained ministers, legal unions (basically for whites) were recorded, leaving a written record of names and dates. The interracial marriage drew notice from the local community:

> *There is only one known instance of intermarriage of races in early Stark County. That was in 1811. Peter Foster negro and Rebecca Butler a pretty white girl were married in that year by Squire Coulter. Old records describe the girl as having "good sense but a perverted taste." Foster was a miller. The story is told that a stranger once stopped at the Foster home to make inquiry about a certain road.*[2]

Heald's next mention of African Americans refers to a settlement known as New Guinea. This two-square-mile settlement in Lexington Township (near Alliance, Ohio) along the Mahoning River is considered the first black settlement in Stark County. According to Heald, the community consisted of two hundred settlers who had regained their freedom legally or illegally according to the laws at that time. The settlement included a church, school and a burial ground. In Heald's own words, the settlement "passed into oblivion" as the settlers sought the more secure freedom of Canada. Indeed, Canada, not Ohio, was the destination enslaved Africans were seeking when they crossed the Ohio River.

Students of history know Ohio was part of the Northwest Territory and subject to the law under the Northwest Ordinance of 1787. This law barred the enslavement of Africans and, by that time, African Americans, in the region east of the Mississippi River and north of the Ohio River. Undoubtedly, this statute increased the probability that some blacks would choose to remain in Ohio rather than continue the journey north to Canada.

By 1800, twelve years after the enactment of the Northwest Ordinance of 1787, the state legislature denied the right to vote to blacks who chose to settle in Ohio, although there were only 337 black people (less than 1 percent of the population) living in the state.[3] Although prohibited by law from being forced into involuntary servitude, African Americans were still subject to fugitive slave laws. Other Ohio laws governing such things as the rights of settlement, jury service and giving testimony in court were more restrictive. Indeed, many "black laws" (laws written exclusively for the African American population) made it difficult for the black man or woman to exercise any civil rights.

Laws passed after 1802 prohibited blacks from testifying in court cases involving whites. In 1804, one year before the founding of Canton, black people who entered the state were required to register with county clerks within twenty days of arrival. The Settlement Law was repealed in 1850, and according to David Gerber, *Black Ohio and the Color Line 1860–1915*, bonds were seldom collected. Instead, local whites or black ministers vouched for people of color moving into Ohio. By 1831, blacks were excluded from serving on juries.

Few black children attended school with their white peers. If education was to be had, it was found within the confines of private academies often held in the back of churches. By 1849, legislation had been passed that required township trustees to use a share of the common school fund for supporting black schools. Curriculum in the black schools was weak, the

school year was shorter than in those schools attended by white children and there was a scarcity of teachers in the black schools.

Gerber provides further explanation as to why such legal restrictions were placed on blacks. Early white settlers, particularly those settling in Cincinnati and other areas north of the Ohio River, generally came from the southern states, where individuals still enslaved black people. Their racial views differed from settlers in the northern part of Ohio, who were mostly from New England.

Gerber does cite the role of renegade southerners, Quakers and blacks in forming anti-enslavement organizations and assisting with the operation of the Underground Railroad in the southern part of the state. It is noteworthy that he included this statement: "While serving as president of Antioch College in Yellow Springs, Ohio, in 1856 and 1857, New Englander Horace Mann defied his board of trustees and faced a loss of several white students when he accepted Blacks at the college."[4]

Oberlin College, located in Oberlin, Ohio, was the first coeducational institution in the United States, as well as the most influential of the early institutions that admitted African Americans. The Cincinnati Conference of the Methodist Episcopal Church, North, opened Wilberforce College, Ohio's first college for the education of blacks, in 1856. Wilberforce University continues to serve a predominately African American student population.

Within Stark County, both Massillon and Alliance retain sites that were stations along the Underground Railroad. Although no historic sites remain (to our knowledge) in Canton, it is safe to assume Canton played a part in the fight to regain freedom for those forcibly enslaved in the South.

David Hall, a miller, is widely accepted as the first black man to settle in Canton.[5] Hall apparently arrived sometime before 1865 and worked at the Canton City Mills. Hall is also credited with being a founding member of the first African American church in the city, St. Paul African Methodist Episcopal Church. Another early Cantonian who deserves mention is Henry Clay Thompson. Thompson gained some measure of notoriety just for being who he was. Trouble, as he was known, was a permanent figure in Canton for many years. Heald stated that Thompson, who served as property man for Canton's Grand Army Band, counted "William McKinley as among his friends."[6]

The 1890 census is the first for which there is aggregate data on black employment in Ohio.[7] This data revealed that Canton grew from five families living in the county to about twenty-five black families living in Canton.[8] Most of these original settlers were property owners, and many descendants from

these families still live in the Canton area. According to Gerber, economic and social progress for the black man was "painfully slow." In 1890, there were only fourteen black attorneys and thirty-two black doctors in Ohio. Professional teachers in the state were regulated to teaching in black-only schools, as school district leaders did not believe that black teachers had the ability to instruct white children. Indeed, they believed "that Black teachers could not serve as fitting models for the moral and intellectual development of white children."[9] Amazingly, this attitude prevailed in Canton until Canton Public Schools hired its first black teacher in 1949.

In 1892, Canton achieved a measure of fame only a few other cities have obtained. The newly elected president of the United States made his home here. Although William McKinley was born in Niles, Ohio, on January 29, 1843, he spent many years in Canton. Following the Civil War, he began practicing law here and married Ida Saxton, daughter of publisher John Saxton. At age thirty-four, McKinley won a seat in Congress. He later became governor of Ohio, serving two terms. McKinley was nominated as the Republican candidate for president in 1892; however, he was not elected. Four years later, with the assistance of Mark Hanna, he defeated William Jennings Bryan in the election of 1896 and became the twenty-fifth president of the United States; McKinley was reelected in 1900. His second term was cut short as a result of an assassin's bullet resulting in his death on September 14. His death occurred eight days after he was shot twice by Leon Czolgosz, an anarchist, whose right hand had been wrapped with a handkerchief.

While many are familiar with the assassination, few are aware that the president was saved from instant death by a black man: "Eye-witnesses of the tragedy agree that the first to seize the assassin was a colored man named James B. Parker. Czolgosz, the assassin, stated that he intended to empty the barrels of his revolver, the probability is that he would have succeeded in firing again had not Parker seized him in time to prevent a third shot."[10]

Leslie's Weekly quoted Parker in his own words:

> *Some way, I did not lose my presence of mind. I leaned forward and struck him in the nose with my right fist, making his nose bleed, and with my left hand, I reached to take the pistol from him. I missed the pistol and grabbed him by the throat and choked him. He raised his right hand and pointed it either at me or the President; I could not tell which, I am sure that he meant to fire again. At that moment, he raised up with his right hand, with the burning handkerchief in it and the special officer grabbed the pistol*

and took it away from him. Then a marine jumped on the officer and took the pistol from him and the crowd commenced to kick and pummel him, thinking he had done the shooting. A man whom I believe to be a Secret Service officer gave Czolgosz a terrible blow in the face, which threw me and him down. Then the officer who was being attacked through mistake kept yelling to the crowd, "I'm not the man. I'm a special officer. There's the man, over there," pointing to where I had Czolgosz on the floor. We had struggled some seconds on the floor before the exposition police reached us. And they stopped him with two awful licks on the head. I believe that my striking Czolgosz kept him from emptying his pistol, and probably prevented the President from being shot again. I am more than glad to have been the right man in the right place, not for my benefit, but for the benefit of my race. Out of the 100,000 white people on the ground, I am glad it came to a colored man to do this act.

The 1800s began as a paradox. English settlers had fought a horrendous war with their brothers across the Atlantic, removed their political shackles, declared themselves "free" of an oppressive government and called themselves Americans. Africans continued to be forcibly shackled and brought to America, where they were enslaved by a people and a government that did not consider them politically, legally or naturally free.

That this paradox resulted in a clash where brother killed brother is not surprising. What is not expected is that the oppressed would rise to produce outstanding giants in the fields of intellectual research, education, journalism, scholarship, sports and the arts, making their mark on American history locally and nationally.

3
THE 1900s

Lifting as We Climb

rriving in Canton in 1901, George Titus, an accomplished metallurgist, was born in Princeton, New Jersey.[11] His reputation followed him. The Dueber-Hampden Watch Company—a large producer of solid-gold, gold-filled and coin silver watch cases—was having difficulty processing the gold it needed and sent for Titus. Titus trained his son James and eight other African American men who worked at Dueber-Hampden. The first Mr. Titus was said to hold the most distinguished job of any African American in the area.

Other early black Cantonians included Robert Jennings, who arrived about 1908. Jennings's wife came to Canton before he did and ran a rooming house for black waiters and black employees working at Dueber-Hampden. Jennings's manner of death placed him in the early history books of the city. Jennings served as a waiter at the Brookside Country Club, and the job proved hazardous to his health. "A tragic event took his life on August 23, 1919. Along with six other victims, Robert Jennings died of poison caused by over-ripe olives served at the country club."[12]

As more and more black men came to the area, most were employed as manual laborers, working as brick and mortar carriers for one dollar per hour. The building trades were considered "colored men's work" and few white men were seen laying brick or paving roads. More research needs to be done on these early black pioneers.

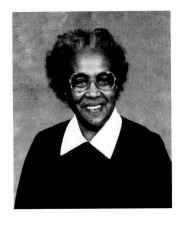

The Jacob Gaskins family was among the first families to live in the North Canton area, but definitely not the last. In the northwest area of Stark County, a small community of black families, drawn by the offer of jobs in the brickyards and railroads, lived, worked and thrived. This area was known as Aultman. A history of the Aultman community was preserved by the late Emaline Turpin, a resident of the area for over forty years.

Emaline Turpin, early resident of Aultman.

CANTON TREASURES

Jacob Gaskins, A Man of Color

By Mike Miller

In 1985, while researching a prominent family in Plain Township from the 1800s, I looked at the opposite page, which had an entry "Elizabeth Gaskins, colored..." It caught my attention, because I wasn't aware of any African Americans in early Stark County history, let alone any African Americans that were prominent enough to be listed in an otherwise "white" history book.

In the biography of Elizabeth Gaskins, a large amount of the documentation was devoted to her father, Jacob Gaskins, who played a prominent role in Stark County/Plain Township/North Canton history in the 1800s. Gaskin was born into slavery in 1792 in Winchester, Virginia. His original "owner" died, and all of his slaves were freed, except for those under the age of twenty-one. Gaskins and the other children remained enslaved and were sold. His second "owner" admired Gaskins for his "industry and honesty," so when Gaskins regained his freedom, he continued to work for him and shared in the profits of the work. In 1816 or 1817, Gaskins moved to Stark County, Ohio, and married Hannah Robinson.

The 1820 Census revealed the Gaskinses were one of five African American families living in Stark County at that time. Those five families

comprised 23 African Americans, accounting for less than 2 percent of approximately 1,200 total persons living in Stark County. Being an African American in Ohio was not easy in 1820. While Ohio did not have slavery, the initial Ohio Constitution of 1803 denied both African Americans and women the right to vote. By January 1804, many other laws were passed, referred to as "black laws," designed to keep African Americans out of Ohio. The legislature for Ohio kept passing new laws with the same goals of keeping African Americans out or disenfranchised. African Americans had to obtain a "certificate of freedom" and pay $50 to renew the certificate every two years. There were laws against hiring any African Americans who did not have a certificate. African Americans were excluded by law from attending public schools.

Another law prohibited African Americans and persons of mixed race from marrying whites. African Americans were required to have a $500 bond in place to remain in Ohio. The reasoning for the bond was purportedly to keep African Americans from becoming a burden on the state in the event they couldn't meet their financial obligations. Despite those obstacles, Gaskins and his family stayed in Plain Township and prospered. To quote from *Old Landmarks of Canton and Stark County Ohio, Volume I* (1904), "Without any capital except the natural endowment of industry and economy, he accumulated a large property." It is stated in *History of Stark County* (1981), "He was respected by all that knew him, for his honesty and industry." He was a fixture at barn raisings. He was able to carry timbers that would take four other men to carry. In corn-husking contests, he was always the winner. One of the stories about him concerns a barn raising incident, where a citizen of Stark County was giving him a hard time. It got to the point where Gaskins went to his bondholder and asked permission to thrash the citizen. The bondholder declined to give permission, but after he left, Jacob became so upset that he picked the offending citizen up, carried him over to a three-rail-high fence and threw the citizen over it into a pigpen. Gaskins became distraught, thinking he had gotten himself in trouble, but those at the barn raising reassured him that all was well.

During the period leading up to the Civil War, Jacob Gaskins's homestead served as a station on the Underground Railroad. This was confirmed by Wilbur Seibert's authoritative book on the Underground Railroad, in which he states that escaping slaves were transported from Massillon to the station, which was the homestead of an African (Gaskins) northeast of Massillon. Gaskins helped escaping slaves despite all the personal risks. The link to Massillon and the Underground Railroad has a stronger input in the context

of his wife, Hannah, a Quaker, and their church in Kendal, which is now part of Massillon. The Underground Railroad trail ran from Massillon northeast to Marlboro and beyond through the Gaskins homestead.

On February 12, 2005, the Friends of Freedom Society dedicated an Underground Railroad Marker to Gaskins at his former homestead, paid for by the citizens of North Canton. It is located on his former homestead, "The Fairways" golf course in North Canton, which used to be known as Arrowhead Country Club. It is the first Underground Railroad Marker in Ohio to honor an individual African American and the first to have a photo.

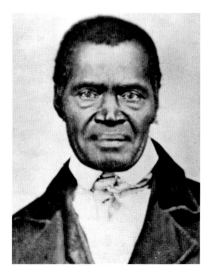

Jacob Gaskins. *Courtesy of North Canton Heritage Society.*

At his death, Gaskins owned nearly 400 acres of property in Stark County. As noted earlier, one parcel (136 acres) is now the Fairways Golf Course. On other parts of that 136-acre tract are Orchard Hill Elementary School and a portion of Lansdowne subdivision. He owned other large tracts in Jackson Township, tracts of 82 acres and 160 acres. The 82-acre tract is now home to Kent State Stark Campus and a Jackson Township Fire Station. Later in his life, Gaskins owned a home on South Main Street, the largest lot on Main Street and the largest house until "Boss" Hoover later built his.

With the Ohio passage of the Fifteenth Amendment in 1870, Gaskins became the first African American to vote in Plain Township/North Canton. He and his family ironically overcame all the other obstacles placed in their path by Ohio. In March 1873, Gaskins transferred ownership of his property to his daughter Elizabeth. His second wife's attorney was future president William McKinley. Coincidentally, less than two months later, in May 1873, Jacob Gaskins was killed by horses.

His first wife, Hannah, had passed away in 1861 and was buried in Westlawn Cemetery two years after it opened. Westlawn Cemetery is also Jacob's resting place. Jacob and Hannah's monument, tragically like many others in Westlawn, has been vandalized over the years, but it still is a grand monument, standing over eight feet high. What is also amazing is that the monument is the only reminder of Jacob Gaskins and his family. There are

pictures of Gaskins and his granddaughter. The first picture of a public school class in North Canton in the 1880s shows his granddaughter Susan Gaskins. When his surviving daughter Elizabeth died in 1896, she had a sizable estate, with loans out to, among others, the predecessors of Mohler Lumber Company. There is much yet to uncover about Jacob Gaskins. He and Hannah had nine children. The fate and location of six are known, but nothing is known of two of the boys and a girl. The remaining family moved to Cleveland during the Depression. Jacob's second wife was from Cleveland. Hopefully, descendants can be found. There are seventeen Gaskinses who fought on the Union side with the U.S. Colored Troops in the Civil War—are any of them related?

THE NEW NEGRO

The 1900s found the United States struggling with two world wars; unparalleled economic depression; killing fields in Korea, Vietnam and Iraq; and a persistent, unwavering force destined to obtain the acceptance of all Americans within the civil arena. Although these events are incorporated into the history books, students have to dig deeply to resurrect the bodies of Emmett Till and Medgar Evers. To learn about men like W.E.B. DuBois, upon whose shoulders the Reverend Martin L. King Jr. stood, students must reach higher than their classrooms. For the first half of the century, both de facto and de jure segregation were practiced throughout the United States. Although there is evidence that black people have always struggled against oppression, the 1950s brought recognition that change had to come if this country was going to survive.

> *By the 1920's a "New Negro" had evolved, with a personality crystallized by two major events: World War I and the mass migration of Blacks from the South to the cities of the North… The impact of the New Negro Movement was enormous. Politically, the decision to migrate in and of itself was an act of defiance against the social order and political constraints of the South, and a vote cast for the liberating possibilities of the North. The new sense of political activism was reflected in the massive shift in Black affiliation from the Republican to the Democratic Party and in the increasing influence of Black organizations. The National Association for the Advancement of Colored People (NAACP) was founded in 1909 and*

*dedicated to securing full civil and political rights for Black Americans. The
Urban League was founded in 1910 with the goal of acclimating recent
migrants to the rigors of urban life.*[13]

The transition from the rural South to the urban North strained the
services of the cities and challenged the lifestyle of those migrating.
Canton was no different. Southern black men heard from their sisters,
brothers, cousins, uncles, aunties and friends that Canton was a place
where a black man could get a decent job and support himself and his
entire family. Most came from the South, although others came from as
far away as Philadelphia.

Fannie Bonner, a native of Tennessee, moved to Canton in 1924. Bonner
was born the same week that Abraham Lincoln signed the Emancipation
Proclamation, January 1, 1863. She is quoted as saying, "I was the first 'free-
born Negro child in that part of the country [Tennessee].'"

Bonner's children were Ora Marshall, Susie Hutchinson, Della Johnson
and Sam Bonner. At the time of the 100th anniversary of her birth,

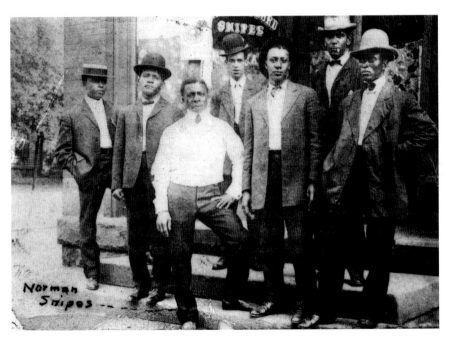

Norman Snipes (*center, in white shirt*) and friends in front of Snipes Billiard Parlor on
Walnut Street.

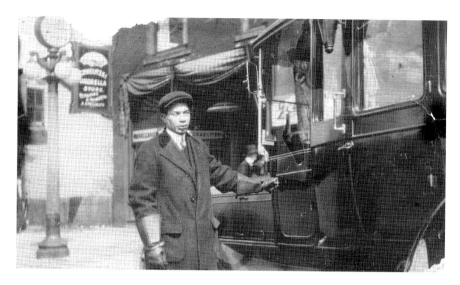

Norman Snipes with his new automobile.

Bonner had four children, seventeen grandchildren, thirty-three great-grandchildren and thirty-two great-great grandchildren. The Bonner family still celebrates an annual family reunion.

The father of the late Dr. Norma Marcere, a noted educator in the area, arrived in Canton around this time. His name was Norman Snipes, and along with Zadock Hunter and Val Cook, he migrated from Raleigh, North Carolina, in December 1905 and relocated to Canton.[14] All three men got jobs serving as waiters at the Courtland Hotel (later known as the McKinley Hotel), Canton's largest and finest hotel at that time. Their landlord, David Hall, persuaded the young men to attend church and get to know the "right people."

Snipes became Canton's first black businessman as owner and operator of the Snipes Billiard Parlor and Grill. The Grill had its grand opening in August 1906 and was located on Third Street and Walnut Avenue. His son and the brother of Dr. Marcere, Carl Snipes, started as a caddy at Brookside Country Club and later became the manager of the East Aurora County Club in Buffalo, New York.

CANTON TREASURES

Norma Marcere

By Lois DiGiacomo-Jacobson

"If it wasn't for you I could be playing bridge and out shopping in the malls!" are words I spoke often to Norma Marcere. In 1992, I began writing a play about her life (1908–2004) adapted from her two autobiographies, *'Round the Dining Room Table* and *The Fences Between*. Learning about her life has forever changed mine.

Norma's life did not conform to anyone's standards or expectations but her own. She had admirers and detractors in both the black and white worlds. Norma was called the "N" word and worse by whites and "oreo" and worse by the blacks. Converting to the Catholic faith as a young adult and lifelong membership in the organization "Black Catholics" made her a minority in all worlds. If any of this bothered her, her smile never let it be revealed—publicly.

She wrote her books because her grandchildren never asked her what it was like growing up. Norma felt it was important that they know their history but gave them the respect of allowing them the choice to learn it. Her history reveals a family of many colors: her great-great-grandfather was a white plantation owner; her great-grandmother, a white woman from Ireland; her octoroon grandmother could have "passed" as white (as did her siblings), but she did not. She married an African American man and birthed Norma's mother, then called a mulatto, who married a man from South Carolina. Norma's father, Norman Snipes, came north to marry a "high yellow" in order to have light children, but none of his six children was. The Snipes-Evans Wedding was heralded as the first formal colored wedding in the new St. Paul African Methodist Episcopal Church.

Norma's love and acceptance of everyone, regardless of the color of their skin, existed maybe because of her father's remark at her birth, "Kinda dark, isn't she?" Norman Snipes worked as a waiter in a Canton hotel, quite a prestigious job at the time. He then became a businessman owning a pool hall, until his partner absconded with the funds. During all this time, he studied at night to become a lawyer. Eventually, his dreams and courage failed, and he abandoned his family when Norma was twelve.

Everyone who reads Norma's books or has seen her play, *The Fences Between*, is inspired by her life. As a teenager, she confronted the pastor of St. John's

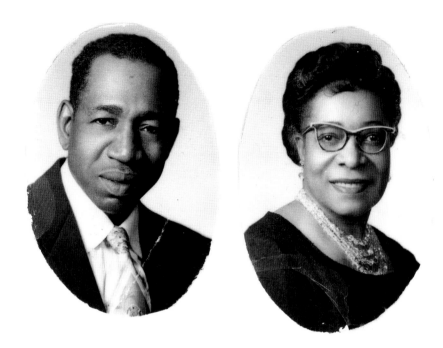

Percy and Dr. Norma Marcere, married forty-three years.

Catholic Church about their performances of a minstrel play with blackface actors—and had it shut down. As the first high school graduate in her family, she went on to receive a degree from Kent Normal School (now Kent State University) in 1928 as a teacher. She had high grades and perfect attendance; however, Canton's school superintendent at that time, Jesse Mason, refused her a position, saying, "Go south!" She did—to Philadelphia—to get a degree in social work. This led to a position in the early '40s that gave her the highest salary paid to a black woman in Stark County. Along the way, she participated in a sit-in at the restaurant in Stark Dry Goods Department Store that led to its becoming integrated. She did the same at a downtown soda fountain. Norma was an activist far ahead of her time, encouraged and strengthened by a strong mother and maternal grandparents.

Norma was a lifelong student, learning and teaching her whole life. Her husband, Percy, a constant support for her, helped to raise their two children while she took night classes, earning a master's degree in psychology and counseling from Kent State University. She also received an honorary doctorate from Walsh University. With these degrees, Norma

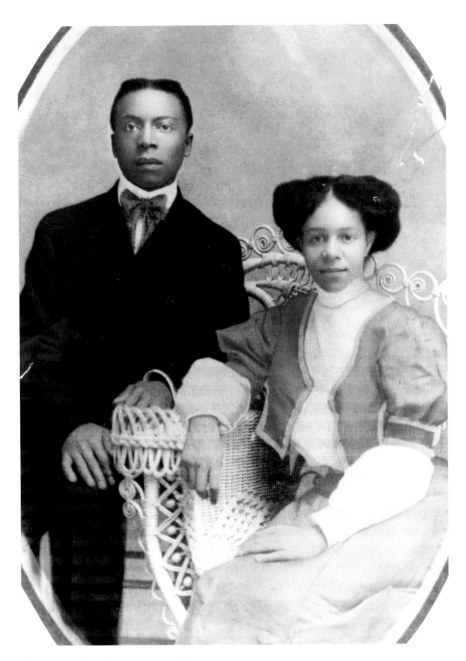

Norman and Ida Evans Snipes, 1906.

worked in eight schools within the Akron school system, teaching and counseling both in all-white and all-black schools and later in Massillon City schools.

Her stories through the years are countless, yet there is one that stands out for both of us. I was with her when Kent State gave her the "Outstanding Alumni" almost seventy years after they refused to allow her, as a student, to live in one of their dorm rooms.

Dr. Marcere did not live to finish her third book, but she left a legacy of stories and pictures, which touched the hearts of all Cantonians.

There are many stories of African Americans who were either born or migrated to Canton. Most of these early histories remain unwritten. We thank pioneers like Norma Marcere, who had the foresight to write her family history.

4

THE WAR YEARS

*L*ike other patriots, black men answered Uncle Sam's call. Black soldiers participated in every war in which the United States was involved, although not with equal treatment to the white soldiers. Crispus Attucks, a black man, was the first to die in the Boston Massacre of 1770, the beginning of the American Revolution. By 1792, a congressional act restricted military service to free, able-bodied, white male citizens. When the Marine Corps was established in 1798, the rules stated that "no Negro, mulatto or Indian" was to be enlisted. Although blacks were still excluded from most land forces during the War of 1812, experienced blacks proved to be a valued resource in this largely naval war. When Commodore Perry won his great victory on Lake Erie, at least one out of every ten sailors on his ship was black.

President Lincoln announced in his 1861 inaugural address that he had no intention or legal right to interfere with the "institution" in which blacks were enslaved in those states "where it now exists." By mid-1862, the supply of Union volunteers had slowed and Congress revoked the laws against blacks in the militia or blacks as laborers. Finally, in August, Secretary of War Stanton approved black recruitment. According to Herbert T.O. Blue's *History of Stark County*, "Massillon furnished eighteen colored volunteers for the Fifth United States Infantry, while, so far as known, no other portion of the county furnished a colored man, at least at that time."

On September 22, 1862, Lincoln authorized participation of blacks in "the armed services of the United States to garrison forts, positions, stations,

and other places to man vessels of all sorts in said service." After Lincoln's Emancipation Proclamation, effective January 1, 1863, black soldiers were officially allowed to participate in the war. Over 180,000 African Americans served in the Union army during the Civil War.

In May 1863, the War Department created the Bureau of Colored Troops to handle recruitment. The United States Colored Troops (USCT) was created, but all officers were still white. Black soldiers were paid considerably less than white soldiers until January 1864, when equal pay was achieved. The 180,000 blacks of the USCT comprised 10 percent of the total Union strength. Another 200,000 blacks served in service units. Fewer than 100 served as officers. Thirteen black noncommissioned officers received Medals of Honor for action at Chapin's Farm, Virginia, where they assumed command of their units and led assaults after their white officers had been killed or wounded. Of the 1,523 Medals of Honor awarded during the Civil War, 23 were awarded to black soldiers and sailors. The navy enlisted blacks beginning in September 1861. By 1862, regular seaman ranks were opened to blacks. By the war's end, 30,000 blacks had served in the navy out of a total naval enlisted strength of 118,000. By 1865, over 37,000 black soldiers had died—almost 35 percent of all blacks who served in combat.

In 1939, as World War II was about to erupt, Congress enacted the Civilian Pilot Training Act to create a reserve of trained pilots in case of war with the requirement that at least one of the schools train black aviators. In early 1941, the Tuskegee Training Program began at Tuskegee Institute in Alabama. Nearly 1,000 "Tuskegee Airmen" trained through this program, and Tuskegee Institute was the single training facility for black pilots until the flying program closed in 1946. At the same time, the 99th Pursuit Squadron was formed as part of the program. Later designated the 99th Fighter Squadron, this exclusively black flying unit participated in campaigns throughout Europe and earned three Distinguished Unit Citations. The pilots

George Lemon Sr.

41

were noted for destroying five enemy aircraft in less than four minutes, a feat never before accomplished. Another all-black Army Air Corps flying unit, the 332nd Fighter Group, first saw combat in early 1944. These pilots destroyed a German navy destroyer with their fighter aircraft, which had never been done before. This unit was under the command of Lieutenant Colonel Benjamin O. Davis Jr., the first black graduate of the U.S. Military Academy to become a general officer in the regular army. (He retired at the rank of lieutenant general.) In all, the Tuskegee Airmen destroyed 261 aircraft and damaged 148 more. They flew 15,533 sorties and 1,578 missions, with 66 of their members killed in action between 1941 and 1945. Some blacks received the Silver Star and other combat decorations, but there were no black recipients of the 431 Medals of Honor.

George W. Lemon Sr. is an example of the black men who served in the U.S. Air Force. Although he did not complete basic training, he served from 1944 to 1945. George was stationed at Alamogordo Air Force Base in Alamogordo, New Mexico. George enjoyed telling his most famous war story of witnessing the testing of the atomic bomb. At 5:00 a.m., he saw the bright light eight to ten miles away from the testing site. Also, he remembered serving in segregated units in the U.S. Army.

Segregation was as prevalent in the armed services as it was in civilian life. But the one place where black and white were equal was in love for family. Love for family back home sustained many soldiers through long periods of time away from loved ones, as expressed in letters like that written by Private William Dantzler to his wife, Elizabeth, during World War II.

Executive Order 9981 issued by President Harry S Truman on July 26, 1948, established a policy of equality of treatment and opportunity for all persons in the armed forces without regard to race, color, religion or national origin. A presidential committee concluded that full utilization of blacks would improve military efficiency and that segregated units were an inefficient use of black resources. In June 1949, Wesley A. Brown became the first black graduate of the U.S. Naval Academy.

During the Korean War, the family of the late Freeman Wright will never forget the news they received of their son, Private First Class Roy C. Wright. The Wrights learned of their son's death when they received that dreaded telegram. Roy died while held captive in a communist prison camp. He was only twenty-two years old and had enlisted in the service in May 1950. Wright was declared missing in action since December 1, 1950. Until they received the telegram, the Wrights did not know their son was being held captive.

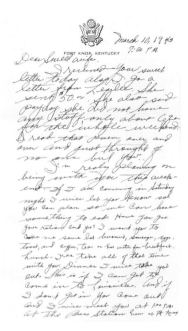

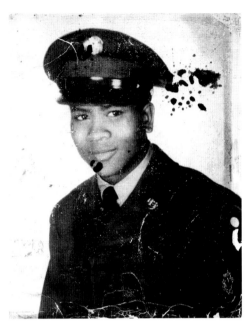

Left: With a promise to meet in Fort Knox, Kentucky, Private Dantzler ended this love letter to his wife, Elizabeth.

Right: Roy Wright.

The service of African American soldiers did not end with World War II or the Korean War. Many served in Vietnam, the Gulf, Iraq and Afghanistan. We continue to serve and to give the best we have, our sons and daughters. To assist those returning from combat, the Veterans of Foreign Wars was established. In 1958, Canton had several VFW posts. Post 3417, which catered mostly to African American veterans, was organized about 1934.

Canton Treasures

Theodore Knight

Knight was born in Clio, Alabama, on February 16, 1956, raised in Canton and attended Allen School, Hartford Jr. High and Timken Vocational

High School. He enlisted in the navy in December 1974 and attended Quartermaster "A" School in Orlando, where he was a top graduate and advanced from seaman recruit to third class petty officer.

After graduating from A School, he reported aboard USS *Brooke* in San Diego in March 1975. He subsequently made three nine-month deployments to the western Pacific, was promoted and selected as USS *Brooke*'s Sailor of the Quarter, Destroyer Squadron Sailor of the Quarter and Cruiser Destroyer Group Five Sailor of the Quarter. His accomplishments culminated in Knight's selection as USS *Brooke*'s 1978 Sailor of the Year and runner-up for US Pacific Fleet Sailor of the Year.

Knight was awarded as the instructor training class honor graduate and returned to Mare Island, California, where he taught and mentored sailors in the Naval Tactical Data Systems "C" School. Knight became the leading petty officer for the computer branch and was selected and advanced to chief petty officer in August 1984.

Serving more than twenty-five years in naval service, he retired in June 2000. His personal awards include the Meritorious Service Medal, Navy Commendation Medal (with Gold Star) and Navy Achievement Medal (with two Gold Stars), as well as various unit, campaign and marksmanship awards. Throughout Ted's navy career, he attended multiple colleges and obtained an advanced degree. Ted was employed as a defense contractor and adjunct professor; later he returned to government employment in 2008 as the executive director of the Global Network Operations Center overseeing the Navy Marine Corps Intranet with over 700,000 user accounts, the largest intranet in the world.

Harold White

By Bridget Hill

Harold White was born on July 12, 1921, in Canton to Clarence and Anna White. White attended McKinley High School for three years. Following his junior year, he was granted early enrollment at Tuskegee Institute, a fully accredited Negro college in Alabama. In 1940, White, nineteen years of age, arrived on campus. In addition to classroom studies, he was required to take flight training. After two years at Tuskegee, Harold and his comrades were shipped overseas and became known as the Tuskegee Airmen of the famed Ninety-Ninth Fighter Squadron of World War II.

They would fly 15,553 sorties and 1,578 missions over Germany and Italy. They destroyed 409 enemy aircraft, numerous boats, bridges, barges, locomotives and radar installations.

Fifty percent of the Tuskegee Airmen would never return to their base. They were shot out of the sky and either killed or captured by the Axis forces. Eventually, several books were published and a made-for-television movie was produced that chronicles the lives of the famous Airmen.

In 1985, at the age of sixty-three, while wearing a cap and gown, Harold formally graduated from McKinley High. The audience stood and applauded. Harold wept as he remembered his comrades who never returned to their homes. After returning from active duty, Harold was employed at the Diebold Corporation as a machine operator, retiring in 1981 after providing twenty-three years of service. Harold became the first licensed African American pilot in northeastern Ohio and was a flight instructor.

Harold still has several family members living in the area, such as his sister, Florence Goodwin; niece Gerrie Baker; great-nieces Amber Baker and Florence Anna Goodwin; and great-nephews Harold L. Goodwin, Mandel Baker, Leon Goodwin, and Bobbie Goodwin.

On September 13, 2004, at age eighty-three, Harold A. White, known to his flying buddies as "Whitey," began his final flight. He is buried in Forest Hill Cemetery.

5

THE PROFESSIONALS

The Medical Professionals

We look to those men who wore suits and ties and to the women who did not have to wrap or cover their heads for work as inspirations for a better future. African American professionals have served and continue to serve as role models for the next generations.

The first black physician in Canton was Dr. J.B. Walker. Along with his wife, Theresa Etna Nutt Walker, Walker was an early fighter for African Americans in Canton. Dr. Walker was born in Virginia, and Mrs. Walker was born in Washington, D.C. Dr. Walker received his medical degree in 1919 and began practicing in Canton in 1920. He helped organize the Canton Urban League in 1921 and served as a member of its board of directors. Joining Dr. Walker in serving Canton's African American community were Dr. Mantel Birt (or Bert) Williams, Dr. P.M. Ross, Dr. A.B. Royal and Dr. S.W. Gregory. Dr. Williams, the father of Marian Crenshaw, a noted Canton educator about whom more is included in this book, served Canton for over thirty years.

For Canton black families, another servant of medical needs was Dr. S.W. Gregory. Gregory was a contemporary of Dr. P.M. Ross and Dr. Mantel Williams, although younger than both. He continued to practice medicine long after their deaths. Born on October 5, 1921, and dying on November 23, 2010, Dr. Gregory lived to be eighty-nine years old. He had a private practice in the city for many years before retiring in 1992.

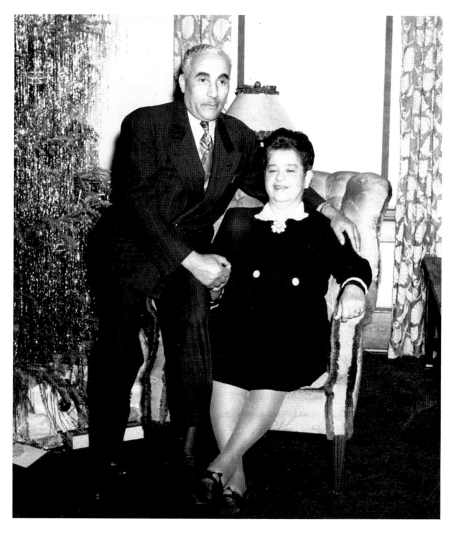

Dr. J.B. and Mrs. Etna Walker.

Gwendolyn Ford may be the first native Cantonian African American woman to practice medicine in the city. A graduate of Glenoak High School and The Ohio State University College of Medicine, she served as an assistant professor at Case Western Reserve University and is a neurologist practicing at Universities Hospital in Cleveland.

Canton has a number of practicing physicians, both African and African American, including Dr. John Hamilton, a gynecologist; Dr. Agnes Chuckamerjer, a general practitioner; Dr. Bryan Simmons, a heart specialist;

Dr. Cosmas Onuora, an obstetrician; and Dr. Gregory Hill, orthopedic surgeon. Dr. Jamesetta Holloway Lewis, a Glenoak graduate and granddaughter of longtime retired educator Oweda Conn and daughter of retired teacher Lewistine Holloway-Moore, is affiliated with Dunlap Memorial Hospital in Orrville, Ohio. Two native sons, Boyd Curtis and Steven Thompson, have medical practices outside of the city. We are certain that there are others whom we have not documented.

In addition to the medical doctors, Canton was home to a number of dentists, including Dr. P.M. Richardson, Dr. Guy Taylor and Dr. William Wilson. Dr. Wilson's son, Dr. Chester Wilson, owns and operates a dental office located on Tuscarawas Street East in Canton. Dr. Brian Amison recently opened an office on Whipple Avenue Northwest, and Dr. Safuratu Aranmolate has a practice providing pediatric dental care. The quality of those professionals serving the Canton community was noted not only by their patients but also by local and state officials. Dr. Taylor was appointed by Governor Frank J. Laushe to serve as a member of the Ohio delegation to the White House Conference on Education. He served as president of the Canton Urban League and as a board member for several community organizations.

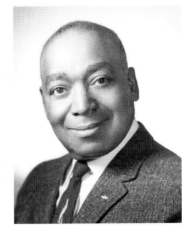

Dr. P.M. Ross. *Courtesy of the Greater Stark County Urban League.*

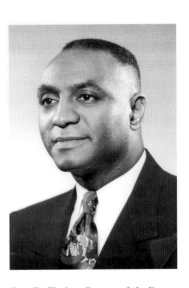

Guy R. Taylor. *Courtesy of the Greater Stark County Urban League.*

Working along with the doctors were and are many African American nurses. Margaret Warren, a registered nurse, worked for Mercy Hospital in Canton as early as 1953. Bernice Inman, daughter of Reverend J.W. Inman, a graduate of McKinley High and Harlem Hospital New York Nursing School, is credited with being the first native Cantonian to work as a member of the Mercy Hospital staff as a registered nurse. Geraldine Lemon Radcliffe, Dr. Ella Scott, Dr. Perry

Bomar, Nazanobia Adams-Phillips, Dominga Hall, Cynthia Kelly, Lovie Hailey and Jo Emma Williams were among the city's first black nurses. Patricia Fowler-Smith, a 1955 graduate of McKinley High School, received an associate's degree in nursing (Capital University), a bachelor's in social work (Ohio University) and a master of science in nursing (Akron University). Patricia and Gerry Radcliffe's research on heart disease in African American men won recognition from the American Heart Association, Ohio chapter, for their research studies, titled "Heart Disease in African American Men, Age 35 and Older." During her forty-seven years of nursing, Patricia held various nursing positions, including director of nursing at Apple Creek Developmental Center. Sadly, Patricia died on February 16, 2019.

Doris Ashworth Wilson, RN, PhD, died at the age of eighty-seven on April 19, 2016. In 1946, Doris graduated with honors from West High School in Akron and went on to Harlem Hospital School of Nursing. She received a bachelor of science degree in nursing from the University of Akron. She married Dr. William Edward Wilson in 1955. She completed her master's degree in public administration at Kent State University. In 1985, she received her doctorate in public administration from Nova Southeastern University in Fort Lauderdale. Doris served on the faculty of Aultman Hospital School of Nursing. She was a vocal advocate for community mental health awareness, lobbying the state as associate director of the Stark County Mental Health Board. Doris was a founding member of the National Black Nurses Association Inc. (NBNA). She served as treasurer for several years. The goal of the NBNA was to improve the health status of black people in the United States and to open nursing education and leadership positions for African Americans. The founding members of the NBNA proposed to make strides by building consumer knowledge and continuing education for registered nurses, nursing students and retired nurses. She was the voice of the African American nurse, fighting to improve the delivery of healthcare services, better working conditions and equal salaries

Ella Mae Mitchell, a graduate of Massillon Community Hospital School of Nursing, worked for over thirty years full time simultaneously at both Massillon and Aultman Hospitals in various positions and as director of the pediatric department. Other early nursing pioneers upon whose shoulders we stood upon and who paved the way for local African American nurses were Carol Anderson, Gloria Balious, Betty Leslie, Madeline Burkes, Gloria Dent Davis, Jane Dancy (director of Stark County Health Department), Gloria Lott, Doris Parks, Janet High McNair, Ophelia Owens, Eileen Arrington, Carol Jennings, Tanya Tyrus Williams, Brittney Lemon and Kelly Fields.

Here is a listing of just a few licensed practical nurses: Estella Averette, Amelia Evans, Marva Dodson, Helynn Hall Terrel, Pearl Yvonne High, Clara Martin, Dorothy Massey, Antoinette Merandes, Dolores Weir, Ivy Jorden and Elizabeth Williams

Cynthia Kelly became the first nurse anesthetist in the city at Aultman Hospital. There is no record of the first black men to serve as nurses in the city. However, Roy Yancy, a 1962 graduate of McKinley High, is a nurse in California. Stanford Stevens, Herman Wesley and Reggie Pryor are also nurses.

Veronica Hanon Bolden was the first African American to serve as a public school nurse for the Canton City Schools. Other African American women school nurses were Carol Kennedy, Arlene Thompson and Dimitri Holston Miles. Allison Hurd Goshay is retired from her position as director of nursing at Mercy Medical Center. Currently serving as nurses in the city are Tasha (Compton) Foster, employed by Aultman Hospital and a graduate of Canton South High School and Kent State University; and Shala (Kirtdoll) Brown, who worked at Mercy Medical and is a graduate of Timken High School and Kent State University. Shala worked for Allison Goshay before moving to Florida. Latoya Dickens is a nurse practitioner at Aultman Hospital. Dickens has received several recognitions for her service to the community. This list, like others, is not exhaustive.

THE PHARMACISTS

The first African American pharmacist in Canton was J.L. Brewer, who owned and operated Southside Pharmacy, established in 1934. In the early 1940s, he purchased his own building at the corner of Cherry and Fifth Street Southeast. His drugstore was a favorite hangout until the late 1970s, when the area was demolished due to urban renewal. Since the other pharmacy serving most of the southeast residents was owned by a white man also named Joe, many distinguished the two by calling them Colored Joe and White Joe.

White Joe was Joe Israel, who, along with his wife, Molly, owned Adelman's Drugstore on the corner of Cherry and Sixth Street Southeast. They recruited a young Fred Johnson, who worked as a pharmacist when he came to Canton in 1952. Even though Israel was not a pharmacist, patrons would often ignore Johnson and hand their prescriptions directly to Israel, ignoring the black man in the white pharmacy jacket. Johnson became owner and

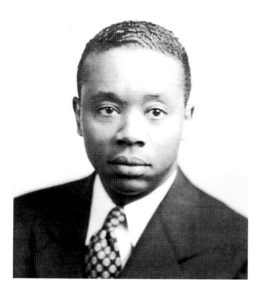
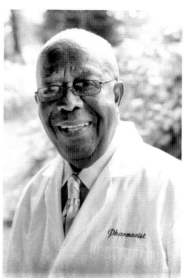

Left: Joe Brewer, owner of Southside Pharmacy.

Right: Fred Johnson.

operator of the McKinley Pharmacy at Market and Second Street Southeast. Despite celebrating his eightieth birthday in 2006, Fred continued to work part-time, including serving with the Veterans Administration and Rite-Aid Pharmacy until his death. Fred was married to Robin Johnson, also a pharmacist, who worked in Columbus.

Another pharmacist, Merion J. Cosey, worked for Adelman's Drug Store for a while and later purchased this store from Joseph Israel. He named his new business Cosey's Drug Store.

Other Canton pharmacists were Clayton Umbles, brother of Gwen Umbles Singleterry, and James Thigpen. Umbles practiced for many years in Toledo. Thigpen, whose father was a foreman at Republic Steel, graduated from Ohio State University and owned a drugstore in Columbus.

Before leaving the medical professionals, there is one other individual who deserves mention, Norman Hall. Hall is a self-taught medical artist who "made his first anatomical drawings in 1962, when he was employed at the Brogdon Funeral Home." Hall attended the old South Market School and later Lathrop Elementary School, graduating from McKinley High in 1961. "His diagrams and drawings have been used by licensed practical nurses to illustrate techniques when instructing pupils in the public schools. His works also may be seen in the library of Allen School."[15]

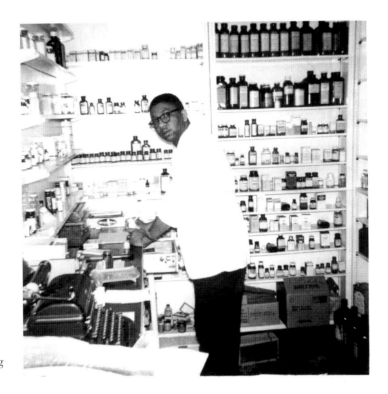

Cosey's Drug
Store.

Other healthcare professionals include Hortense Bobbitt, RD, LD (registered dietician, licensed dietician). These are now medical assistants: Jean Ulmer, Phyllis Butler, Marlia Ross, Melinda Tuck and others too numerous to list. Shirley Anders Wyatt, laboratory technologist, held many positions at Aultman Hospital and North Canton Medical foundation as laboratory and purchasing director.

ATTORNEYS AND JUDGES

The first black lawyer in Stark County was Robert A. Pinn, whose father came to Canton in 1822 and purchased a farm in Perry Township. Pinn was born in 1843. During the Civil War, he offered to join the Union army but was denied because no black soldiers were being accepted.[16] When the Union army finally put out the call for black soldiers, Pinn was one of the first to enlist. He was only eighteen when he entered the Nineteenth Ohio Infantry by joining the Fifth U.S. Colored Troops regiment at Massillon. In the Battle

The Honorable Clay E. Hunter.

"Lawyer" Frank Beane.

of Fort Harrison, 3,200 Union soldiers—1,700 black soldiers—were killed. Pinn was shot three times—"one in the left thigh, then in his left arm and finally in his right shoulder."[17] Pinn received two gold medals from the U.S. Congress for gallant and heroic conduct. Later, he attended Oberlin College, studied law and was admitted to the bar in 1879 at age thirty-four. He became a U.S. Patent attorney and a delegate to the Republican State Convention that nominated McKinley for governor. Although Pinn was the first black attorney in the county, the first black attorney in Canton was Louis Howard, about whom little is known.

More notable is Canton's second black attorney, the late Judge Clay E. Hunter. Judge Hunter came to Canton around 1920 and began practicing law in 1923. At age sixty-seven, he was appointed judge of the Canton Municipal Court, which made him the first black to serve on any court in Stark County.

Serving in the same law office as Judge Hunter was Frank C. Beane, who practiced in Canton until his retirement in 1995 at age ninety-three. His son, a 1961 graduate of McKinley High, became a lawyer and practiced until his death in 2018. Much could be said about "Lawyer Beane," as the senior Beane was affectionately called. Most would agree he was outspoken on civil and legal issues, particularly when these issues involved African Americans and their treatment. Beane believed in the United States and its ability to live out "the true meaning of its creed," to quote the Reverend Dr. Martin Luther King Jr. Beane said his proudest moment came when the people elected Ira G. Turpin, a black man, to the Stark County Common Pleas Court bench.

The third attorney to practice in Canton was Ira Turpin. At the time he began his practice, he was more noted for being the brother of Vince Turpin, a professional boxer. Vince became the nation's tenth-ranking

welterweight. Although better known than his brother, Ira claimed Vince as his idol. Following in his older brother's footsteps, Ira became a tap dancer at the age of ten and later a boxer. Ira won four fights and when he lost his fifth match, he ended his boxing career. Turpin's wife, Genevieve, convinced him to go to college. He did and decided to become a lawyer. At the time of his retirement, Judge Turpin held the highest elective post of any black person in Ohio. Turpin died on August 11, 1989, at the age of sixty-four.

Canton can boast of two native sons who attained the ranks of judges in other cities. Jeffery Hopkins serves as a federal judge in the U.S. Bankruptcy Court for the

The Honorable Ira G. Turpin, Fifth Distirct Court of Appeals.

Sixth District, in Cincinnati. Appointed by the U.S. Court of Appeals for the Sixth Circuit in April 1996, he served a fourteen-year term and was reappointed to another fourteen-year term in 2010. Jeff is the son of the late Minnie Hopkins, a noted educator in the city.

Judge Hopkins is an adjunct law professor at University of Cincinnati and is president-elect of the National Conference of Bankruptcy Judges. He has also served as a faculty member of the American Law Institute American Bar Association since 2001 and teaches a course on the fundamentals of bankruptcy law. Most recently, he received the Distinguished Jurist from Ohio State University's College of Law. Alan Page, a 1962 graduate of Central Catholic High School, won fame and fortune as a professional football player for the Minnesota Vikings. He was elected as the first African American justice to serve on the Minnesota Supreme Court.

Clarence Mingo attended The Ohio State University, earning an undergraduate and law degree in a little more than five years. Franklin County courts frequently appointed Mingo to serve as a guardian ad litem representing the interests of children in abuse, neglect and divorce cases. In 2007, the late chief justice of the Ohio Supreme Court Thomas J. Moyer appointed Clarence as a commissioner in the Ohio Court of Claims. In 2009, Clarence was appointed as Franklin County auditor. In both 2010 and 2014, Franklin County voters awarded Clarence a full four-year term. His sister Stephanie Mingo was appointed on December 26, 2018, by Governor

John Kasich as municipal court environmental judge in Columbus, Ohio. The first African American woman from Canton to become an attorney may be Yvonne Tate, who graduated from McKinley High in 1967. Yvonne Tate Laremont serves as a member of New York mayor Bill de Blasio's cabinet as general counsel for the City Planning Commission.

A 1970 graduate of Canton McKinley, Bertha Bailey Whatley is now serving as the in-house attorney for the Fort Worth Independent School District. Although born in Camilla, Georgia, to Clarence and Wyolene Bailey, Bertha moved with her family to Canton in 1952. While Bertha was attending Theodore Roosevelt Elementary, her teacher told her, 'You should attend Timken Vocational High because a poor colored girl like you will not be able to go to college.'

The exact opposite was true. Her parents assured her it was possible for her to attend college. Bertha took college preparatory courses and excelled at McKinley. She was on the newspaper and yearbook staffs. She led the freshman class as its president and was elected into the National Honor Society.

As Bertha Whatley explains, hers are not the only remarkable achievements in the family:

> *My brother, Jerry D. Bailey, may be the first black male attorney of the post-war generation. He graduated from McKinley in 1968, Ohio University in 1972, and Boston University Law School in 1975. Jerry may be the first Canton black male to obtain an advanced degree from the Massachusetts Institute of Technology. He received his MBA from Sloan Business School in 1978. He then went on to have a distinguished career in private industry, which included assignments in New York City, London, and Singapore.*
>
> *My cousin, Dr. Donald E. Tarver, Jr. may be the first black from Canton to graduate from Harvard. He received his undergraduate degree from Harvard in 1981. He received MD from the commissioner on the Board of Health for San Francisco.*

We are fortunate to have several locally born and educated Cantonians return to the city after obtaining their juris doctor degrees. Adrian Allison, son of Bruce Allison, served as the superintendent for the Canton City Schools. Allison's wife, Krista L. Allison also served students of Canton City Schools as an education administrator. Sean Ruffin, son of Reverend Jimmy and Bertha Jean Ruffin, has a private practice. Although not Canton-born, Jonathan Morris serves private clients in his law offices. Esther Lynise Bryant-Weekes is a district court judge for the Thirty-Sixth District Court

in Michigan. She is the daughter of Esther Bryant of Massillon, Ohio. Other local attorneys are Angela Walls Alexander, prosecutor; Sandra N. Boogaard, immigration law; Beverly Proctor-Donald, sole practitioner; Melissa N. Hawkins, bond attorney; Monique A. Hall, counsel for Nationwide Mutual Insurance Company; Meleah M. Kinlow, practicing attorney with Buckingham, Dooittle and Burroughs LLC; Michael Leftwich, attorney with the Timken Company; Jamila Mitchell, assistant prosecutor in the Juvenile Division of the Stark County Prosecutor's Office; Kyle Stone, managing attorney at KLS Law LLC; Marcus L. Wainwright, associate attorney with Wilkins, Griffiths & Dougherty Co., L.P.A.; and Gregory L. Williams, principal attorney in the law office of Gregory L. Williams and principal consultant of Equal Opportunity Consulting, LLC.

The first Canton-born African American woman to practice law in the city is Jeaneen J. (McIlwain) McDaniels, wife of Jeffery S. McDaniels and daughter of Albert H. and Nadine McIlwain-Massey. Other black women who have attained law degrees since 1984 include Kimberlé Crenshaw, granddaughter of Dr. Mantel B. Williams and daughter of Marian and Walter Crenshaw; Edwina Wilson Divins, daughter of Dr. William and Dr. Doris Wilson; Emanuella Harris Groves, sister of Olympic gold medalist Ronnie Harris; Agatha Martin Williams; Sylvia Strickland Ramos; Judith Barnes Lancaster; Corey Minor Smith; Angelene Bonner; Kim Smith; and others whose names we do not have. Those with law practices in the city are Minor Smith and Lancaster. Minor Smith is chief of legal services for the Stark Metropolitan Housing Authority and was recently elected to an at-large position on the Canton City Council.

CANTON TREASURES

Jeaneen McIlwain McDaniels

By Floyd R. McIlwain

"Mom's Precious Son." Don't mistake the title as a term of endearment, at least not yet. It's a Big Sister's way of calling her precocious, charming and cute little Brother a "Mamma's Boy." It has been the enduring descriptive phrase used by my sister, Jeaneen J. (McIlwain) McDaniels, countless times in describing me over the course of my life. When I was little I would have

Jeaneen J. (McIlwain) McDaniels and her brother Floyd (Randy) McIlwain attending the Hall of Fame Brunch, circa 1985.

preferred being physically attacked than seeing the look in her face as she called me "Mom's Precious Son." Heck I figured she was right, I was a soft little Mamma's Boy…a sister seven years your senior could certainly make you feel that way, and Jeaneen was no ordinary sister.

Every school I ever attended, every teacher I ever had spoke of Jeaneen's excellence!!! Her grades were the best. She was the most talented, a leader among her peers and the most popular boy in school would have walked through fire for her.

Jeaneen managed to graduate from High School (McKinley) in three years (my mom and dad sent both of us to Brazil our junior years as Rotary Exchange Students)! After spending a year abroad, she returned to McKinley High School and then on to Central State University. She finished her Bachelor's Degree in three years and graduated Summa Cum Laude. It was on to Akron University's School of Law. Three years straight and done, passed the Bar Exam on her first try and was prosecuting cases as an Assistant District Attorney in Stark County. Whew! See what I had to endure?

Now for those of you who don't have a Big Sister especially like Jeaneen, there is an unwritten rule to their torment, be it intentional or not of their Little Brothers. A BIG SISTER IS ENTITLED to tormenting her Little Brother, YOU ARE NOT!!!

I first learned this in at a grocery store. I needed adventure, and I found it in a slightly older and much larger boy. I agitated him to the point where he wanted to fight...problem was he was too slow to catch me, dashing through aisles I would easily avoid him for a good twenty minutes, running by and smacking him in the back of his head and taking off...fun, fun, fun, until I lost track of which aisle he was in and he caught me! Just as he was about to lower the boom, it was big sister to the rescue and the look on her face told him that if he so much as breathed on me he would get a butt kickin' "BIG SISTA STYLE."

Jeaneen would save my bacon many, many times but none more important than in 1987 when as a college student facing a criminal charge (it was bogus and racially motivated) but the penalty was potentially twenty years in prison!!! After telling my family what happened and that I didn't do it, I got the normal reassurances from my parents who told me not to worry—easy for them to say and exactly what a parent would say—but what Police and Prosecutors didn't know is that they had picked on the WRONG LITTLE BROTHER. She told me, "Don't worry Ran, you just concentrate on classes and keep playing ball, I'm not going to let anything happen to you."

Jeaneen put that brilliant mind I'd witnessed and heard about all those years into overdrive, finding my attorney, planning my defense and even testifying on my behalf. I remember it like yesterday how she told those jurors at my criminal trial that her Little Brother was no criminal and how as "an officer of the court" she knew the penalties for perjury and that she would neither lie or need to lie for her Little Brother, that I was simply not guilty.

I remember that look in her face on the witness stand staring down that prosecutor as he actually tried to challenge her saying as a blood relative she was biased...it was the same look she gave that boy in the grocery store. The

jury heard three days of testimony; it took them six minutes of deliberation to find me "NOT GUILTY."

I know my parents footed the bill for the attorney, I know I had absolute truth on my side but if I hadn't had Jeaneen's complete devotion and love I could have easily been another brother behind bars. I'm blessed to have her, Canton is blessed to have her...so if she still insists on calling me "Mom's Precious Son" I'll take it...I know I'm precious to her too!

Alan Page

Alan Cedric Page was born in and lived on Canton's southeast side. The family home was within walking distance to the Main Event, a nightclub on Cherry Avenue Southeast owned and operated by Alan's father. His mother's salary as a locker room attendant at Brookside Country Club provided Alan and his family with a standard of living that others in the heart of Canton's black community considered well-to-do. Alan attended Central Catholic, graduating in 1963.

The Honorable Alan Page.

Alan had the combination that most coaches dream about, size and quickness. Page was highly recruited by colleges and universities but chose Notre Dame, where he led the Notre Dame Fighting Irish to the 1966 national championship. He earned a bachelor of arts degree in political science from the University of Notre Dame in 1966.

Although he gained fame and fortune playing professional football, his real passion is for education, particularly the education of minority students. Page chose Willarene Beasley, principal of North Community High School in Minnesota, as his presenter when enshrined into the Pro Football Hall of Fame.

Elected in 1993, Page continues to serve as an associate justice of the Minnesota Supreme Court. He has also served as an assistant attorney general for the State of Minnesota and a special assistant attorney general (Employment Law Division) and other positions. Page has since retired. On November 16, 2018, Page was named one of seven Presidential Medal of Freedom recipients, the United States' top civilian honor.

Kimberlé Williams Crenshaw

Kimberlé Williams Crenshaw received her bachelor's from Cornell (1981), JD from Harvard (1984) and LLM from Wisconsin in 1985. Presently, Crenshaw serves as a professor of law at UCLA and Columbia and has published in the areas of civil rights, black feminist legal theory, race, racism and the law. Her work has appeared in the *Harvard Law Review*, the *National Black Law Journal*, the *Stanford Law Review* and the *Southern California Law Review*.

Kimberlé Crenshaw, law professor.

She specializes in teaching civil rights and other courses in critical race studies and constitutional law. Her primary scholarly interests center on race and the law, and she was a founder of and has been a leader in the intellectual movement called Critical Race Theory. Crenshaw also was a founding coordinator of the Critical Race Theory workshop and coeditor of *Critical Race Theory: Key Documents That Shaped the Movement*; she has lectured nationally and internationally on race matters, addressing audiences throughout Europe, Africa and South America. She has facilitated workshops for civil rights activists in Brazil and constitutional court judges in South Africa. Her work on race and gender was influential in the drafting of the equality clause in the South African Constitution. In 2001, she authored the background paper on race and gender discrimination for the United Nations World Conference on Racism and helped facilitate the inclusion of gender in the WCAR Conference Declaration. She was elected Professor of the Year by the 1991 and 1994 graduating classes.

In the domestic arena, she has served as a member of the National Science Foundation Committee to Research Violence Against Women and has assisted the legal team representing Anita Hill. In 1996, she co-founded the African American Policy Forum to highlight the centrality of gender in racial justice discourse. Professor Crenshaw is also a founding member of the Women's Media Initiative and was a regular commentator on NPR's *The Tavis Smiley Show*. She received the Lucy Terry Prince Unsung Heroine Award, presented by the Lawyers Committee on Civil Rights Under Law,

for her path-breaking work on black women and the law. At the University of Wisconsin Law School, where she received her LLM, Professor Crenshaw was a William H. Hastie Fellow. She clerked for Justice Shirley Abrahamson of the Wisconsin Supreme Court.

Emanuella Harris Groves

Groves is a 1975 graduate of McKinley High School and 1978 graduate of Kent State University. Groves serves as a municipal court judge for the city of Cleveland. She began her legal career in Cleveland as an assistant police prosecutor. In 1998, she and her husband, Greg, opened their own law firm. First elected to the bench in 2001, Groves also co-founded "Get on Track," an intensive supervision program that requires probationers to complete high school, secure employment and compete personal development training and community service.

CANTON TREASURES

The Honorable Jeffery Hopkins
A Tribute to Those Who Have Inspired Him

I owe all my success to the parents I had and the teachers and coaches and people of Canton who took some small interest in me as I was growing up. I can identify a few who had an influential impact upon me.

From my fourth/fifth grade teacher, Ms. Mendez, at J.J. Burns School, I learned to expect the best of myself and to work like heck to achieve it. I also learned valuable lessons in ethics and integrity. Ms. Mendez had a military background, and she was quick to remind her students. Discipline and regimen were her trademarks.

Coach Bruce Carter was another important person in my early life. We were the undefeated, un-scored-upon Canton Midget Football champs—the Rams. Coach Carter would always give a short prayer before every game, which I still respect him for today. He also taught us the beauty of teamwork and unselfish play and to give everything we had toward the common victory. At my cousin's retirement party in Columbus several years ago, I had a special chance to tell Coach Carter how important his efforts had been to

me. One practice that I adopted from Mr. Carter's influence is to say a short prayer to do justice before assuming the bench in my work today.

Mrs. Wilbanks at Crenshaw Junior High School, my history teacher, had our class memorize the Declaration of Independence. As a lawyer and judge, I am forever grateful for that lesson. The beautiful words of that historic document, which I still remember, serve as a constant reminder for me of the importance of the role of law and the promise of freedom, justice and equality that America holds for all her citizens.

I am blessed with having had wonderful parents who valued education and insisted that we work hard to achieve it. If I had one wish to give to the world, it would be that every child had a mother like Minnie L. Hopkins and father like Eddie P. Hopkins Jr. They were strict disciplinarians, but they let us experiment just enough to learn for ourselves. My aunt Lula Mae Harris Kite and her husband, Ernest, were also influential and helpful, providing words of encouragement and advice on life's endless challenges.

Thank You, Grandmother

By Corey Minor Smith

At one point in my life, I considered myself an orphan. My mother was ill, and my father distanced himself from me by not calling, writing or sending cards. Children's Services became involved, and foster care was an immediate suggestion. However, my paternal grandmother signed for custody. I was grateful and so was my dad, who flew in from California for the court hearing.

After moving in with my grandmother, I attended Timken Senior High and was able to participate in every extracurricular activity that I always wanted. I was finally enrolled and stayed at one school until the grade levels were complete. I graduated at the top of the class after maintaining a 4.2 my entire senior year. There are so many people to whom I attribute my achievements. However, the one that will always be at the top of the list is my grandmother Bluchelle Scott McDonald, who took care of five other children in addition to her own five children.

I feel if it wasn't for her devotion, dedication and guidance as a grandmother, I would not be standing here today with a law degree known as Corey Minor Smith, Attorney-At-Law. She became my guardian when others were not able. After I lived in seven other households, three states and

attending fourteen schools, my grandmother provided the stability that I always wanted and needed. It is difficult to formulate words that describe the joy I feel for her being there for me. I thank her soooo much.

On September 11, 2001, what was just a thought appeared to become a reality. All the news stations covered the reports of the Twin Towers being destroyed. At the time, no one knew exactly what happened and what was going on. All I wanted to do was get my son from school and get to the hospital to be with my grandmother. We continued to watch the news from my grandmother's bedside. I thought to myself: "I guess what I always thought is about to happen…my grandmother

Corey Minor Smith.

would not die before me…we are all going to die." Terrorist attacks were confirmed, and six days later, my grandmother silently passed away. I never really expressed the sadness that my heart felt from her death, but as I write, the tears are steaming down my face. Corey's life story is revealed in her autobiography, *#Driven*, which was released in 2019.

These Canton treasures are inspirations for those who have humble beginnings but high aspirations.

POLICE AND SAFETY OFFICERS

W.R. Smallwood was the first black deputy sheriff. When he died, his son Lewis Smallwood was named in his place and served for over sixteen years. James Calhoun was the first African American appointed to the Canton police force. Calhoun was born in Montgomery, Alabama, on June 29, 1899. Civil Service records indicate May 31, 1929, as his appointment date. His actual application is dated July 30, 1927, according to the minutes of the Civil Service Commission in which James Calhoun and another man, Charles Frazier, who lived at 1404 Fourth Street Southeast, also believed to be African American, received their commissions. Further evidence is provided by Kathleen Borboza, who was born in 1919 and lived on the 900 block of Carnahan Avenue Northeast since she was ten years

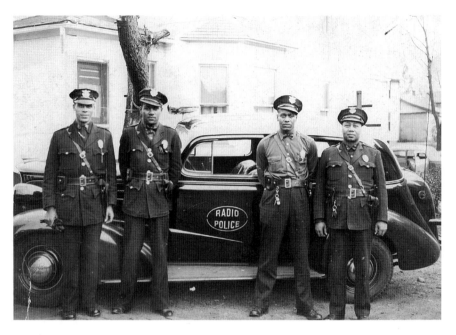

Early African American police officers (*left to right*) Louis Early, Theodore Lancaster, Guy Mack and James Calhoun. *Courtesy of the Brenda Lancaster Baylor Collection.*

old. Borboza was part of the Oral History Project of the Stark County District Library. In her transcript, Borboza stated that "the first one of the policemen was Frazer [*sic*]."

Another early police officer in Canton was Louis F. Early, appointed on September 8, 1937. Others were Theodore Lancaster, appointed in 1937; Guy Mack, appointed on November 18, 1949; Walter L. Cherry, appointed on February 1, 1956; Mark M. Smith, appointed on August 1, 1957; Guy Bomar Jr., May 11, 1959; and Ronald L. Inman, appointed on October 26, 1960. Today, the force has several black male and female police officers.

The first African American police woman and one of the first two women ever appointed to the city's safety force was Eldoris Bonner, who was appointed on April 27, 1959. The first modern-day African American woman officer is Lora J. Biggums, appointed on May 5, 1984. Jacqueline Holmes was appointed and is still serving as an officer today.

The police department was not always viewed favorably by blacks living in Canton. In a letter to the editor published in the *Canton Repository* on May 2, 1956, the writer, Hubert D. Bradley of 1245 Housel Avenues Southeast, complains about his son's mistreatment: "In Canton, old Jim

Crow is alive and strong." The editor's note attached at the end of the letter noted that Canton's safety director, Stanley A. Cmich, was conducting a full investigation.

One of the most renowned African Americans serving in the Canton Police Department was Officer Guy Mack, whose murder attracted national attention. Having served over thirty years, Officer Mack was killed while shopping with his wife in a local grocery store, now the home of the St. Paul AME Church. Off-duty at the time, Officer Mack attempted to stop an armed robbery.

A recap of Mack's life story was printed in the Sunday, March 3, 2013 edition of the *Repository*. Mack was a much-loved and respected police officer and member of the community. His funeral, according to the story, was "one of the largest and saddest in the city's history," as evidenced by calling hours, which lasted from 6:00 p.m. to around 11:00 p.m.

Bruce Edward Allison holds the distinction of serving as the first African American lieutenant, appointed on May 20, 2002, and the first captain in the Canton Police Department, appointed on November 19, 2004. Allison was appointed to the police force on September 1979 as a patrolman.

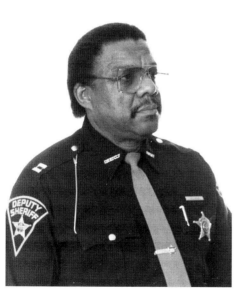

Sargeant George Hogan. Major Jack Calhoun.

Patrolman Allison was responsible for leading a model community policing effort in the Highland Park/Skyline Terrace community that helped enhance relationships with citizens and police department.

We cannot chronicle all the stories of African American police officers who have served and protected the citizens of Canton, but this section would not be complete without the men and women who served as deputy sheriffs for the Stark County Sheriff Department. Sergeant George Hogan and Major Jack Calhoun rose to prominence within the department. Calhoun served the department for thirty-five years and rose to be a major and the head of the sheriff's civil division, overseeing court security and conducting foreclosure auctions for about a decade before his retirement around 2006. His daughter, Rayetta J. Calhoun-Kanters, is an investigator for the Ohio State Highway Patrol.

Hogan worked for the sheriff for twenty-eight years and was the first black deputy assigned to Jackson Township. After his retirement, he spent another twenty years working in the security department for Stark State College. This section is not complete without including Beulah Wesley, who was recently recognized for her thirty years working as a bailiff for the Canton Municipal Court.

THE FIREFIGHTERS

The Canton City Fire Department hired its first and second black firefighters in 1976. In 2008, there were twenty-one black firefighters. As of this writing, Pete Goshay attained the highest rank of any African American serving in the fire department. Cynthia Norris was the first black woman to serve in the fire department. Carl Jordan was the first black union president, and Harry Cavitt was the first black to retire with a service pension.

There was another black in the department who served for a short period; he is not identified, but we did find records for Ronnie Martin (Abdul Ali), who left to pursue another career for a short period and then came back to the department. Ali probably was a member of the fire department longer than any other black.

THE SOCIAL WORKERS

Norma Marcere was employed at the Stark County Tuberculosis and Health Association. She was a past president of the Community Service Institute. Pearl Williams worked for Family Services as a receptionist and clerical assistant, and Warren Kelly was also employed there. John W. Crawford, born in Texas, came to Canton and served as executive secretary of the Canton Urban League for twenty-two years. He was succeeded by Sterling Tucker, who came from Akron to lead the league. Working with Tucker were Clarence A. Thomas, youth director, and Elizabeth Evans, health and welfare secretary.

Thomas West. *Courtesy of Mark Bigsbee.*

Many know Thomas E. West as the Canton city councilmember representing the second ward or as the first African American from Stark County elected to serve in the state legislature. Before becoming an elected official, he was and still is an innovative social worker. Among his accomplishments is the creation of a certified Christian Childcare Center, Aphesis Childcare Development Center, as a part of the ministry of Deliverance Christian Church. Employed with the Child and Adolescent Service Center as transitional services coordinator, West developed and implemented an innovative transitional program for young people ages sixteen to twenty-two. While serving as a member of the Canton City Council, West spearheaded the revival of Nimisilla Park. Along with Curtis "Cap III" Perry, he sponsored the first and subsequent JoyFests, which brought hundreds to the northeast park for fun, food and entertainment. In part, JoyFest was a response to the relocation of the Hall of Fame Ribs Burnoff from downtown Canton to the Stark County Fairgrounds. To demonstrate his concern for and belief in the northeast part of Canton, West joined with others to name a portion of Mahoning Road after the Canton singing group the O'Jays. West also purchased a former restaurant and renamed it the Cantonian. The restaurant operated for approximately two years before closing.

Probably one of the first social workers in the city was Theresa Etna N. Walker, wife of Dr. J.B. Walker. Although trained as a schoolteacher in Washington, D.C., after coming to Canton, she worked in the Urban

League and the Women's Republican Club. Whether Mrs. Walker applied for a position with the Canton City Schools or any school district in Stark County is not known. However, there were no African American teachers in the public schools at that time. In 1934, she organized the Phillis Wheatley Association. The Walkers had two children, John Jr. and Theresa.

Another committed social worker is Beverly Jordan, retired founder of Stark Social Workers Network (SSWN), a community-based organization comprising several major service deliveries: respite care for foster parents, after school tutoring and enrichment programs and women and family community outreach.

The agency started in 1994 after Beverly Jordan completed seven years investigating child abuse and neglect with the Department of Job and Family Services. SSWN has addressed needs that are evident with underserved populations and continues to strengthen programs that have a twenty-year history with the agency and to build new programming to address the needs of current populations. Prior to her retirement, Jordan received the Community Salute Award from the Greater Canton Chamber of Commerce.

Canton is forever grateful for Betty Mack Smith, an outstanding social worker. Smith was born and lived in Logansport, Indiana, for eighteen years. After living in Chicago for forty years, working in social services for thirty-one years, she took an early retirement and moved to Canton in 1998 as a result of her marriage to Reverend Mark Smith, a former Canton police officer. In March 1999, Smith opened the Minority Development Services of Stark County, later called Multi-Development Services of Stark County (MDS-SC). Smith also has a weekly cable television show called *On Track with Betty Mack*. Smith is the founder of En-Rich-Ment, an organization promoting music education for children.

In an article written by Ed Balient and published in the Sunday, January 7, 2001 edition of the *Repository*, Terrell Clifford is acknowledged as a nominee to receive the Golden Dove Award from Minority Development Services of Stark County. As an employee of the Stark County Department of Jobs and Family Services, Clifford was promoted from social worker to supervisor. A graduate and former member of the Edinboro University football team, Clifford coaches midget football and referees basketball games.

Social workers could not do their jobs without the help of community members willing to assist when family problems become overwhelming for adults and unsatisfactory for children. The heroes are the foster parents who step in and provide a safe home for the children. Dorothy Wells is one

such individual. At sixty years old, Wells decided to become a foster parent. Children need love according to Wells, and that is why this mother of eight, grandmother of twenty-five and great-grandmother of five extended her love to her "other" children.

Canton Treasures

Theresa Etna Nutt Walker

By Marilyn Thomas Jones

When I was a little girl, my mother, Alice Elizabeth Hayes Thomas, and I used to visit downtown Canton for many reasons—it was the place to be, full of activity. I remember my mother introducing me to an elegant lady, Mrs. Walker, whose husband was a doctor, on one of our trips. My mother told me about the wonderful things Mrs. Walker had done for colored girls and women in Canton. As I was growing up, I always remembered meeting the elegant lady who was dressed beautifully and carried herself with dignity and grace.

My mother told me that Dr. Walker had come to Canton from Virginia in 1920 with Theresa Etna Nutt Walker as his bride. J.B. Walker, the first colored physician in Canton, was born in Avalon, Virginia. He received his MD degree from Howard University in Washington, D.C., in 1919. His ancestors won their freedom at the time of the American Revolution while participating with thirty thousand Negroes in the fight for independence for this country. Dr. and Mrs. Walker had two children, Theresa and John B. Walker Jr.

Theresa Etna Nutt Walker's life and accomplishments serve as an inspiration to me and lead me to share this story about a few of her outstanding accomplishments. She was a graduate of Howard University in Washington, D.C. She was involved in the Canton Women's Republican Club and was the founder of the Canton Chapter of the Phillis Wheatley Association, which included a character-building program for young African American boys and girls. She founded the association in 1933 and from 1934 to 1954 served as the executive director of the organization without monetary compensation. The Phillis Wheatley association was originally located at 236 Fifth Street Southeast and eventually moved to 612 Market

Avenue South. There were Phillis Wheatley Associations throughout the South but none in this area. Many colored women were coming to Canton in the 1930s and '40s to work as domestics, maids, cooks, nannies, laundresses and other menial jobs. Many stayed with relatives when there was room—but the colored housing situation was not good, and most dwellings were overcrowded. These women paid to stay at the Phillis Wheatley Association. They got a room and a meal and they were well chaperoned. They stayed until they "got on their feet."

Mrs. Walker enjoyed her time working with the Amerman workshop for the blind, which was housed in the carriage house behind the Phillis Wheatley building. The workshop was for the colored blind. Mrs. Walker was the Junior League of Canton Ohio Inc. Woman of the Year on May 19, 1954, the first colored woman to be so honored. She received an orchid and a silver bowl presented to her by Mrs. Robert E. Schreiber, Junior League of Canton president, at the annual luncheon held at the Onesto hotel. Mrs. Ivy Baker Priest, treasurer of the United States of America, was the keynote speaker. My mother is my hero because she raised me by being an example and made sure I was introduced to as many quality things in life as she possibly could, and that included an elegant lady who dressed beautifully, carried herself with dignity and grace, was well educated, a change agent, an outstanding citizen, a woman of vision, Theresa Etna Nutt Walker.

Gwendolyn Singleterry: Her Story

By Twila Page

Gwendolyn Louise Umbles Singleterry was born on March 1, 1933, the daughter of the late Floyd J. Umbles Jr. and the late Edna Lee Edwards Umbles. Being the only daughter, Gwen was much loved and spoiled by her three brothers, the late Floyd Jr., the late Clayton E. and John Michael Umbles of Toledo, Ohio.

Growing up on Housel Avenue Southeast, she attended South Market Grade School and is a graduate of Canton McKinley, class of 1950. Education was an integral part of her family, and she attended The Ohio State University and Kent State University, majoring in education. She met her husband, Leroy Singleterry, at South Market when they were in the sixth grade and later married him, producing four children, Karen, Cathy, Lisa and Kenny.

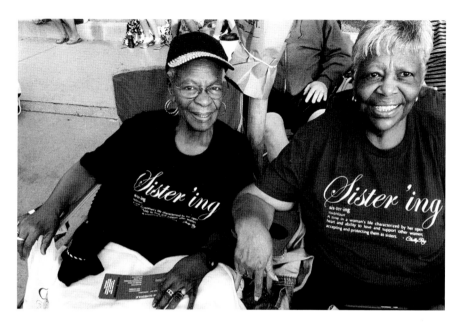

Rita Barrett (*left*) and Gwen Singleterry.

She began her life's work as a public servant working as a playground supervisor at Jackson Park along with her good friend and lifelong buddy Willie Paul Milan. She was employed by the Stark County Welfare Department, where she worked for thirty years. Being a supervisor of her department, she was hired as one of the first black women to hold this position in Stark County.

She has always been community driven and a community servant. Holding memberships in the Urban League and the Mary Terrell Federated Club, she has served on the board of A.B.C.D. and is a founding member, along with her good friend Queen Rita Barrett, of the South West Association of Neighbors (SWAN). Growing up as a Canton McKinley Bulldog, having a brother, Clayton, being a star football player at the University of Toledo and two cousins, Howard and Alan, starring at Canton Central Catholic, Gwen became an avid sports fan, an aficionado of football and basketball at both the college and professional levels. Following her cousin the Honorable Justice Alan Page's career, she has attended three Super Bowls and his swearing-in ceremony when he became the Supreme Court justice for the state of Minnesota. Throughout her life she has been a dutiful daughter, a loving wife, a nurturing mother and a steadfast and unwavering friend.

6

BRICK CITY
AND CHERRY STREET

The federal housing known as the Sherrick Court–Jackson Park housing project, Brick City or simply the Projects was opened basically for the African Americans returning from the war and/ or migrating from the South. Jackson Sherrick, as the homes were officially named, was divided into two constructions. The Don Mellett Housing project in the southwest was restricted to whites only; all of Sherrick Court's 100 units were entirely for blacks. Of the 220 units of Jackson Park, only 20 were for blacks. Heald noted that rents, including heating and cooking facilities, ranged from $34.75 for one-bedroom units to $42 for three-bedroom units. A home-buying program in Canton in the 1940s increased the proportion of blacks who owned homes from 10 percent to between 30 and 40 percent of the total black population.[18]

Mirroring the story of many African Americans who came north in search of better lives, the McIlwains joined what later was called the "Great Migration." Edna Gamble McIlwain was born the youngest of nine children on February 28, 1912, in Waxhaw, North Carolina. She married Bubber Lee McIlwain in 1932, and in 1943, the couple moved to Canton with their three sons, Edward, Albert and Floyd. A daughter, Norma, was born in Canton. Bubber, known as Lee, worked for the Timken Roller Bearing Company for over forty years. Hard work and prudent living allowed the family to be one of the first to move "out of the projects." They purchased a house at 1018 Rowland Avenue Northeast. Both lived long enough to enjoy their retirement and to see not only their children but also their grandchildren

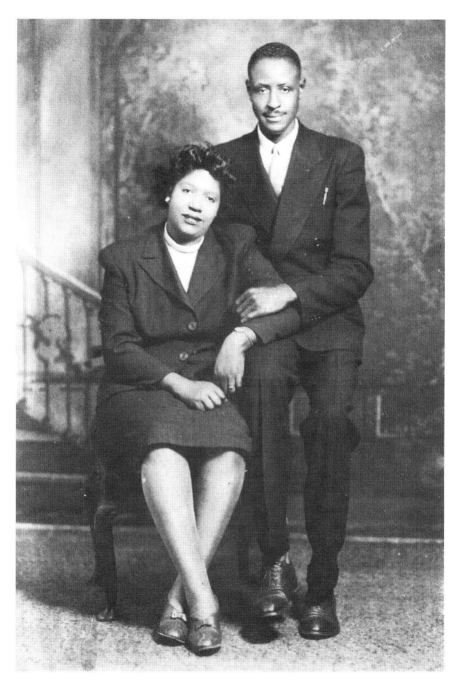

Mr. and Mrs. Bubber Lee McIlwain, circa 1940, one of the first families to migrate from North Carolina and move into "Brick City." Their address for many years would be 1104 Moline Place Southeast Canton, 7, Ohio. *Courtesy of the late Edna McIlwain.*

grow into productive citizens. Lee and Edna McIlwain were known for their Christian faith. Edna received numerous recognitions for her giving nature, cooking skills and "bring down the church" singing. She lived to be ninety-nine years old, passing on June 18, 2010, the twenty-first anniversary of her son Albert's death. The couple was married for over sixty years.

Besides the McIlwains, others families in this area were the Fishers and the Martins. Southeast Canton was the destination for many southern African Americans who migrated north. Several families breathed life into the Southeast, home to many ethnic groups. African Americans lived in neighborhoods with Italian, Spanish and Greek Americans, sharing stores, schools and recreation areas separate and unequal.

One of the families that added value to the area was headed by Norman Austin. Staff Sergeant Austin served in World War II and returned to Canton when the war ended. Austin became a member of St. Paul African Methodist Episcopal Church in 1946. He taught Sunday school, served on the Literary Forum and brought in speakers such as Walter White, executive director of the NAACP; Alderman Perry of Chicago; and Harrison Dillard, a gold medal winner in the 1948 Olympic games. Austin was instrumental in getting Dorothy White, the first black schoolteacher, hired. He was on the boards of the NAACP and Urban League and worked with Sterling Tucker and Clarence Thomas. Austin was president of the Penguin Club when it started hosting formal dances, gave scholarships and participated in other various community activities. Norman retired in 1985 from the Canton City School System after twenty-eight years of service. He celebrated his ninetieth birthday in 2007.

On January 19, 1948, Norman married Betty Jane Daniels, daughter of the late Mr. and Mrs. James R. Daniels, charter members of St. Paul AME Church. Born on April 23, 1921, in Canton, Betty graduated from Central State College. She retired from the Ohio State Employment Service as a labor market analyst in 1986, after forty-four years. Betty was the first black labor market analyst in Ohio. Betty Jane (Daniels) Austin passed away on April 7, 2007, at eighty-five years old.

Talk to any black person who lived in Canton between 1940 and the late 1960s, and they will vividly recall Cherry Street as the hub of Canton's black community. Charita Goshay's description of life on Cherry Street is so visibly informative; we have included portions of it here.

CHERRY AVENUE SOUTHEAST:
GOLDEN AGE OF BLACK BUSINESS IN CANTON

By Charita Goshay

For decades, the 13 blocks that comprised Cherry Avenue SE were the hub of the city's black-owned businesses. Today, virtually nothing remains of the neighborhood, which was demolished to make way for an overpass in the 1970s. Just hearing the phrase "Cherry Street" can put a smile on the faces of the people in whose memories its Golden Age still lives.

Cherry, say those who remember it, had everything. You could get your hair pressed, your clothes cleaned and your soul saved. In the days before integration, Cherry was an oasis. Blacks could hail a cab, have lunch at the Tennessee or rent a room at the Hotel Milner with no hassle. Anyone could get groceries on a tab, find the latest hits at the Record Rack and enjoy a milkshake at Cosey Drugs. You could lay a bet at Beanie's or order a "pony" (pint) of beer from one of the clubs. You could grab a soda at Cox's Corner and head out to the baseball game at Jackson Park.

You could practically live out your whole life without leaving the neighborhood. It was Canton's unofficial-but-understood discrimination practices that precipitated a flourish of black-owned businesses on Cherry. Cherry was a neighborhood in which rogues and role models co-existed. Some establishments were mere fronts for such illegalities as the numbers racket, poker and after-hours liquor, said Jasper Harris, whose parents, Odie and Lillian, opened an ice cream shop at 504 Cherry Ave. SE in 1938.

Cherry Street was to the African American business community what Jackson Park was to the African American recreational community. During the week, children could be found playing on swings, going to Jackson Park pool or just hanging out in the park. Come Sunday afternoon, as many as five hundred people would come together to watch the men or women ball teams or view the Elks parade. Women who played softball for the NAACP brought crowds of fans to the Jackson Park Fields. Not to be outdone by the women, several outstanding male teams, including the Victory Club–sponsored team, vied to win the eight-team league city championship.

What happened to the community is described through many eyes, and viewpoints do differ. Many point to the construction of Route 30 through the heart of the community. Others blame urban renewal for

destroying the cohesiveness of the neighborhood. Elder Gilbert Carter, long a force and voice for black empowerment, records his interpretation of the events leading to the eradication of the Southeast community in his book, *Cast Down Your Bucket Where You Are: My Midia Experience in Stark County*. We have reprinted excerpts from Section 3, "Legacy," with permission from Elder Carter:

According to Carter,

> *The combination of a high-density concentration of poverty residents and aged and deteriorated housing led to deplorable slum conditions....Lathrop-Madison Urban Renewal acquired and demolished all property from Twelfth St. SE to Fourth St. SE and from Madison Court to Cherry Ave. Loss of the business community of approximately 112 Black-owned businesses on both sides of Cherry Ave. According to Fourth Ward Councilman Charles Ede, the 1964 Lathrop-Madison Urban Renewal Report stated, "There were at least 68 property owners in this neighborhood. When*

> *relocated, only 43 were able to repurchase homes. Thus, there was a 25% loss in equity base." A significant portion of these homes were older homes. However, at least two-thirds were not. When these people relocated many received inadequate funds to purchase a new home. Due to the lack of affordable housing for Blacks, some had to move into subsided rental properties. Five suburban allotments were formed. The James Brown allotment was created in East Canton, Perry Heights located in Massillon Ohio; Dueber Extension, Cedar Garden Allotment and Orchard View Dr. in Canton Township.*

Charles Ede.

Due to normal social mobility, middle-class black people began to migrate out of the Southeast quadrant. Businesses closed, and even the black churches, the spiritual force that propelled black Canton, had to seek new homes. Despite the effects of "urban renewal," many Southeast residents remained in the area and sought to maintain lovely, safe neighborhoods. Members of the Southeast Community Organization were examples of such homeowners.

CANTON TREASURES

Albert H. McIlwain

Albert H. McIlwain was born on April 25, 1936, in Lancaster County, South Carolina. He lived in the Canton community for over forty-five years, attending Allen and Worley Elementary Schools, graduating from McKinley High and serving for many years as a member of the 1955 McKinley Class Reunion Committee.

McIlwain attended Kent State University and received a degree from Malone College. Teaching young people was truly his calling, and for six years following his graduation, he taught and coached basketball at Youtz and Mason Elementary Schools. When called to serve as deputy director of the Stark Metropolitan Housing Authority, Al, an exemplary educator, was honored by his students in a tearful, emotional "Goodbye, Mr. Chips" program, as reported in the *Canton Repository*.

McIlwain family (*left to right*) Randy, Al, Nadine, Jeaneen, Mabel Williams, Edna and Lee McIlwain.

Al served on the board of the Stark Metropolitan Housing Authority from 1969 to 1970. In 1982, he was named executive director and served in that position until his death. His legacy to the residents of SMHA is memorialized in the annual Albert H. McIlwain Scholarship given to deserving residents of Stark Metropolitan Housing Authority.

In March 1989, the governor asked him to serve as a member of a special housing commission to study housing in Ohio. Al enjoyed serving God through fellowship with members of the Mt. Olive Baptist Church, where he maintained an active membership and served as a member of the board of trustees.

He loved the Omega Psi Phi fraternity and considered members of Kappa Tau true brothers. Through the efforts of his Omega brothers, the SMHA administration building in downtown Canton bears his name, the Albert H. McIlwain Administration Building.

Cherrie Turner
Former Director, Stark Metropolitan Housing Authority

My husband and I moved to Canton, Ohio, in 1959 from a little town called Fayetteville, West Virginia. We were fortunate to have my husband's sister, Susie Jordan, to live with until my husband, George Turner, was able to find employment.

Once all of my children had started school, I began to look for employment. It was Joe Smith, then the executive director of the Canton Urban League, who encouraged me to attend college, and he was instrumental in finding me a job while going to school. My first job was with Freedman Window Cleaning Company as an accounts receivable clerk, a job that was supposed to be part-time. It became full-time, and I worked there for five years. During that time, we lived in Stark Metropolitan Housing Authority as tenants. We have, in fact, been able to live the American Dream....That at a time when my family and I needed help, public housing was there for us. I accepted that help, but then I was able to assist and support others. I eventually became the executive director of that same organization. You develop a different perspective when you are both the recipient and the giver...and that opportunity has enriched my life significantly.

I owe a great deal to the late Walter Crenshaw, who was the executive director of SMHA. He hired me to work at the Jackson-Sherrick Rent

Office. He passed away the day before I was to begin work. During my tenure at SMHA, I held several positions. I retired in 2001 after serving as the executive director. I am grateful for the chance to leave a "footprint" on Stark County and Stark Metropolitan Housing Authority, both of which gave me the opportunity to "give back."

I owe so much to those people who were there for me during my thirty-two years at SMHA. My friends Allie Harpster, Joe Smith, Walter Crenshaw, John Wirtz, Robert Fisher and Harrison Joseph, to name a few. I would be remiss if I did not mention Lillian Beane, who was the backbone of the housing authority in the early years, and Albert H. McIlwain, my prior director, who was always there for his employees.

I am especially grateful and appreciative to my wonderful family: George, Tina, Marilyn, Carolyn, George Jr. and my loving brother Charles. Cherrie Turner is now deceased. Turner was born in New York City. In 1989, she became the first woman to oversee the county public housing agency. Yetta Cherrie Turner served over a decade as executive director of the Stark Metropolitan Housing Authority. After leaving the post as executive director in 2001, Turner, seventy, was appointed to the housing authority board, on which she served until 2010. Turner died on March 26, 2011.

Brick City

By Patricia A. Kennard

My earliest recollection of life in Canton was about age three. I recall crying because my big sister, Carolyn, four years my senior, left me to attend Allen Elementary School. What my mother and I did during the day is foggy, but when my sister came home, she and I would listen to the "Story Lady" on the radio and we would go outside to just play. I still love to be out of doors today.

We lived in the old "brick city" public housing units on Parson Court Southeast. The term "black community" had not evolved, but truly that was what it was back then. People of color lived, worked, worshipped and played literally "across the tracks." You could find schools, churches, auto mechanic shops, funeral homes, doctors' offices, pharmacies, bars, the skating rink, the chicken house and other places that provided some employment for those in the southeast quadrant.

Coxes' Corner was a landmark and an ice cream haven. My father knew the Coxes personally, and often we were treated to ice cream because

Mrs. Cox was a warm and affectionate woman. My grandparents lived in the rear of Wilbert Page's Confectionary on Cherry Avenue Southeast, and we had ready access to more ice cream, fulfilling a child's dream. Trips to Dugan's Grocery Store on Sherrick Road were treasured visits to buy lots of two for a penny candies. Many of the families I can recall still reside in Canton. I will never forget Jipp, a German shepherd that was the terror of the neighborhood when he was loose, and that seemed to be often.

I learned a great deal listening to my sister's and adult conversations. My mother worked nights at Dueble's Jewelry Store downtown. Sometimes she would take my sister and me with her. I had a vivid imagination, and we engaged in make-believe pretending to be rich.

Our family attended Shiloh Baptist Church on Nimisilla Avenue. That was long before padded church pews. But church was the pillar of black life and also was a social outlet. Another social outlet was the drive-in movie theaters. I remember many family outings to the East 30 Drive-in Movie Theatre. What a joy the popcorn and the massiveness of the place were to my tiny eyes.

I want to emphasize, while life could be hard, there was a social consciousness among the people living in Brick City. We were our brother's keeper, and acts of kindness ran rampant in the neighborhood. Anyone who is anyone in Canton, or even those who have moved away or came through the Southeast end and "brick city" back in the day, is richer for the wealth of experience and life that they experienced.

Unlike today, where generations of families fail to move on or become trapped in public housing, back then families did not remain in the "projects." We were passing through, reaching and expecting a better life for our families and ourselves.

Taylor Matthews

Taylor Matthews was born on February 24, 1905, in Wedowee, Alabama. He came to Canton when he was fifteen years old. After graduating from McKinley High in 1928, Matthews became interested in photography. He and his camera were inseparable. Matthews received an early discharge from the army due to a heart problem. Upon returning home, he was employed by the U.S. Post Office as a special delivery carrier. The brother of Esther Archer, Matthews had his first studio in the family home at 603

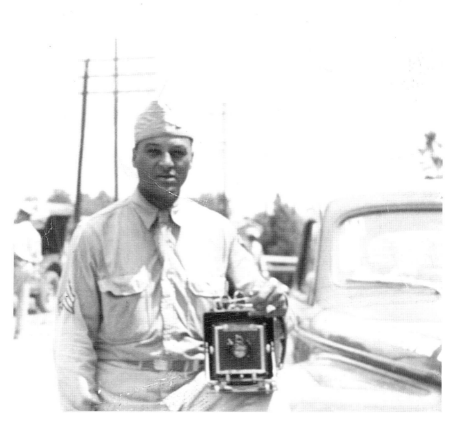

Taylor Matthews, fifty years of photographing the Stark County African American community.

Ninth Street Southeast. He later moved to 333 Hammerly Street Southeast, where his family still lives.

Taylor Matthews died on January 7, 1974. He left behind a legacy of memories and pictorial histories of black life in Stark County. A $10,000 grant was obtained from the Ohio Historical Society to honor Matthews's work. Exhibits of his photographs were displayed at the McKinley Presidential Library & Museum from February through June 2001. The exhibit was hosted and co-organized by Geraldine Radcliffe.

"The Place to Be Was down on Cherry Street!"

By Mabel C. Jones

The Black Community had its own street
Groovin' and movin' to their own beat
Down on Cherry Street (circa 1930's–1960's)
We had our own…
Beauty Shops, Barber Shops,
Bars, Restaurants, and Night Clubs, too
And one-of-a-kind—
A pharmacy, a funeral home,
And, an ice cream/confection stand
We were just being the best we could be—
A whole, unified, cohesive community

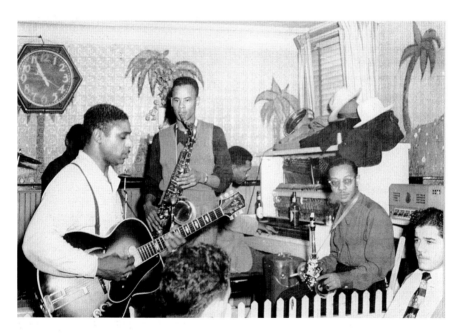

Count Head Band (*left to right*) Buggy Mitchell, Milford Archer, Count Head and Mr. Butler.

7

THE CHURCHES

*I*n Canton's early years, there were thirteen principal African American churches. The oldest and largest was the African Methodist Church, founded by Reverend A.W. Hackley in 1883 in the home of Martha Corneal on Second Street Southwest. The church occupied several sites before purchasing the former United Brethren Church at 314 Thirteenth Street Southeast in 1897. The name was changed to St. Paul African Methodist Episcopal. Under the leadership of Reverend A.E. Allen, a new brick building was constructed on the Thirteenth Street site between 1926 and 1930. Construction costs excluding furnishings were $30,000.

At that time, St. Paul was Canton's first modern church for African Americans and had a membership of 440 persons. The church remained at the Thirteenth Street address until urban renewal forced a move to its present location at 1800 East Tuscarawas Street.

Fortunately, St. Paul African Methodist Episcopal Church has compiled its history in a pamphlet: *Historical Review of St. Paul's Organization and Development*. We have used information from that source to report the church history.

In 1816, with fifteen ministers and laymen, Richard Allen organized the national African Methodist Episcopal Church as a protest against segregation. It is somewhat ironic that there was no relationship between Richard Allen and the pastor of Canton's St. Paul A.M.E. Church at the time of the church's dedication service in 1930, Reverend A.E. Allen.

In 1883, just twenty-nine years after Canton became a chartered city, Martha Corneal joined with other charter members David Hall, T.H. Grimes, John Henson, Isaac Noville, Ella Games and Jennis M. Grimes to establish St. Paul African Methodist Episcopal Church. The national A.M.E. Church was not quite one hundred years old and was still experiencing growing pains. Canton's A.M.E. experienced similar pains as members sought to secure a permanent place of worship. The group moved into the basement of the historic Saxton Block and shortly thereafter moved to Temperance Hall on the corner of Fifth and Court Streets Southwest. A fruitless attempt was made to purchase this property; the financial obligation was more than the newly formed congregation could bear.

The annals of St. Paul contain the following humorous account of the incident: "One day, some of the members going down to the Church found the Church going up Cleveland Avenue on wheels. So we had to go back into a private home again."

The next place secured for services was on Sixth Street Southwest and here again we see a bit of humor in the records: "This building had a nice large sign over the door; 'Smoked Ham, Sausage and Bacon,' and only by the organ pealing forth the strains of 'Blest Be the Tie That Binds' or 'Praise God from Whom All Blessings Flow,' would anyone know that church services were being conducted there." In 1897, early members were able to secure a permanent home at the corner of Charles Street (now Thirteenth Street) and Willet Avenue Southeast. This building, which had been occupied by the congregation of the First Evangelical United Brethren Church, became the home for St. Paul's congregation for thirty-three years. In 1920, the need for a new church was realized, and the members of St. Paul chose the site on which they were located for the new building.

On Sunday, May 2, 1926, the last services were held in the old church. At 3:00 p.m. groundbreaking ceremonies were held with Brother David Hall, one of the three surviving original members, turning the first spade of earth. On Monday morning, the razing of the old church began.

With financial assistance from W.H. Hoover and H.W. Hoover of North Canton and the George D. Harter Bank through the intervention of Will R. Myers, progress was eventually made. Assistance of another type was received from Warren Hoffman, one of the city's leading general contractors, who offered his services for free. Reverend Archie E. Allen was the energetic and sacrificing pastor who led the congregation into the new church building in November 1930.

In a routine visit in July 1979, church member Odes Kyle coincidentally met fellow church member Charles Mack at the home of Cuff Brogdon. Brogdon made a startling revelation. Unbeknownst to St. Paul A.M.E. Church, a final detailed 1975 report by the State of Ohio Highway Department was brought to the attention of the trustees. This report stated that St. Paul A.M.E. Church had been contacted and that their minister and boards had been told to move ahead with their relocation plans. In essence, the church was told that the building was being taken because of the relocation of U.S. Route 30. The truth was, *the Church had not been informed*. In fact, the question still remains unanswered as to why the church was not relocated in 1975 when four other area churches were moved.

In September 1979, Mayor Stanley Cmich was summoned to a meeting in the basement of St. Paul. There he announced to over two hundred people that 1) St. Paul would be relocated and that by March 1980, the final and official letter to purchase would be in the hands of the trustees; 2) that money was now available to the City of Canton for action; and 3) that the project would get underway immediately.

After meetings, accusations, playing politics and discussion, plans were finally made to purchase the "old" A&P store building at 1800 East Tuscarawas Street. The building at Thirteenth Street and Willet was sold to the city, and the deal was closed in August 1980. The donation of $10,000 by the United National Bank & Trust Company in memory of slain employee and St. Paul member Leona Edwards assisted the move. A wing of the new church building on East Tuscarawas Street is named in honor of Edwards. Charles Mack and Juanita Mack donated their old family home to the church in honor of slain Canton detective and St. Paul member Guy A. Mack. A wing of the new St. Paul is named in his honor.

Urban renewal (or black removal as it is sometimes called) wreaked havoc on the black-owned homes, churches and businesses in Southeast Canton. To make way for progress, St. Paul had to be torn down. Many attempts were made to save the building on Thirteenth Street. Pleas from church leaders went unheeded. Beulah Meacham's letter to the Canton Preservation Society expresses the concern of the African American population. Mr. and Mrs. James Jenkins provided the committee with this original letter written prior to the destruction of the building. Unfortunately, the letter and pleas were to no avail. The beautiful structure was destroyed.

Congregants purchased and remolded the former A&P, and it became and remains the home of St. Paul A.M.E. Church today.

According to Heald, between 1940 and 1950, there were about two thousand members in thirteen principal black churches in Canton. Mt. Calvary Second Baptist Church, located at 1000 Third Street Northeast, was founded in 1902. Its first location was 708 Madison Avenue, under the name Second Baptist Church, with Reverend J.R. Greene, pastor. Later, Mt. Calvary moved at 609 Eighth Street Southeast, with Reverend G.T. Speaks as pastor. In 1930, it became the Mt. Calvary Second Baptist Church with Reverend A.W. Ross, pastor.

In 1941, Mt. Calvary appeared at 808 Eighth Street Southeast, under Robert Vaughn as pastor, then at 1131 Lafayette Southeast and a year later at 519 Ninth Street Southeast. In 1937, Reverend I.T. Lively began at ten-year pastorate; in 1948, Reverend John S. Sanders began another ten-year pastorate; and in 1957, Reverend C.A. Lightbourn became pastor and served until his death.

Lightbourn married Edna Mae Carter on the same day he accepted the leadership of Mt. Calvary. Reverend Lightbourn served the members of Mt. Calvary Second Baptist Church for thirty-six and one-half years. In 1962, the church moved to its current location, on Third Street. Four years later, a fire nearly destroyed the building. The congregation worshiped in nearby Lathrop School until it moved into the current building, which was dedicated in 1969.

Reverend Lightbourn not only served his church, but he also served his community through membership and leadership roles in the NAACP, the Canton Urban League and the Stark Metropolitan Housing Authority, serving as vice-chair and chair. Born on August 14, 1921 in Nassau in the Bahamas, Reverend Lightbourn died on September 15, 1999.

Antioch Baptist Church was organized on the third Sunday in May 1919 by the late Reverend R.T. Harris and seven members and located at 728 Madison Avenue Southeast. Members were Sally Harris, Anne Price, Irene Jordan Townsend, Odell Rice, George Stevenson and Beatrice Stevenson. The first location was in a small house in Jackson Park. In 1926, the members moved to 600 Ninth Street Southeast, where they worshiped until April 1958. The first pastor, Reverend R.T. Harris, served for twenty-two years and later pastored Jerusalem Baptist Church at 925 Liberty Avenue Southeast.

A popular pastor, Reverend W.C. Henderson led the congregants of Antioch for over thirty years. A native of Mound City, Arkansas, he was appointed to Macedonia Baptist Church in Waynesburg in 1954, followed by three years at Union Baptist in Canton. He came to Antioch in 1962.

Reverend W.C. Henderson.

Under Henderson's leadership, Antioch became one of the largest congregations in Stark County.

After Henderson's retirement, the church appointed Reverend Richard Jordan to the pastorate, where he still serves today. Pastor Jordan and the Antioch congregation moved into their latest facility at 1844 Ira Turpin Way in 2009 after the church purchased the former Canton Negro Oldtimers Activity Center.

Jerusalem Baptist Church is a split-off from the Antioch Baptist Church. The group, which left Antioch in 1946, followed Reverend Harris to the new church on Liberty Avenue. Although the congregation paid $10,000 for the church, many repairs were necessary before the new church could be used for worship. During this time, the church body worshipped in the chapel of the March Funeral Home on Eleventh and Liberty Southeast. The new name chosen by Deacon Shade Bess was Jerusalem Baptist Church. In October 1948, the remodeling was completed, and the membership worshipped in the newly remolded edifice. On March 15, 1959, Reverend R.T. Harris and a small group of members departed the main body of Jerusalem Baptist Church, leaving the church without a pastor. The church changed its name to Greater Jerusalem Baptist Church. In July 1959, Reverend Henry Winter was called and served Jerusalem for five years.

On July 25, 1964, Reverend Floyd Summers became the pastor. The church was renamed Mt. Olive Baptist Church. The church purchased property at 1403 Thirteenth Street Southeast. Groundbreaking occurred on September 1, 1967. The building was completed, and the first services were held on December 31, 1967.

Ten years after the Mt. Olive Baptist Church moved into its new building, the church held a mortgage burning service. The loan, which the congregation received for the church and its contents, of $200,000 had been paid off in ten years.

Reverend Summers provided the leadership to make Mt. Olive the first black Baptist Church in the city to build a new church "from the ground up,' as the elders described it. The building still stands on Thirteenth Street Southeast.

Greater Jerusalem Missionary Baptist Church mothers.

Pastor Floyd and Mrs. Juanita Summers.

Turner's Chapel, also called Turner's Methodist Mission, first appeared in the city directory in 1927 at 928 Cherry Avenue Southeast with Reverend Loftin, pastor. With changing locations, it was in and out of the directory until 1942, when Reverend J.A. Loftin of Akron was back again with services at 806 Cherry Avenue Southeast. The church moved to 1451 Nimisilla Court Southeast on February 8, 1959. One pastor made national news when *Jet* magazine published this story on February 13, 1964:

> *First Negro Is Named Head of Ohio City FEPC. The Rev. Herbert Seavers, 34-year-old minister in Canton, Ohio was named the first director of Canton's Fair Employment Practices Commission. The Rev. Seavers, pastor of Turner's Chapel Methodist Church was named to a post that was created seven years ago but never filled.*

Turner's Chapel, renamed James S. Thomas Methodist Church, is located at 3412 Harmont Avenue Northeast and was cited in the August 1981 edition of *Black Enterprise* as an example of black churches using their power to help their congregations in particular and the black population in general. The article stated that Turner's Chapel was able to parlay a $5,000 start-up grant from the predominately white United Methodist Church (UMC) into an independent program of community investments into a cooperative supermarket and a cooperative food distribution system. Many credit Turner's Chapel with the formation of ABCD, formerly known as Advocates for Black Community Development.

Shiloh Baptist Church at 813 Nimisilla Court Southeast appeared first at 811 Nimisilla Court with Reverend G.T. Speaks as pastor. In 1938, Reverend J.R. Sanders (often confused with Reverend J.S. Sanders, pastor of Mt. Calvary Second Baptist) became the pastor. Adding to the confusion, the two ministers married the same woman. Pearlie Sanders married Reverend J.R. Sanders, and when he died, she married Reverend J.S. Sanders. Shiloh is located at 700 Market Avenue South.

Peoples Baptist Church, originally located at 1300 Market Avenue South, appeared first in the 1930–31 directory with Reverend E.M. Kaigler as pastor. Reverend W.H. Cotton had been the pastor since 1944, when there were about five hundred members. Now located at 701 Seventeenth Street Southeast, the church is served by Pastor Walter J. Arrington. Reverend Arrington is the son of the late Reverend Eddie Arrington and Annie M. Arrington of Massillon, Ohio. Pastor Arrington has served as the pastor of the Peoples Baptist Church of Canton for more than twenty years. Pastor

Arrington and Peoples' Baptist Church host an annual Martin L. King Jr. Holiday service. For the past several years, Pastor Arrington served as chairman of the Canton, Ohio King Holiday Commission.

Bethel Christian Methodist Episcopal Church began as the New Salem CME Church, appearing first in the 1932 city directory at 1930 Eleventh Street Northeast, with Reverend C.A. Jackson, pastor. The name was changed about 1954, following a move from its first location to 1415 Tuscarawas East. It moved to a parsonage at 1233 Third Street Southeast. The letter *C* was mistakenly taken for *colored*, but there is no color line, and a few of the 150 members are whites. Reverend W.C. Crenshaw was in his third year as pastor there in 1950s. Bethel is now located at 1903 Second Street Northeast.

Mt. Zion Church of God in Christ, 1007 Eleventh Street Southeast, was organized in 1933 at 517 Second Street Southeast under the leadership of Elder William Evans. In 1935, Bishop R. F. Williams asked Elder J.W. Inman to take charge. Services were being held in a small store room at 815 Cherry Avenue South. The Interdenominational Missionary Society had erected a church basement on the present site for $9,000 plus cost of lot. Later, the members abandoned their worship there and offered it for sale for $4,000. Reverend Inman finally secured it for $1,500 with a down payment of $100 in March 1938. Over several years, the balance was paid and $5,000 raised toward a new building. The foundation for a new building was laid on June 1, 1949, and the first service in the new building was held on March 23, 1952. The cornerstone was laid on September 27, 1953. The building was dedicated free of debt on October 20, 1957. Dr. George E. Parkinson brought the dedicatory message. The Reverend J.M. Mainor, state secretary of the Ohio Churches of God in Christ; Mayor Carl F. Wise; and other prominent persons were present. Credit for this unusual record goes to Reverend J.W. Inman, who waged a successful up-hill fight, has a distinguished bearing and preserved accurate records. There are seventy-eight families in the membership, representing about 234 persons. Mt. Zion Church of God is now located at 1208 Sherrick Road Southeast.

The Cherry Avenue Christian Church at 1217 Cherry Avenue Southeast began as a result of John Lee Bradley and S. John Compton moving to Canton from Warren, Ohio, in 1923. S.J. Compton and John and Alice Bradley decided that since there was no black Christian church in Canton they would start a Bible School. They were joined by Elder Rufus and Sister Daisy Edwards, their family and John Lee Bradley's parents, James and Sarah, and their eleven children. Lillie Pearl Mitchell joined the group after

marring Compton. After Joe and Ella (S.J. Compton's sister) Bush moved to Canton, the study group began to meet in their home. The church moved from the Bushes' home to a dance hall on Cherry Avenue Southeast and Ninth Street to various storefronts on Cherry Avenue and then to Kimbel Tabernacle on Thirteenth Street Southeast. From Kimbel Tabernacle, the group moved to March Funeral Home's Chapel and remained there until the members started building a church. With a donation of $7,000 from the First Christian Church in 1939 and a loan of $10,000 from the Church Extension Department of the Disciples of Christ (Christian Churches) in Indianapolis, together with $10,000 raised by the church, the new building was completed. The new church, located at 1217 Cherry Avenue Southeast, was dedicated in February 1949. There were 175 members. The congregation worshipped there until 1977, when the highway department built Route 30 East through that area. The name of the church was changed to Faith United Christian Church.

Following Reverend Compton's pastorate, which ended in August 1954, Reverend Ernest J. Newborn became pastor and served fourteen years. The church is located at 3411 Richmond Avenue Northeast.

Of course we have not included all of the historic African American churches in Canton, nor have we adequately described the impact these churches and their pastors have had on the community. They have truly made a difference.

One nondenominational church that has grown with a large, mostly African American congregation, is L.I.F.E. Ministries, founded by the Reverends George and Robin Dunwoody. A former pastor of St. Mark's Baptist Church, Reverend George Dunwoody and several followers stated the fellowship to welcome all Christian denominations. L.I.F.E. Ministries is located on Market Avenue North. Since the death of Pastor George, his wife, Robin, has served the congregation.

There are several older and newer congregations that deserve inclusion in this volume; however, information was not submitted about their history or current situation. This list includes Bethel Apostolic Church, pastored by Elder Ralph Byrd; Gethsemane Baptist Church, pastored by Reverned C.R. Hood and now Reverend Tommie Brewer. Other churches are Mt. Hebron Baptist Church, Mt. Pleasant Baptist Church, God Given Church of God in Christ, Sherrick Road Church of God in Christ and Mt. Zion Church of God in Christ. Although we have not listed all of the churches, we were able to include a representation of the rich spiritual history of Canton, Ohio.

SINGING WONDERS
of CANTON, OHIO

Place

Date

Time **Adm.**

PERRY RANGE, Mgr. Curtis Logan, Booking Agent
GL 3-2860 GL 6-4810

Original members of the Singing Wonders (*bottom, left to right*): William Smith, Ed McIlwain, Ernest Turner (*top, left to right*) Perry Range, Nicoleon Torrence, Curtis Logan and George Hogan.

The Singing Wonders grew out of the spiritual background of the church. The all-male musical group has performed in concert around the state for over fifty years. Edward McIlwain is widely considered as the group's founder. Original Singing Wonders are William Smith, Ed McIlwain, Ernest Turner, Perry Range, Nicoleon Torrence, Curtis Logan and George Hogan. Other members over the years include Reverend Ricky Brown, Lance Hawkins, Ron Culver, Arthur Hill, Ben Eutsey, Trey Eutsey, Eddie Williams, Azi Sultan and Steve Mathis. Nationally known, the Singing Wonders of Canton were spun from the spiritual genesis of the Canton African American Church.

CANTON TREASURES

The First Church of God in Christ

By Rita Barrett and Vince Watts

Another church holding the distinction of being one of the firsts is the First Church of God in Christ. Two local residents, Rita Barrett and Vince Watts, wrote about the history of this church. The First Church of God in Christ (C.O.G.I.C.) was founded in 1920 here in Canton. It is the first C.O.G.I.C. church in this area and the second in Ohio. Only Jonas Temple C.O.G.I.C. is older in Ohio. Every church in the denomination between here and Akron has some foundation in First Church—over twenty-six churches. In its eight-five-year history, First Church has had only three pastors. It was founded by Elder Finney, who passed away in 1962. Elder Elzie Linton took over the church until his passing in 1984.

The first First Church was in the home of Ed McIntyre, former president of the Canton Negro Oldtimers, and Elder John McIntyre Sr., pastor of Community Life Church of God in Christ. As Elder McIntyre puts it, "When we went to church as kids we didn't have to leave home." Barrett stated that she didn't know what year Elder James Linton (J.L.) Finney came to Canton, but she remembered him saying the Lord showed him Canton in a vision when he lived in Omaha, Nebraska. Dianna Nelson came to Canton in 1923, to join Barrett's father, Henry R. Nelson, who came here from Savannah, Georgia, after World War I. Henry Nelson was from Jacksonboro, South Carolina, a little watermelon-growing burg just outside of Charleston.

Elder Finney started the Church of God in Christ. In those days, they called it preaching out a church because they would preach on street corners. Thus, the name—First Church of God in Christ. Barrett remembers a new building being built on the corner of Eighth Street and Lafayette Southeast where she was married. As a result of the urban renewal program called the Candlelight District, the church was moved to 1125 Gonder Avenue Southeast, where it now stands.

When Elder Finney died, there was a time when the church was without a pastor, and then elder Elzie Linton became pastor and when he died his son-in-law, elder Joseph Morgan, became pastor. Some of the older members at the First Church of God in Christ on Eighth Street were Brother and Sister Burlson, Sis Osborne, Sis Hattie Phillips, the sister of McKinley football great, Jim Huff, Deacon Wright Byrom and Sister Sylvenia Byrom, Sister Jeanette McIntyre, the mother of Canton Negro Oldtimers president Edward R. McIntyre, Sara Williams, Brother Hosea and Sister Ardie Lee Gillespie, Sister Ora B. Gates, Sister Mary Tinsly and her husband, Sis Jewel Chin, Elder Walter Williams and Sister Irene Williams, who was the aunt of Harold White, the Tuskegee Airman.

Warren P. Chavers

Submitted by Deliverance Christian Church Family

An example of a newly formed church, that is, a church which did not exist when Heald authored his history of Canton, is Deliverance Christian Church, founded by its former pastor Reverend Warren P. Chavers. Born in Canton on April 22, 1952, Dr. Chavers is active in the Stark County community. Some of his many organizational memberships include founder and president of Deliverance Bible Institute; chairman of the Pastor's Advocacy Coalition (PAC); founder and CEO of Aphesis, Incorporated; president, Stark County African American Federation; signing member, City of Canton Declaration 2000 Agreement for Racial Equality; co-founder, Stark County Black Federation; Gang Intervention Ministries; and the Canton United Way Compass Community Awareness Board Member, to list a few.

In 1979, when God gave Pastor Chavers the command to begin his ministry, he was given the scripture Luke 4:18: "The Spirit of the Lord is upon me, because He has anointed me to preach the Gospel to the poor. He has sent me to heal the broken hearted, preach DELIVERANCE to the

captives, recovering of sight to the blind, and to set at liberty them that are bruised." This one verse gave birth to the Ministry of Deliverance Christian Church. Pastor Chavers has remained faithful and true to this scripture for twenty-five years!

As the pastor of Deliverance Christian Church, Dr. Chavers works passionately winning souls for Christ. Dr. Chavers is a mentor to the youth and older people alike; he has the ability to relate and deliver messages that children can understand, teenagers can identify with, older adults are experiencing and senior citizens have lived through. Anyone who has listened to Dr.

Reverend Warren P. Chavers.

Chavers will definitely remember him. His ability to deliver the Word of God and not sugarcoat the truth makes everyone feel as though they can make it!! Correction, makes them KNOW they will make it. He teaches that God has made us "the head and not the tail."

"When you have done all that you can do, 'YOU STAND.'" Dr. Chavers does not want Deliverance to be considered a "black church." His mission is to see all people come together to worship the Lord "in Spirit and in Truth." Dr. Chavers is loyal to the Stark County community and its residents.

He could be anywhere he chooses to be, in a larger city, a bigger church, a higher profile position, but he chooses to remain in Canton, Ohio, preaching salvation to those who are lost and suffering. Stark County would not be the great community that it is without the contributions of preacher, teacher, mentor and friend, Dr. Warren P. Chavers. In 2007, Pastor Chavers wrote and published the book *The Mess in the Messenger*, an examination into the phenomena of mega churches. He has since retired, and the church has been sold. His son leads a smaller Deliverance Christian Church housed on Cleveland Avenue North. The congregation recently purchased the former Jewish Community Center on Twenty-Fifth Street Northwest and uses this location as an activity center.

Myrtis Cole

Many spinoffs from the spiritual involvement of African Americans in Canton have evolved. Among them was the spiritual radio program of Myrtis

Cole. Her son, Eddie Cole, is the mayor of historic Eatonville, Florida. Her daughter, Vera Thomas, provided us with information about her mother. Myrtis Cole was born on November 15, 1932, and relocated to Canton in 1954 from Columbia, South Carolina. She was the mother of four children and wife of Reverend Percy Cole. She was the first African American to have a gospel radio program in Canton. A promoter of gospel music, she was responsible for bringing Shirley Caesar, Bill Moss and the Celestials, the Volunteers, Blind Boys, the Staple Singers, Willie Banks and the Jackson Southernaires to various church programs in the area. The Gospel Keynotes and other gospel musicians were often guests in her home when they came to sing at local churches.

Back in the day, gospel singers did not charge as they do today and, in most cases, accepted whatever offering was raised during the program. All programs were contained within the designated church. Many came to my father's church, Zion, some to Gethsemane. I remember specifically when the Staples Singers came to Gethsemane when it was on Eleventh Street before it was torn down. I would venture to say almost every Baptist church in Canton had groups that came in because of my mom.

With a God-given talent and ear for music, Mom could literally teach anyone to carry a tune. She organized, played and sang in various groups, including the Gospel Highlights, and with her children, the Traveling Angels, throughout the country.

She also had an entrepreneurial spirit and operated a costume jewelry stand in one of the local drugstores downtown. She was often the guest speaker for Women's Day and for special functions within the religious community. She received numerous awards and commendations for her radio work and service to the community.

A loving mother and loyal friend, she died at the age of forty-three on August 5, 1977. She left a legacy as a bulwark within the religious community and children who loved her, including Vera, Pearlene, Edward and Mary Lee.

Leona E. Edwards

Leona was born in South Carolina on December 11, 1928, and moved to Canton in 1930. She received her elementary education in Canton and graduated from McKinley High School in 1946. She had been employed by United National Bank and Trust Company located in the Clarkins' lobby on Route 62 and Harmont Northeast. for two years. No one ever thought that

Leona Edwards.

May 9, 1980, would be her last day on earth as a wife, mother, sister or friend. Fifty-one years old, Leona was shot and killed as the bank was being robbed.

This tragic news came as a shock to the entire community. Everyone knew Leona, since she had worked for Dr. Ross as his receptionist/nurse for more than twenty years. After Dr. Ross retired, she applied for and was hired as one of the first African American women tellers for United Bank and Trust Company. The bank robber was apprehended the same day. He is still serving time for the murder.

"Giving Honor to Our Black Churches"

By Mabel C. Jones

Black churches have long been
The focal point of the Black Community
Refuges of hope, faith,
And spiritual tranquility

They kept us seeking
And striving for a better life
Assured we'd someday overcome
Our own hatred and strife

Once they were portraits
Of Sunday morning segregation
Now they stand proud as examples
Of racial and social integration

All hail to our Black Churches

CIVIL RIGHTS IN CANTON

*T*he persistent complaint about life in Canton is the lack of diversity and inclusion within the social, political and economic community. In order to improve the plight of blacks, various civil rights organizations were formed.

NAACP

The National Association for the Advancement of Colored People (NAACP) is America's oldest, largest, most effective and most respected civil rights organization. It was organized on February 12, 1909, in New York City by a group of concerned individuals, black and white, and members represented a variety of social and civic organizations. In 1910, offices were set up in New York with the late Dr. W.E.B. DuBois as director of publicity and research and the editor of the *Crisis* magazine. Its first objectives were to stand for the rights of men, irrespective of color or race, for the highest ideals of American democracy and for the reasonable but earnest and persistent attempts to gain these rights and realize these ideas. For over one hundred years, the NAACP has fought within the system, under the Constitution, to improve the conditions of black and white Americans in the areas of education, employment, political action, public accommodations, voter registration and respect for the rights of black Americans.

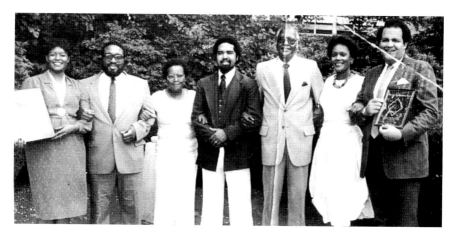

Stark County NAACP Executive Board, circa 1973.

The association's ultimate goal is the establishment of full and equal rights for Americans of all races in respect to security of the person, voting, housing, treatment in the courts, health facilities, public facilities and accommodations. To deny equal rights to any citizen solely because of his race or color not only is morally wrong, but it also is psychologically destructive to persons of both races, economically foolhardy and internationally explosive.

On February 8, 1956, William E. Mayo was installed as president of the Canton Senior Chapter. At that time, Mayo was the youngest person ever elected to the president's post. Others installed at the same time were Charles S. Mack, vice-president; Elnora Holt, secretary; and Ralph Ford, treasurer. Executive board members installed were Ella Green, Carlon Jones, Euphriam Mayle, Mariam Coppock, Willa Mae Webb and Dorothy White. The list reads like a who's who of black Canton.

By 1979, the Stark County NAACP was headed by Ronald Ponder. Among many advocacies pursued by the organization, Ponder stated that the Stark NAACP was ready to support "authentic" revitalization of Canton's central city as a benefit for all residents. Ponder led NAACP leadership to challenge the city by seeking to increase the number of women and minorities serving as members of the public safety forces.

THE CANTON URBAN LEAGUE

Dr. Walker is largely credited with the founding of the Canton Urban League, now known as the Greater Stark County Urban League, in 1921. The Canton Urban League started to help newly migrated blacks from the South settle into the industrial cities of the North and escape Jim Crow laws. It was originally known as Community House and was located at Eighth and Lafayette Southeast. The league was one black organization dealing with the lack of recreation for black youth. The league filled this void by providing street dances and a gym for basketball, volleyball, skating, Scouts, chess, checkers and other activities. During the height of the Depression, the league had classes to teach mothers and fathers to stretch their money, as well as free sewing, cooking and canning classes. John Crawford was the executive director at this time.

A.A. Andrews.

The Mission of the Urban League is the elimination of racial discrimination and segregation in this country and achievement of parity for blacks and other minorities in every phase of American life. In 1937, the Urban League participated in a study that brought $3 million to the area and formed CMHA (Canton Metropolitan Housing Authority). During World War II, the league participated in selecting blacks for defense jobs. Clarence A. Thomas became one of the premier programmers in Stark County, pioneering many innovative programs. Serving as chairman of the board of the league was A.A. Andrews. Andrews was also on the board of Wilberforce University and was a member of St. Paul AME Church. Unfortunately, it was also on Thomas's watch that the Urban League moved to Thirteenth Street Southeast and Lathrop-Madison urban renewal occurred.

Clarence A. Thomas, executive director of the Canton Urban League.

Joseph Smith is considered the grandfather of the Canton and National Urban League

movement. He played a major role in the advocacy, planning and development of the Southeast Community Center. He is also known for mentoring and placing more people as Urban League executives than any other person in the country. Deborah Emery, Janet Gordon and Steve Jenkins served as executive directors of the Urban League following Smith's death.

Vince Watts.

Vincent Watts can be credited with saving the organization. When the board of directors voted to close the local affiliate following a decision by the local United Way to discontinue funding, Watts contacted several community representatives to stave off the closing. Nadine McIlwain was selected to lead a fund-raising campaign designed to raise $100,000 in 100 days. In efforts launched on October 12, 2009, and concluding on Martin L. King Day, January 18, 2010, a total of $102,700 was raised and the 100 in 100 campaign had exceeded its goal.

The future of the Greater Stark County Urban League is still tenuous. However there are signs of optimism. Longtime Urban Leaguer Diane Stevens Robinson is serving as interim executive director.

THE PHILLIS WHEATLEY ASSOCIATION

Founded by Mrs. J.B. Walker in 1934, the Phillis Wheatley Association was a civically oriented organization that provided housing for black travelers not permitted to rent a room in the downtown hotels. It was originally located at 236 Fifth Street Southeast and eventually moved to 612 Market Avenue South. There were Phillis Wheatley Associations throughout the South but none in this area. Many blacks, particularly women, came to Canton in the 1930s and '40s looking for menial work. Although relatives who had arrived earlier would house some, the housing situation was not good and most dwellings were overcrowded. The Phillis Wheatley filled this void.

The association had four distinctive services: a residence for employed colored girls and women without a local home affiliation, a meeting place for Negro women's clubs (thirty-five clubs with about two thousand members

used the building), providing lodging for women travelers (and on occasion gentlemen travelers) and employment training.

Edna Christian described it as "an excellent place. The rooms were lovely and the service was beautiful."

THE FUTURE OUTLOOK LEAGUE

Organized around 1937, the Future Outlook League (FOL) adopted the slogan "Don't spend where you can't work." Operating during World War II, the league filed a historic law suit against Warner and Swasey and Thompson Products Companies involving the refusal of the companies to employ black women in skilled and semi-skilled jobs because of color.

This quote is not identified but was found in a newspaper clipping about the FOL:

> *Mr. Gillespie, Mr. Johnson and myself do not pretend to know all of the law. We believe that we are well-versed in the matter of freedom of contract. We have not argued in this case whether or not an employer has the right to select his own employees, but we believe the constitution of the United States and the state of Ohio uphold our contention that no individual or corporation has the right to use the taxpayers' money and refuse that taxpayer the right to work simple because he is black!*

With the outbreak of World War II, many blacks began working at places like Republic Steel, although Diebold and Hercules primarily hired only whites. A few blacks passing as white worked in these places, but as soon as they were found out, they were laid off and not rehired. Two targets of the FOL were Canton Valve Factory and Vogue Cleaners. After a few days of picketing, Canton Valve Factory, accused of permitting unsanitary working conditions for blacks, decided it could improve conditions a little for its black employees. Vogue Cleaners, located in a predominately black neighborhood, employed only white clerks to wait on the customers at the front desk, while blacks cleaned and pressed clothing in the back of the store. Vogue responded to the picketing by hiring Bernice Singletary, the first black woman clerk at that business.

The FOL worked to get more blacks hired at the big industrial plants, including Timken, Hoover, and Bliss. FOL members solicited the help of the Canton City Chamber of Commerce:

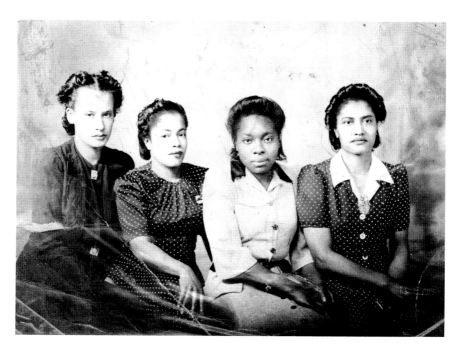

Among the first women to work at the Timken Roller Bearing Company, although all of the women in the photo have not been identified, the anchor on the left is Esther Archer and on the extreme right is Effie Bonner Edmondson. *Courtesy of Judy Sessions Jones.*

One of the members advised them to write to the Chamber telling of F.O.L.'s unsuccessful contacts with the personnel offices. When the communication was read in the Chamber of Commerce meeting, this particular member of the Chamber got up in the meeting and asked the representatives of these plants why these Blacks received no answer from their letters. Then one of the personnel officers said that he felt these communications from the Blacks should be reconsidered. From that time on, members of the Board of the Chamber of Commerce contacted the Future Outlook League for names of perspective Black employees. And through their efforts, in 1939, F.O.L. broke the ice at Timken and Hoover for Black women.

The Future Outlook League was directly responsible for Mildred Clark's employment at the Kroger Company. She later became the first African American in Stark County to be named as a deputy county recorder. Because of the FOL's influence, C.C. Crawford's Ready to Wear store hired its first black clerk, Ida Mae Taylor, according to E.T. Heald. Olive Mason was the first black salesman in a hardware store.

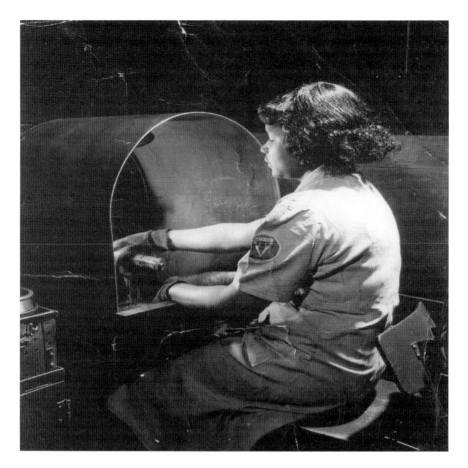

Mabel Williams, early Timken Company employee.

Another first in government was the appointment of Wavelan J. Simms to the post of sanitation superintendent. Selected by Mayor Charles L. Babcock, Simms was the first African American to hold a supervisory position in Canton's city government. His appointment was the subject of an article printed in the July 14, 1958 edition of the *Repository*.

In addition to the Future Outlook League, the traditional civil rights organizations such as NAACP and the National Urban League continued the fight for equal rights for all Americans.

United Parish Community Organization (UPCO)

This organization began in 1969 and was a church-affiliated group. The group established four goals: to aid senior citizens, to aid in strengthening family life, to upgrade the appearance of the neighborhoods and to hire youth for summer jobs, generally for beautification programs. Most would agree the UPCO was successful in its community service attempts; however, the organization no longer exists.

Save the Family Now Movement

Save the Family Now Movement is a faith-based movement founded by R.B. Holmes of Tallahassee, Florida; he is a graduate of Malone University. The first event sponsored by the organization in Canton was the Celebrating the Family banquet held on March 18, 2011. At the banquet, sixty African American couples who had been married twenty-five years or more were honored. The couple receiving the most accolades that evening was Deacon Oswald and Mrs. Annie Brown. In 2011, the couple had been married for seventy years. The couple married in 1941 after being childhood sweethearts. In total, they had eight children, thirty-five grandchildren, ninety great-grandchildren, five great-great-grandchildren and still counting. In 2018, Raymond and Margaret Booker celebrated their seventieth wedding anniversary.

Cleveland Cavaliers press conference prior to exhibition game in Canton.

CANTON BLACK UNITED FUND

The Canton Black United Fund (CBUF) was a black-controlled fundraising organization chartered as a nonprofit corporation by the State of Ohio as an affiliate of the LA-based National Black United Fund. CBUF accomplished something no other organizations has attempted or completed. Under the leadership of CBUF's fundraising chairperson, Nadine McIlwain, CBUF sponsored two pre-season NBA games at the Canton Memorial Civic Center. The first game featured the Cleveland Cavaliers versus the Chicago Bulls, and the second game pitted the Cavaliers against the Phoenix Suns. During the 2011 NBA basketball season, the Cleveland Cavaliers returned to the Canton Memorial Civic Center, and some sport enthusiasts claimed this game as the first for Canton. However, it was CBUF who first brought the Cavs to Canton.

OHIO BLACK WOMEN'S LEADERSHIP CAUCUS CANTON CHAPTER 1983

The Ohio Black Women's Leadership Caucus was officially recognized as a state-chartered organization on December 30, 1974. The Canton chapter was organized two years prior by Beth Smoot and Liz Short on March 9, 1972. At that time, there were only nine members, which grew to seventeen members with a goal of having one hundred members.

When the caucus was first organized, the name was Black Women's Political Caucus. Its purpose was to work "tirelessly to achieve leadership excellence for its members through education, political awareness and community involvement." An active chapter still exists in Akron, but the Canton chapter was dissolved.

CANTON HUMAN RESOURCE CORPORATION

Canton Human Resource Corporation (CHRC) was incorporated in 1975. Its general mission was to focus all available local, state, private and federal resources. The purpose was to enable low-income families and individuals of all ages to obtain the skills, knowledge and motivation to secure the

opportunities to become fully self-sufficient. CHRC operated at Northeast and Southeast Centers. Initial efforts included organizing residents into effective associations.

VICTORY ECONOMIC DEVELOPMENT CORPORATION

On June 30, 1972, the Victory Economic Development Corporation was organized to assist and encourage small minority businesses. In order for minorities to become involved in professional and technical fields, or in any other type of business, assistance is provided to the public. The Victory Economic Development Corporation was organized to serve the Stark County Area and expanded its services to include Summit County. The first and only executive director to date is John Lucas Jr.

STARK COUNTY HEAD START CHILD DEVELOPMENT PROGRAM

Head Start was organized in 1969, successfully serving children throughout Stark County. The health services include a daily health check, a physical examination, immunizations, TB test, dental care, visual and auditory screening and other important health services. A committee composed of parents and medical personnel makes decisions relative to health plans and delivery of services.

Head Start's position is that parents are the first and most important educators of their children. Parents have been enrolled in schools and colleges in greater numbers; Parent Effectiveness Training workshops; and First-Aid, Nutrition, Speech and Hearing, Mental Health and Storytelling Workshops. Parents assist with assessment of their children prior to enrollment in centers.

Fair Employment Practices Commission

During 1974–75, the Fair Employment Advisory Commission (FEPC) attempted to address itself primarily to two areas: 1) fair employment practices, and 2) contract compliance. The FEPC is no longer a department in city government. There are, however, a compliance director and a Fair Housing Commission.

The Stark County Town Hall on Race Relations
Coming Together Stark County

The Stark County Town Hall on Race Relations became the Sisters of Charity Foundation of Canton's first incubator agency in January 2004. "One of the most immediate funding concerns for any organization is the need for office space and equipment," said Vince Watts, executive director of Town Hall. "The incubator process with the foundation allowed Town Hall to focus on getting the message of diversity into the community, rather than the nuts and bolts of establishing an office," Watts concluded.

Delivering "the message of diversity" has been the goal of Town Hall since its inception in January 1998, following a religious service conducted by Rabbi John Spitzer in observance of the Martin Luther King holiday. Ron Ponder, a former president of the Stark County Chapter of the NAACP and former assistant to Mayor Sam Purses, was the main speaker. Ron challenged those in attendance that evening to actively work to improve the racial climate in Stark County.

His challenge came on the back of a national initiative promoted by President Clinton's charge to Americans to come together to discuss race relations. Several community members answered the challenge by joining together to present Stark County's first community discussion, A Town Hall on Race, on May 12, 1998. Since then, there have been eight more discussions on issues ranging from justice to health conducted by Town Hall. In 2003, the decision was made to take Town Hall to the level of a nonprofit corporation. The Sisters of Charity Foundation of Canton provided partial funding for some of the previous programs, so it was a

natural evolution to help the organization establish itself as an ongoing concern. In May 2003, with funding from the foundation, Town Hall was able to secure nonprofit status and to hire its first employee. Vincent Watts was selected to serve as the first executive director of the organization in July 2003. Under Watts's leadership, the organization continued to grow in many ways. In order to improve the participation of minorities in the arts community, Town Hall collaborated with the Players Guild Theater of Canton and the Rainbow Repertory Theater to present *A Raisin in the Sun* during the 2005 Martin Luther King Holiday season. *Raisin* was the first drama staged by an African American on Broadway when it opened on March 11, 1959. Locally, it proved to be one of the greatest theatrical performances offered at the Guild in terms of attendance and quality of the production.

Town Hall has grown from the incubator program to a stand-alone organization with offices located at 116 Cleveland Avenue North Suite 700. The diligence of the board and the direction of Watts have allowed the organization to focus on the future. In 2005, the organization started a Hispanic initiative.

In 2008, Nadine McIlwain was appointed executive director of the newly named Coming Together Stark County. The agency expanded its outreach throughout the county by hosting Community Chats on race relations across the county. McIlwain retired in December 2011, and the board chose Remel Moore to fill the post of executive director. Moore has resigned from her position; however, the organization continues with offices housed in the Ken Weber Community Campus at Goodwill.

CANTON TREASURES

When it comes to civil rights icons in the area, two individuals stand out, Esther M. Archer and Robert F. Fisher.

Esther M. Archer

Esther M. Archer was born in Wedowee, Alabama, on November 13, 1906. In 1920, the fourteen-year-old orphaned Esther came to Canton with her brother and grandmother from Alabama. Archer graduated from McKinley High School and later retired from the Timken Roller Bearing Company

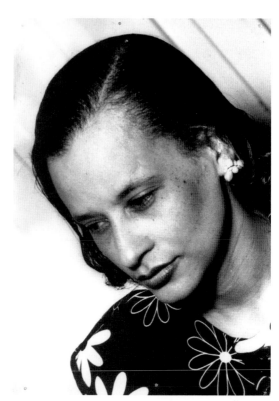

Right: Esther Archer.

Below: Esther Archer (*left*) and
Vera Elliott, city council members.

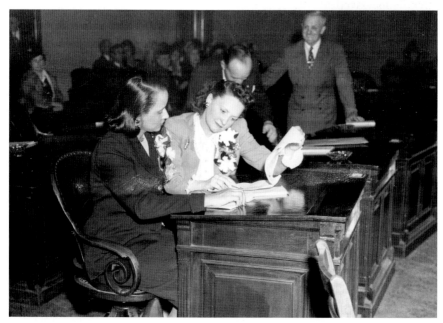

in 1968 after twenty-six years of dedicated service. She also sold real estate for Motts Realty. In 1947, Esther Archer became the first African American woman in the state of Ohio to be elected to city council. She represented the Fourth Ward for four terms. She was a member of Mt. Calvary Second Baptist Church, the NAACP, the Jane Hunter Civic Club and a variety of other civic and political organization. Archer began her career as an inspector working for Timken Roller Bearing Company, where she had to use the separate restroom for blacks only.

As a result of her factory employment during World War II, when most men were at war and even black women could find work, she worked hard and was able to put her four children through school and college.

In 1947, Canton City government was a white man's world when Esther Archer became the first African American woman to be elected to Canton City Council or in the state of Ohio as a councilwoman. The entire black community, including the churches, got involved and registered blacks to vote in record numbers. As councilperson for the Fourth Ward, her job was not easy.

"You had to fight to get in there and then, after you got in there, you had to fight to stay," Archer was often quoted as saying.

Ward Four was known for its sporting houses, gambling dens and houses of prostitution. However, there were people in the ward who wanted streetlights, paved streets, trash pickup and attention from city hall.

During her ten-year tenure as councilwoman, Esther garnered many different services for her constituents. During her second term, she was accused of extorting money (twenty-five dollars a month) from the head of the city dump. There were two trials. At the second trial, she was acquitted.

Later, during the 1950s, Esther's good friend Vera Elliot sold Archer her first home, located in an all-white neighborhood. Many of her new neighbors treated her "terrible" but later Esther received her own real estate license and sold their homes for them. Esther Archer once again made it possible for many African Americans to own their own homes. Archer was well liked and respected by this community. The Third Street Northeast bridge and a street are named in her honor.

Robert F. Fisher

Robert F. Fisher was born on November 22, 1936, the first child born to Frederick and Sarah Douglas Fisher on the Southeast side of Canton.

Being the eldest son of thirteen children, Bobby knew the struggles and responsibilities of being poor and black at an early age. In fact, his father worked two jobs in order to make ends meet for his large family. Much of the household responsibility for raising the younger children was left in Bobby's hands. In many aspects, Bobby became the household role model for his younger brothers and sisters. In 1954, Robert graduated from McKinley High. Following graduation, he worked as a stock boy at Fisher Foods. He also studied and eventually became an orderly at Aultman Hospital.

On September 14, 1958, Robert Fisher was married to Mary Rose Whitehurst. Soon after their marriage, Robert attended Kent State and majored in economics. From 1962 to 1965, Robert worked as a commercial income tax accountant and was an examiner for the Ohio Bureau of Inspection and Supervision of Public Offices of the Municipal Division. Finally, on June 26, 1965, Fisher accepted his first job with the City of Canton as budget coordinator. Over time, this position was expanded to include community services supervision. By 1966, Robert Fisher was named acting city license inspector by Mayor Stanley Cmich. From 1965 to 1973, Fisher coordinated the application process for all federal and state funds for the city, became community liaison and public relations representative for the mayor, arranged a suitable debt management system for Canton and prepared annual departmental budgets in cooperation with the city auditor. In July 1973, Robert Fisher was appointed to serve as the director of public service by Mayor Cmich.

Robert Fisher made a promise to the editors of this book to submit a story. His untimely death did not allow him to fulfill this promise. Thanks to Jenny Wells, who interviewed Fisher for a class project, we have captured a small piece of his voice:

> *There was difficulty, and probably some, not probably, discrimination in the hiring of black police officers. Either the tests were wrong, or somebody was not doing a proper investigation. Some of it certainly was deliberate. It seemed to be a thorn with the mayor, who was fair and wanted the system to work. The police didn't want a decree, thought it would lower the standards. That's always an issue when it comes to affirmative action and that wasn't it. Keep the standards but just make sure everybody…so we had schools for black men who wanted to be policemen and some still weren't getting scored right.…Instead of it becoming something that was normal that was a big deal every time a black was appointed to police and fire department. It was 1979 and the ministers came to [Cmich] and said,*

"Mayor, we know you know it's wrong, but we have to sue you and the city for discrimination and not having a sufficient number of black people on the police department." There was a candid discussion and it was like August 1979, and the mayor said, "Fellows we getting along, but if you'll wait until this election is over, in November, not only can you sue me, I'll assign Bob to help you and we can call it a friendly law suit to change things," because all over the country, there were decrees coming along.

So they waited. The ministers, along with the NAACP, prepared the lawsuit….Some people called it a friendly lawsuit, other people who were black say it wasn't a friendly lawsuit, but the mayor never fought the lawsuit, neither did the safety director, neither did I, neither did the law director. They welcomed it. Because they knew the only way to change the civil service system and the system for hiring police and firemen is by the court.

So the lawsuit was filed. The court did exactly what [the mayor] *said. For every three, one had to be black. And…I've got to tell you something. The day after the decree went in and was implemented, and we had to hire about 25 policemen, and 10 firefighters, and they all got sworn in, I was on the platform with the mayor and the council of chambers and I cried.* [Fisher begins to cry.] *And I'm doing it right now. It was like you went to the mountain and even though people may not have the* [same] *feeling… it was a victory that you had won. To see those guys stand up, and that room looked like Canton. Ten or eleven policemen and five or six firemen for the first time. But that was a glorious day. That was a glorious day.*

The entire interview was several pages long, but we could only include a portion of the conversation here.

THE SCHOOLS AND TEACHERS

\mathcal{T}he history of education in Ohio begins with the Land Ordinance of 1785, passed to establish a system for selling land in the Northwest Territory. Land was divided into townships made up of thirty-six sections, each six miles square. One section in each township was designated to support public schools. The earliest schools for white children opened in Marietta soon after Ohio Company settlers arrived in the late 1780s.

During the first half century of statehood, state government did not play an active role in establishing the educational system. Although the General Assembly enacted several laws regulating schools, most financial and administrative activity that impacted education took place at the township, county or city level. Public, or common schools did not come into existence until 1825.

Adrian Allison was appointed as the superintendent of Canton City Schools in January 2013. He was the first African American and the youngest person ever appointed to that position.

One early educational leader was James W. Lathrop, who came to Canton from Connecticut in 1816 at the age of twenty-five to practice law. Lathrop was instrumental in the town incorporation and became its first president, established the first library and the first fire department, served as attorney for the first bank in Canton and was elected county auditor. He was later elected to the state legislature in 1824 through 1828. As a representative, Lathrop sponsored a bill for free public education through

taxes. The first tax levied was one-half of one mill, and it met with great resentment from taxpayers. Although both black and white landowners were taxed, the law opened public schools to white children only. Neither Lathrop nor his legislative colleagues advocated for the education of African American children.

With the 1929 opening of Charity Rotch School in Kendall, a part of Perry Township, a milestone in the history of Ohio education occurred. When Charity Rotch died in 1824, she left her estate for the establishment of a free school. The school was the first vocational school in Ohio. Its curriculum included courses in home economics, agriculture and regular

Adrian Allison, superintendent of Canton City Schools, 2013–19.

academic classes. The school existed until 1924, when it was torn down. Approximately twenty years later, a petition signed by ninety-six citizens of Massillon to the directors of Union School argued against the admission of African American students to the school. The petition was in response to an 1848 Ohio law that allowed African American children could be admitted to common schools if there were no more than twenty black children and if the parents of white children did not object. The petition states that African Americans should "be debarred the privilege and benefits of said Union School erected expressly for the white children of said Town of Massillon."

Regardless of Lathrop's lack of concern for African American students, he is still considered an educational leader. His speeches in the House earned him the title "Father of the Public School System in Ohio." Those serving as members of the Canton City Schools Board of Education decided to name a new school building constructed in 1955–56 to replace the old South Market Street School built in 1896 on Canton's Southeast the James W. Lathrop Elementary School. However, the naming was not without controversy. African Americans leaders wanted the building named in honor of Dr. Mantel Williams. Had the school board agreed, it would have been the first school building in the district to be named honoring an African American. The board did not agree. The school gym was then named after Dr. Williams, either in an effort to appease or dismiss the request from the African American community. In 2004, under the leadership of Nadine

Paralee Watkins Compton.

McIlwain, who was serving as president of the school board, Lathrop school was changed to the Paralee Watkins Compton Elementary School in honor of this outstanding educator. Compton worked for Canton City Schools for almost fifty years in roles from secretary to teacher and principal to assistant superintendent. Throughout her career, Compton was a guiding force in education reform and teaching methods. She retired in 1993 but, in 2000, returned to coordinate GEAR UP, a college preparatory program that begins with Canton City middle school students and takes them through high school into college.

The other Canton school named after an African American is Crenshaw Middle School, named in honor of Walter C. Crenshaw Jr., former executive director of Stark Metropolitan Housing Authority and the first African American to serve in that capacity. Crenshaw, a former teacher in the Canton City School System, was born in 1935 and met an untimely death in 1969. A park in Canton is also named in his honor. In 2013, the board of education increased the buildings named in honor of African Americans by naming the Canton City School District headquarters the Nadine McIlwain Administrative Center prior to her retirement as a member of the school board.

Educational opportunities were available for white children only until the school law of 1853 was passed. This law required school boards to establish one or more separate schools for African American children. However, this law was applicable when and if there were more than thirty African American children living in the district. With a district having reached the desired number, then a school for African Americans had to be established, although school boards could operate integrated schools if no (white) parents objected. The law changed in 1878, when boards of education were required to provide free education to all, although they were still allowed to maintain segregated schools. An 1887 school law revoked authority to maintain separate schools, requiring school boards to provide the same educational opportunities to students of all races.

Much credit for changing the laws allowing, and in some cases requiring, separate schools for blacks and whites is owed to the School Fund Society, a state organization of black citizens whose main objective was to ensure educational opportunities for black children in the state because a state law, passed in 1829, specifically prohibited the attendance of black or mulatto children in public schools. Though the law provided for taxes collected from the property of colored persons to be appropriated for instruction for blacks, in practice, funds were seldom used for this purpose. Successful in opening

schools for African Americans in Springfield, Cincinnati, Columbus and Cleveland, the School Fund Society also petitioned the state legislature to change exclusionary laws. The statewide convention to address educational concerns led to future meetings of black Ohioans, which came to be known as Conventions of the Colored People of Ohio. St. Paul African Methodist Episcopal Church joined fellow A.M.E. churches in providing for higher education opportunities for African American college-age students in Ohio. The admonition to A.M.E. preachers to present four discourses annually on education, temperance and moral reform had a desired effect.

A group of Ohioans, including four African American men, established Wilberforce University near Xenia, Ohio, in 1856 and named it after the famous British abolitionist William Wilberforce. When the school failed to meet its financial obligations, leaders of the African Methodist Episcopal Church purchased it in 1863. The articles of association of Wilberforce University, dated July 10, 1863, state that its purpose was "to promote education, religion and morality amongst the colored race." Even though the university was established by and for people of color, the articles stipulated that no one should 'be excluded from the benefits of said institution as officers, faculty, or pupils on account of merely race or color.'

In the spring of 1851, the first board of education for Canton Public Schools was elected. Board members chose Ira M. Allen to serve as the first general superintendent. Despite the fact that the first Ohio public school law was passed in 1829 and blacks were taxed locally to support the public school, black children were universally excluded from the state's new school system. E.T. Heald noted in 1951, one hundred years after the first school board was sworn-in, the largest African American population in Canton City Schools was in the following schools: Market, Allen and Martin. Market School had a 60 percent African American student population However, Heald noted the Franklin School in Alliance had the highest percentage of African American student with 87 percent, and Massillon's Lincoln School was 28 percent African American. Heald also pointed out that there were nineteen of Canton's thirty-one schools that had no "Negroes."[19]

All of the Canton schools listed previously were located in the Southeast. Burns and Washington were in the Northeast. McKinley High had 285 African American pupils of the 1,873 enrolled, and Timken had 41 of 1,437. Still, McKinley, a public high school, supported by all citizens, whose programs and classes should have been available upon request, did not permit African Americans to swim in the school pool until the 1940s.

Mrs. Kanagy's second grade class of South Market School.

To accommodate protests about this practice, the school principal, a Mr. Potter, allowed black students to swim on Fridays, as the pool was cleaned over the weekend.[20]

One outstanding graduate of Canton McKinley High was Leila Green, valedictorian of the class of 1932. Green won many national honors in debating and speaking and, after graduation from Howard University, gained her master's degree at Radcliffe College with Phi Beta Kappa honors. As the story goes, after graduation from Radcliffe, Green applied for a teaching position with Canton City Schools. She was offered a kindergarten teaching position. She refused. At that time, kindergarten was not considered a part of a student's academic track. Green's graduate work in organic chemistry led to research in cortisone and later to an instructor's position at Wilberforce University.

According to oral history, the offer to teach a kindergarten class in Canton came from Jesse H. Mason, who was district superintendent. This same superintendent refused to hire Norma Marcere. Mason is remembered as saying that the only way a black person would teach in Canton City Schools would be over his dead body. Eventually, Canton City Schools hired African

Americans as teachers in the district. Having a black teacher was a first for many black students, and the impact of those teachers was felt long after students became adults. Ed Averette, McKinley High class of 1962, expressed this feeling in an email sent to the editors:

> *And do you remember Mr. Pickens (Civics and History teacher), Mr. Armour (French teacher),* [Mr. Armour taught German] *and Bob Evans (Coach) at McKinley during our period? They were great inspirations for us. Role models, we call them now. I'm living in Atlanta and attending Clark Atlanta University School of social work's doctoral program. Yeh, after years of hard work in California, I finally got an opportunity to study at this level. And I'm enjoying it. My focus is upon social conditions that self-empower Black men. Certainly, recognizing the leaders and elders (including past ancestors) that surrounded us in Canton was a contributing factor for our generation. I believe that's why you are compiling this book.* [Ed is now deceased.]

Much is known about Bulldog grads who attained national recognition for athletic ability. Less is known about graduates who attained national recognition in the arts. Notable for achieving fame in speech and drama was Irving Barnes. Beginning with his high school years, when he competed in national speech tournaments, and continuing with his major touring role in *Porgy and Bess*, Barnes demonstrated a dramatic talent few possess. Etna Walker escorted Barnes to Lexington, Kentucky, where he became Canton's first national speech champion in 1941, placing first in the National Forensic League's Humorous Declamation competition.

Although speech was his forte, Barnes credits McKinley music teacher Leslie Hanson with taking an interest in his singing and encouraging him. For two years, he attended Westminster Choir College. At the same time, he was singing with the New York Philharmonic Orchestra. Money, or lack of, caused him to leave college and to join his parents in East Liverpool, Ohio, where he met and married his wife, Katherine.

After auditioning for the radio show *The Big Break*, he won an appearance on the show in 1947. This *was* his big break, and he landed the role as Husky Miller in the radio theater's *Carmen Jones* and *Porgy and Bess*. Barnes played the male lead in the musical, touring twenty-eight countries on five continents from 1955 to 1958. In 1955, Barnes and the *Porgy and Bess* performers went on a three-month tour behind the Iron Curtain, including Russia, Poland, Hungary, Romania and Czechoslovakia.

Records indicate that Connie Dunn was a substitute cheerleader for McKinley, but Michaele Joan Barnes, class of 1960, was the first black varsity cheerleader at McKinley. Barnes was also chosen to represent McKinley as the 1960 prom queen. The daughter of Owen and Lillian Barnes was part of a trio of sisters who left outstanding marks at McKinley. Judith Barnes Lancaster was the first black elected to serve as a class officer. In 1953, Judith was elected freshman class president. In 1961, Jacqueline Barnes Holmes, the youngest sister, was chosen as the basketball queen. Another example of a McKinley High graduate who made good is Carolyn Byrd. Carolyn was in the Broadway musical *Bubbling Brown Sugar*.

The 1960s ushered in a decade of challenging the status quo. Schools were not excluded. When some felt that the public school system was neglecting the study of black history and culture, members of the Southeast Community Improvement Association (SCIA) established the Canton Community School. Led by Will Dent, Gilbert Carter, Charles Ede and Fred Goodnight, the Community Liberation School, as it was called, offered classes in Swahili, black culture and political action.

THE CANTON CITY BOARD OF EDUCATION

Virginia Jeffries was elected to the Canton City Schools Board in 1989. Repository writer Susan Glaser stated that Jeffries and the late Odes Kyle, who served on the board in the mid-1970s, were the only blacks to run

Virginia Powell Jeffries.

successfully for citywide office. Kyle was the first black person elected to the Canton City Board of Education. He served seven years and was board president. He was a Mason and chair of the board of managers of the YMCA, Canton. He also was selected Canton's Man of the Year in 1965.

Nadine McIlwain joined Kyle and Jeffries as winners of a citywide race. McIlwain was elected to the school board in 2001, 2005 and again in 2009. Both Jeffries and McIlwain served three four-year terms. On June 13, 2010, Pastor Wilbur Allen III was appointed to the board. Pastor Allen's appointment to a seat on the Canton City Schools Board

of Education was historic because it marked the first time in history that two African Americans occupied seats on the board simultaneously. That record was soon broken with the historic election of November 2011. Lisa Singleterry Gissendaner and Ida Ross-Freeman were elected to at-large seats on the Canton City Schools Board of Education, joining Nadine McIlwain.

At the January 2012 meeting of the Canton City Schools Board of Education, the first meeting in which Ross-Freeman and Gissendaner were seated, Gissendaner, Ross-Freeman and McIlwain voted against the superintendent's recommendation to renew the contract of the current McKinley Senior High School head football coach, Ron Johnson. Community uproar resulted, pitting McKinley supporters against one another. The homes of the three African Americans women were picketed by supporters of the non-renewed coach. The three members were told that they were unqualified to fire a white coach. Supporters of the school board members met at the Greater Stark County Urban League and vowed support for the duly elected representatives of the community. Ultimately, the community was reunited as cooler heads prevailed and a new coach was hired. Many in the black community noted that McKinley High School has yet to hire its first black head football coach. Corey Minor Smith was elected to the Canton City Schools Board of Education and began her term in January 2016. She resigned in 2018 because she was elected to serve a two-year term with the Canton City Council.

At this time, the only African American serving on the board is Mark Dillard. Dillard, thirty-eight, was appointed to serve the remainder of Corey Minor Smith's term, which ends on December 31, 2019.

McKinley High School

In addition to the memories many African American have of the athletics, many lives were impacted by the teachers and other school personnel. William H. Hunter was the first African American principal of McKinley Senior High. He was followed by Vernon Russell, former principal of Hartford Junior High. McKinley was led by Jeffrey Talbert, a graduate of Timken Senior High School, until 2009. Additionally, Jean Leavell, Deidre Stokes-Davis, Mark Black and Minerva Morrow served as assistant or associate principals at McKinley. In June 2009, Stokes-Davis was named principal of McKinley Senior High School, the first African American woman to hold this position.

Alvin Bond was the first African American teacher at McKinley High School. In addition to his teaching duties, he served as a counselor. Another early teacher and counselor was Lillian Barnes. Dr. Carol Carter-Lowery taught at Timken Vocational High School as early as the 1970s. She may be the first African American to teach at Timken, followed by Joyce Pope, Gary Huntley and Nadine McIlwain.

In 1953, Canton employed eight African American teachers. Paralee Watkins Compton, a graduate of Timken Vocational High School, was hired as the first secretary in the district. John Allison was the first custodian, and Cheylon Thomas was the first principal. Jean Leavell was the first African American woman to serve as a high school administrator when she was appointed an assistant principal at McKinley High School.

Memories of good times at McKinley High abound. The football rivalry between McKinley and Massillon is legendary. The rivalry is hardly forgotten by any McKinley graduate, as evidenced by an email by Arvis Averette to Bernard Tarver:

> *The last time we saw a football game together was McKinley vs. Massillon in 1956. Four of us went, you, me, Donald and of course Milton. We went in that green Pontiac of your father's. It was the second Saturday of November and the weather was wonderful, in the sixties and the sun was shining. The game was in Massillon.*
>
> *All year long we heard that we were "cheese champs", because in our victory the previous year 13-7, Massillon dominated in every statistic except the score. That was the year of Napoleon Bonaparte Barbosa, our first Black quarterback. A game played in a blinding snowstorm in Fawcett stadium, with a suffocating defense led by John Ifantiedies.*
>
> *Our 1956 backfield was halfbacks, Wayne Fontes and Phil Martin, quarterback, Ike Grimsley, fullback, Arnold Lewis. The line had Paul Martin, Obie Bender, the Patterson brothers recently from Mississippi, Stan Williams on one end and perhaps the greatest football player I ever saw, Robert Lee Williams the other end and heart of this great unbeaten team.*
>
> *The previous year both teams were 9-0 in the big game a point not mentioned a few weeks ago, only what happened 41 years ago. In 1956, Massillon had lost one game. McKinley jumped on the Tigers and beat them down 34-7. The play of the game occurred late in the second quarter with McKinley leading 14-0. Massillon drove furiously down to the McKinley 23 with a few minutes left in the half and McKinley held. Then without a huddle McKinley's Ike Grimsley came to line of scrimmage and told the*

Massillon team that the next play would be a hand off to Phil Martin on the count of two. Massillon's defense laughed, obviously this was a trick play. Ike got under center and on the second count handed off to Phil Martin who exploded for a 77-yard touchdown sprint.

In another email, Arvis notes the accomplishments of his classmates:

Enoch Jenkins, Ph.D., Professor of Chemistry. Enoch Jenkins is a graduate of Canton McKinley. He was our top student in chemistry. He carried a 90+ average from the legendary C.C. Smith while the rest of us, Judy Barnes, Milton Tarver and Arvis Averette struggled in the low 80's range. Dr. Jenkins soared above all of the students, Black and white. He too was a national honor student in his junior year. He never had any grade at McKinley below 90. What a marvelous scholar. With any other class in the past 100 years he would have been the stand alone top student. He was that smart, but that year there was this brilliance of so many that would hurt your eyes. I often make a case for Dr. Jenkins as number one.

Many are aware of the accomplishments of the state champion McKinley football and basketball teams. Most recently, McKinley celebrated another state championship with its girls' basketball team. The girls' volleyball team also won two state champions.

No book about Canton African American schools and teachers would be complete without the inclusion of several well-known educators. Dr. Laura

Laura C. Fisher McIntyre, PhD.

Fisher McIntyre is a perfect example of the consummate educator. Beginning her career as a Catholic school educator, Dr. McIntyre eventually became employed as a teacher with Canton City Schools. At Souers Middle School, McIntyre taught math. Her students recall learning that math is everywhere and in everything. Retirement did not end her education career. Rather, she accepted a position at the University of Akron as an instructor in the math department and as a student teacher evaluator.

Marian Louise Williams Crenshaw, who served for many years as a music educator at Hartford Middle School, was born on

October 15, 1925, at her parents' home at 912 Cherry Southeast in Canton. Marian's proud parents, Pearl Benson Williams and Mantel Bert Williams, met at Allen University in South Carolina. Pearl went on to become a schoolteacher, while Mantel Birt studied to become a doctor at Meharry Medical School in Nashville, Tennessee. After keeping their romance alive through the early years of work and study, they married and relocated to Canton, where they both spent the remainder of their lives.

Marian was raised in a loving environment shaped by values of self-respect, community service, high achievement and race-pride. One of her first memories was as a five-year-old integrating the formerly segregated Fifteenth Street pool in the Southwest section of town. This began a pattern of civil rights activism early in life that Marian would follow for the next seven decades.

Marian's lifetime of involvement in the Canton City School System began with her enrollment at South Market Elementary School. She later attended McKinley High School, where she was the first African American in both the marching band and the orchestra. She also excelled as a student athlete, winning entry into the highly selective Girls' Leaders Club. Graduating in 1943, Marian headed south to Bennett College, a premier women's institute in Greensboro, North Carolina.

Following her freshman year at Bennett College, Marian transferred to Howard University in Washington, D.C., ultimately graduating with a degree in music education in 1948. As a proud member of Alpha Chapter, she was initiated into Delta Sigma Theta sisterhood in 1945. Marian pursued her education by enrolling in a master's program at Columbia University's Teachers College in New York City. She and her husband relocated to Canton after the birth of their son Mantel Bert, and soon after, Marian began teaching English, math and music at South Market Elementary School.

Marian developed a reputation as a strict, fair and deeply involved teacher who liked to be in touch with parents and didn't mind visiting on Sundays and other times so that parents would not have to miss a day at work to keep up with the progress of their children. She also established a tradition of superb musical performance among scores of her students, introducing them to spirituals and other forms of classical music. Carrying on the custom of the Williams household, the first song taught in choir was always "Lift Every Voice and Sing."

Marian Crenshaw retired from Harford Middle School in 1995 after spending forty-six years in the Canton School System. She then returned to

her first career to teach music education at Walsh College, thus completing fifty years of education and service.

Minnie Pearl Lofton Hopkins was the daughter of sharecroppers, born in Newton, Georgia, on August 29, 1940, the third-eldest child of ten children to Queen Hall Lofton and Phillip Lofton. Minnie Pearl graduated as salutatorian of her class in 1958. She was married on June 16, 1956, at age fifteen to Eddie Hopkins Jr., and to this union was born three children.

In 1965, Minnie and Eddie and children moved to Canton. Eddie had a job with Ford Motor Company in Walton Hills, Ohio. Minnie started working as a teacher's aide at Martin Elementary School. She was also a school community worker and librarian while continuing her education at Kent State University. She finished her elementary education degree and started teaching at Madge Youtz Elementary School. Hopkins completed a master's in education at Kent State in December 1980 and was named as a principal to Harter Elementary School, where she worked for twelve years; she was subsequently moved to Lathrop Elementary School as the principal and retired in June 1998.

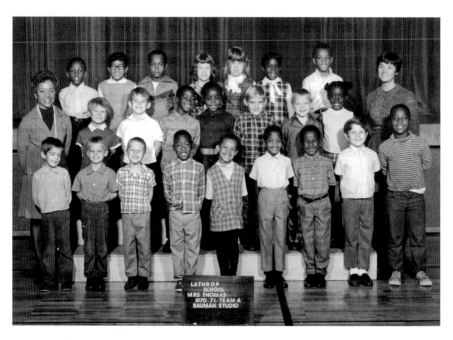

Cheylon Thomas (*second row, left*), teacher, Lathrop Elementary School, 1970–71.

Hopkins was instrumental in her community by helping Habitat for Humanity with building new homes in the neighborhood of Lathrop. Minnie was instrumental in helping to build the new Lathrop School playground, which was named in her honor. There is also a neighborhood center named in her memory.

The first African American principal of a school in the Canton City School District was Cheylon Thomas, wife of C.A. Thomas, executive director of the Canton Urban League. Thomas taught for many years at Lathrop Elementary School. Her first assignment was principal of Martin Elementary School. Later, she was reassigned to serve as principal of Madge Youtz School, and she also served as principal of Lathrop.

IRA M. ALLEN ELEMENTARY SCHOOL

Located in the heart of Canton's black community, Allen School was built in 1915 on the corner of Eleventh Street and Gonder Avenue Southeast. As a result of World War II, housing for returning soldiers and their families was critical. The Jackson Park Homes, now known as Jackson-Sherrick Housing, were built, and the school was quickly overcrowded. African Americans who served as principals of Allen were Ruby Foster, Obie Bender, Stephanie Patrick, Rosaline Henderson and Andrea Compton Ramsey.

Stephanie Patrick was a student at Allen and later became the beloved principal of Allen Elementary and Hartford Middle School. She retired in June 2008 after forty-one years of service to Canton's youth. However, she continued to serve students and their families as program coordinator of the full-service community school located at Hartford and as a substitute principal as needed.

Allen School alumni who have attained prominence are Stephanie Patrick; Albert H. McIlwain, former executive director of SMHA; Robert Fisher, director of public service under Mayor Stanley Cmich; and Dr. Frank Cunningham.

Cunningham attended McKinley High School and graduated from Mount Union College. He earned his doctorate from Boston University and served as president of Morris Brown College in Atlanta, Georgia. His sisters are Ruby Foster, educator, and Mary Alice Garrison. Lillian Barnes, educator and counselor at McKinley High School, and Marion Motley, a pro football hall of famer and member of the Cleveland Browns football

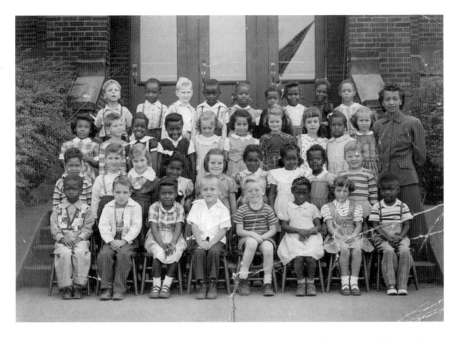

Allen Elementary School, Ruby Foster's first grade class, circa 1948. In the third row, third from left, is Stephanie Rushin Patrick.

team, are former students. Nationally noted singer and Allen alum Irving Barnes traveled with *Porgy and Bess* in Russia and South America. There are too many others to name all of them, but Allen School can remain proud of its former students.

HENRY S. BELDEN ELEMENTARY SCHOOL

The original Belden School was built in 1923 and housed students of many different nationalities. The school was built to relieve overcrowding at Hartford Elementary School. A new school was built on the same spot and completed in 2006. The first African American principal to serve Belden School was Mary Hatchett, followed by Mallory Martin. Andria Smith was also a principal. Like all alumni, former students of Henry S. Belden Elementary School have fond memories of their school.

CRENSHAW MIDDLE SCHOOL

Serving as principal of Crenshaw was Vernal Russell, who later became principal of McKinley Senior High. Wanda Grubbs serves as the principal in 2013, followed by Sandy Womack. Both Sandy and his wife, Monica, earned doctoral degrees. Sandy served as principal at Lathrop, Hartford and Crenshaw Schools. Monica is employed at Stark State College.

HARTFORD MIDDLE SCHOOL

Hartford Middle School has probably had more African American staff and principals than any other school in the district. Serving as principals were Dr. Robert Evans, Vernal Russell, Richard Brown, Jean Leavell, Stephanie Patrick, Sandy Womack Jr. and David Thompson. Although he served as an assistant principal, Dr. Robert Jackson is well known and respected throughout the community. He is noted for his poetic recitations and mentoring of many young men. In addition to the teaching faculty, Mary Ann Clark served as part of the secretary staff, Maple Thompson was a part of the cafeteria staff, JoAnne Grant was a part of the music staff and Louis Thompson was a member of the custodial staff. Georgia Strickland, who began working for Canton City Schools as an attendance officer, held the assistant principal position under Principal Richard Brown for several years.

Outstanding teachers include Marian Crenshaw, Patricia Kaiser and Stephanie Patrick. At Hartford, the Leila Green Alliance of Black School Educators (LGABSE) was founded in the late 1970s by the aforementioned group of outstanding teachers. Unfortunately for the organization, but fortunately for Kent State University, Dr. Robert Evans recruited Patrick for the Kent State desegregation project.

In the interim, Canton City Schools experienced its first and only strike by the teachers in 1978. The strike lasted weeks. African American teachers supported the strike but were concerned about the effect it was having on students, particularly African American students. Much discussion was held about how to overcome the lack of learning, and it was decided to reactivate the black teachers' organization. Marian Crenshaw suggested that they name the organization after Leila Green so that we would never forget her significant place in history of our schools and her treatment at the hands of the school superintendent. Bill Hunter led the drafting of a constitution

and bylaws and filed the incorporation papers, and the organization was incorporated in 1978. Nadine McIlwain was elected the first president and served in that capacity until Stephanie Patrick returned to Canton. With the exception of one school year, Patrick served as president of LGABSE from 1979 to 2008, just short of thirty years. The current president is Yvonne Marie Slay Parks, preceded by Sandy Womack, PhD.

George Dunwoody Jr. worked for Canton City Schools as a community liaison at Hartford Middle School for more than thirty-two years. As a founding pastor of L.I.F.E. ministries, Dunwoody was a beloved member of the Hartford staff and the Canton community.

LEHMAN MIDDLE SCHOOL

Zettie Sims was named principal of Lehman, the only African American to hold that post at Lehman. Tomier Davenport served as an assistant principal at Lehman and later at McKinley Senior High. Wanda Grubbs has served as an assistant principal at Crenshaw Middle School, an assistant principal at Lehman and was recently named freshman academy principal at McKinley High School. In 2010, Grubb became principal of Crenshaw Middle School.

LATHROP ELEMENTARY/PARALEE WATKINS COMPTON ELEMENTARY SCHOOL

Those serving as principals of Lathrop/Compton and the school staff are Minnie Hopkins, Sandy Womack and Dr. Sylveria Green. The school is now an alternate school for students who need extra help in order to meet graduation requirements.

Other Canton City Schools administrators are Adrian Allison, first African American superintendent of Canton City Schools, appointed on January 14, 2013. Allison received a five-year contract, the first ever given to a superintendent. Allison and his wife, Krista Allison, have law degrees but both worked in the field of education. The Allisons were recruited by former superintendent Chris Smith to help lead Canton City Schools.

In total, there have been three African American superintendents of Stark County schools. Dr. Rosemary Johnson was named the superintendent of

Canton Local Schools. Dr. Johnson began working for Canton Local Schools in 1974. She served as principal at Trump Elementary and as assistant principal at Faircrest Middle School. Dr. Johnson was named superintendent of schools in 1985. Although appointed in June, Johnson assumed her position in January and was superintendent for three days before succumbing to cancer.

Jeff Talbert served the Osnaberg Local School District for one year as the superintendent of schools. Talbert left the district to become an assistant superintendent in a Cleveland area district. In 2013, he was appointed superintendent of Alliance City Schools, where he is now serving. Mark Black was principal of Glenoak High School. Presently, Black serves as the executive director of secondary education for Akron Public Schools. His assistant principal, Tamiko Hatcher, was promoted to principal. Black and Hatcher are no longer associated with the Plain Local Schools.

Schools and teachers are important elements of the educational system, but students are necessities. Little was written about African American students and teachers who attended or taught in the other high schools operated by Canton City Schools. Willie J. Williams was the first African American male to graduate from Timken Vocational High School. Willie Tharp, operator of Willie's Muffler Shop, formerly located on the corner of Navarre Road and Cleveland Avenue South, attended Lehman but left school six months before graduating to join the armed services. His siblings, Elizabeth, Mattie and Sammy, may have attended there also but chose to graduate from one of the city schools. As far as Lincoln is concerned, we know that the Booker children, Raymond and Pam, attended Lincoln in the 1960s, but more research needs to be done to determine whether they were the first to attend.

There is evidence that the first African American graduate of Perry High School was Donna Brewer. She graduated in 1963. Graduating from Glenwood High School in 1964 was LaVern Burns, probably the first African American to graduate from Glenwood.

Memories of alma maters and favorite teachers comprised the majority of contributions sent to the editors of this publication. What is the highest tribute a student can give to a former teacher? We are not sure how to answer this question, but we know that teachers must feel a certain sense of gratitude for the kind words written about them by their former students.

CANTON TREASURES

Marian Crenshaw and Norma Marcere

By Sharon Hart

In 1960 (or thereabouts), I saw the Morris Brown College Choir perform at Lathrop Elementary School. It was an awesome experience. I have always loved music, and I sang in the choir at St. Mary's Elementary School from the fourth through the eighth grades. However, until that Lathrop concert, I never experienced black folks singing that kind of music in that special way.

I purchased the choir's record that evening, and I kept it for more than thirty years. It was scratchy and unplayable, but I still treasured it. I have Mrs. Crenshaw to thank for bringing that choir here, and for broadening my awareness of the musical contributions of my race. Mrs. Crenshaw was never my actual classroom teacher, and more's the pity; but nevertheless, I will always thank her for that unforgettable experience. Never before or since has any concert made that great an impact on me.

Another educator who opened my eyes to new experiences and heightened my awareness of the vast contributions of blacks was Mrs. Norma Marcere. As a Catholic school student, Mrs. Marcere, a devout Catholic, was no stranger to me. She not only took me and some of my classmates to visit the Santa Clara Monastery on North Market, but she also arranged for a bus ride and visit to Clearwater Golf Course in East Canton, Ohio.

She relayed the history and significance of this establishment, introduced us to its owner and his family, and gave me another example of the richness and diversity of blacks in America that was sadly lacking in my world at that time. As a kid, reading about history was one thing—especially when slavery was the predominant theme that was taught—but having those rare experiences that confirm your belief that surely your people accomplished more than freedom from bondage, was something else.

I can't believe that I was an adult before I ever heard of Langston Hughes, or "Lift Every Voice" or Billie Holiday. I could go on and on, but I wish kids today could identify with, and be grateful for, the advantages they enjoy by having so many black and other culturally diverse teachers so easily accessible, and so eager to enlighten them to a world of possibilities.

Alistine Thompson, Ruby Foster, William Hunter

By Darlene Moss

My mother, Alistine Thompson, came to Canton with her husband, Adam Thompson, and four of what would be her six children in the 1940s. She was a product of a segregated school system in Parkersburg, West Virginia. After graduating from Charles Sumpter High School, she received an associate degree from Harpers Ferry College. My mother had an amazing wit, and it was nothing to hear her quote Shakespeare and Paul Laurence Dunbar, performing both Negro dialect and the British classics. Mom could debate anyone on a wide range of topics, including education, welfare and racism. She opened her home to those who would come through town from the South for any reason. She became a substitute teacher for Canton City Schools and a business owner. She poured her life into her children. She inspired me to go to college even when my teachers and counselors told me to forget about college. I will always appreciate the fact that she believed in me and did everything within her power to see that I succeeded in life.

Ruby Foster taught fourth grade for many, many years at Allen Elementary School. She was greatly loved by her students. She poured herself into their learning and success. She had a wonderful rule. She did spank, even though she had a wooden arm, however the spanking was never for poor behavior, but for poor performance on tests. An "F" on a test was met with the warm paddle of Ruby Foster. She truly believed that each student could succeed. She impacted the lives of my husband and me.

Mr. William Hunter taught school at Allen Grade School and later became principal of Hartford Junior High School, and then director of personnel for Canton City Schools. Hunter was the principal of McKinley. When he was principal, he met with Walter S. Moss, who had failed in elementary. He told Walter, I believe you can do it, I am moving you up a grade. That boost led Walter into success in school, a starting position on the McKinley football team and a scholarship to Ohio University. When I returned home, looking for a job, it was Mr. Hunter who gave me a chance to teach French and Spanish for the students of Canton City Schools. He was a tremendous mentor for many African Americans in this community.

Thelma Gregory and Dr. Robert Jackson

By Vince Watts

In the course of the lives of many young people, there are specific intersections that determine their success or failure. In my life, there were two points at which, without the caring support of school personnel, I may have been the statistic and not the person writing these stories. The first was so unlikely that I have not heard of her being mentioned in any recognition or acknowledgement programs I have attended.

Mrs. Gregory was a quiet, unassuming person. She never pushed me to be better or to do better. She simply told me every day that I could do the work, I could behave in class and that I was as smart as anyone in the school. At a time when my mother was being challenged to find out what was wrong with me, Mrs. Gregory was busy fixing it. She was not a certified educator, yet she taught me lessons that made all of my other classes relevant. She was not a child psychologist, but she took the time to diagnose and treat a seven-year-old suffering from a severe bout of "don't careitis."

In second grade, I attended Washington Elementary School as a transfer from a year at Roosevelt Elementary. My mother had left my father less than a year before, and I had not yet found new friends outside of family. I began to have issues that frequently landed me in the principal's office. Calls home were an annoyance, though not without punishment, but the attention meant that I had no problems with the class bullies, of which there were many. Partially out of fear, partially out of nature, I made sure that I was not thought of as an easy mark. Though it kept me out of playground altercations, school counselors were at their wits' end. Paddlings were frequent, but not altogether a suitable deterrent. I assume that there were many calls home, but with the six of us the phone was always ringing. With the exception of Glenda and Lisa, the other four of us were as much as a single mother could keep up with. They ordered psychological testing to see if there was something more sinister happening in my head, which offered no answers. And if counselors were concerned, my teachers were totally out of their element with my special brand of taking a classroom hostage. Their answer was to send me to the library, where I could not influence the other students with my constant acting out. It was there that I met a person who changed the negative course my life was taking.

Banished to the basement library, I do not remember much time spent in the classroom toward the end of the second grade and almost none of my

third grade. I remember watching my class bring down the clay ashtrays they made with their palm prints to be fired in the ceramic oven in the basement across from the library. I do not have one of those ashtrays; as usual, I was not in the class. I took the CHAP test there in the library; Mrs. Gregory administered the test to me. I still do not believe I passed that test, and if I did it was only because of that angel on my shoulder who wore the title of school librarian.

I see a lot of students going through the same type of life challenges that I went through. They are more afraid than troublesome and more disconnected than ill-prepared. They need someone to believe in them enough to look beyond their actions to find the reason behind it. Whether it's academic possibility or racial identity, Mrs. Gregory's words have stuck with me, "You are as smart as anyone in this school," or any school. Mrs. Gregory did it for me, and if I do nothing more than what I have done so far in life, I owe it to her to help the next "little Vincent." Thank you Mrs. G.

The benefits of being involved in Canton High Ability Program (CHAP) classes gave me an excellent foundation for success. I was in the unique position to see the different level of education that kids in other schools in the same district were receiving as compared to the students in our neighborhood school. We were studying Shakespeare and Poe while others were still reading starter books. We were expected to learn and were challenged to do so. Teachers had no qualms about giving Ds and Fs if they did not see effort in completing assignments. It was a challenge academically for all, but an additional challenge for the three minorities in the class, Argie Lewis, Angela Williams and I.

By the time we reached middle school, we had found our niche in class and in the schools. Harter had about eight minority students when we left. Souers Middle School had a few more minorities, but still not many. The most beautiful sight at Souers was the science teacher, Mrs. Virginia Jeffries. Not only had I not seen a black teacher in the classroom since leaving Washington Elementary, Mrs. Jeffries lived around the corner from my house. That was a welcome sight.

We heard about the fights at McKinley when *ROOTS* came to television, and the fear was that blacks were coming to bring the fight to Souers. Several black students in the school met in the cafeteria to talk about what that meant to us. Were they coming to fight Souers students or coming to fight the white Souers students? We decided we were not the target and so we perpetuated the story to keep the other students on edge.

I sat in French class watching the clock and willing it to move faster. Suddenly, the P.A. system rang to life and a booming voice with a distinct southern drawl jumped the day to life. I don't remember all of what was said that day, but a familiar phrase punctuated the address, "Be good or be gone. Do it my way or hit the highway." That's what was said, but it sounded more like, "Be gawd or be gaun. Do it my weigh or hit the high weigh." At that time, the students of Souers were mainly white, middle-class and insulated. You could see by the look on their faces that they had never had someone talk to them in such direct terms. As I looked around the room, only Argie and Angela seemed unaffected by the remarks. This was the same type of phrase we heard around the house all the time, a bit of a threat with a touch of a poetic flair. The white students were terrified.

Pushing my English teacher to her limits yet again, I was sent to Mr. Jackson's office to be disciplined. The choice was to take a paddling or be suspended for three days. I knew there was no way I was going to take that swat and I knew I could fake going to school for three days and Mom would never know the difference. Mr. Jackson knew this also and said that he was not going to suspend me and send me home. He was going to take me home to talk to my mother directly. I knew there was no way to avoid a beating when Mom had to face an assistant principal standing on her doorstep.

As we rode along in his new yellow Cadillac, I told Mr. Jackson that I would flatten his tires when I returned to school. He reached into his jacket pocket and brought out his wallet. Mr. Jackson was known to show students his pay stub in order to encourage them to work hard in school so that they could make a good living also. I told him I didn't care how much he made and didn't want to see his pay stub. He said that he was not showing me a stub and he handed me his license to carry a .357 magnum handgun. He said, "If something happens to my car, I'll shoot ya." Suspension served, beating endured, back at school, I sat in the cafeteria when I heard that someone had thrown red paint on Mr. Jackson's yellow Cadillac. I ran to the office to tell him it wasn't me.

From that day until today, I have not made a major life decision without consulting with Mr. Jackson. I talked to him before I married, before I accepted a management position and before I left the company. Without telling me what to do, he helped me clarify the issues in my own mind. Jackson insisted with every discussion that I return to school to get a degree. I thought it just a way to cover achievement, or lack thereof, with a piece of paper. If I could do it, I could do it with or without a degree. In 1995, fifteen years removed from high school, I took advantage of the

company's generosity and attended Malone College's MCMP program. My mom had died and my father had never been in my life, Grandma was sick and unable to attend, so I took solace in the fact that my wife and children would be there to cheer for me when I received my degree. As I came off the stage, the first face I saw in the first row of the public section was Dr. Robert Jackson giving me a "thumbs up." Bitten by the academic bug, I began work on a master's degree at Walsh. In 2000, I completed my studies and again walked across the stage; there again was my assistant principal, Mr. Jackson.

He never took me to a ball game or to the zoo; in fact, we never met outside of the school setting. Occasionally, he would take me out of class to get a checkup on what I was doing. When I attended high school and my girlfriend was at Hartford, he would allow me to stay in the school to see her and just to be around. He was a mentor before mentoring was popular, a Big Brother before the organization was formed. He made a difference to a young boy who had not acknowledged that a difference was needed, and thirty years later it's my pleasure to receive the occasional call from the office.

Owedia English Conn

By Lewistine Conn Moore

Born on January 4, 1924, in Pinehurst, Georgia, to Georgiann and Isom English, Mrs. Conn is a graduate of Fort Valley State College and Tuskegee Institute. She holds bachelor's and master's degrees in education and obtained a certification in special education from Kent State University.

Although Conn is not a native of Canton, Ohio, it didn't matter to her, she still wanted to keep up the traditions of trying to reach out and help someone other than her relatives and special friends. Conn was the first black teacher at Burns Elementary School. She became the first lifetime member of the Canton Black United Fund after initiating the membership program and the first black life member of the Canton Chapter of the NAACP and was inducted into its Wall of Fame. She is a member of the Zeta Phi Beta Sorority and was a member of the Black Women Federated Club, Canton Professional Educators Association, National Educational Association and Ohio Educational Association, until her accident in 1982. Conn is also a life member of Ohio Teacher's Retirement Association and National Teacher's Association.

She was a regular contributor to United Way, Canton Scholarship Foundation, Boys Club, GlenOak Eagles Booster Club and other agencies. Conn was a member of St. Mark Baptist Church, where she held positions of finance secretary, deaconess, trustee board, mother board, Sunday school teacher, chairperson of different projects. She was a member of Deliverance Christian Church at her death. Conn believed the proverb "Charity begins at home, but should not end there." Conn, who came to Canton forty-five years ago from Georgia, has one daughter, Lewistine Moore; two granddaughters, Dr. Jamesetta Lewis and Louidajean Payton; two great-grandsons, Jerrit and Jivon Payton; and one great-granddaughter, Lianna Jordan Payton.

Nadine McIlwain

By Fredricka Early Stewart

As a child, I grew up in a life of confusion. My dad, who showered me with love, was killed when I was six. My mom, who loved me as well, went to prison for a murder when I was eight. By the time I started high school, I was a troubled child staying in trouble.

Despite all the chaos in my life, one teacher was able to see beyond my faults and certain destruction. She saw through to my strengths and weaknesses and found nothing but the best in my character. She gave me the lead part in Timken High School's Black History Month play called *Martin and Angela*. I played the part of Angela Davis. Playing that part caused me to use skills I didn't even know existed within me. The play was a hit, and she became the person God used to make me realize that no matter how many discouragements I've experienced and how many wrong choices I've made in life, I am somebody special!

Years later, after being kicked out of Canton City Schools my sophomore year for shooting another student, I stayed with my second hero, Big Momma, my father's mother. She showed me the love of Jesus in Mississippi for three years. When I returned to Canton, however, I went back into alcohol, drugs and violence until 1991, when I fell in love with Jesus and went to prison, a servant of the Lord.

Finally finished with the life of crime, drugs and violence, I became active in the community through my church and completed a 180-degree turn in my life. God placed my teacher back into my life, and in spite of

my wayward path, she continued to see with eyes that found the best in me. Nadine McIlwain, from childhood to adulthood, is an instrument God has used to sharpen my skills to be a productive citizen and an asset to our community.

Paralee Watkins Compton

By Erma Smith

I began my teaching career in the mid-sixties. After teaching six years, I decided to stay home and be a room mother for my first grader and to care for my ailing mother. I did substitute teaching while filling these roles. I was often called to Martin Elementary School on Third Street Southeast to substitute. When a position opened in a third grade classroom, I was overjoyed!

Martin Elementary School was a small, inner-city school with a staff committed to following an enthusiastic, innovative, child-centered leader. Every day was a day filled with anticipation and the realization that your input was going to be considered. There was no separation of the arts from the other areas of the curriculum. Teamwork was the mode of the day. There was an Open Door policy in the principal's office. Every child was welcome to enter. Ongoing staff development was expected and welcomed. Parents were present and appreciated.

Mrs. Paralee Watkins Compton, principal of Martin Elementary School, started as a secretary in the district and, while raising a family, completed her college degree. Among her many accomplishments with the school system were serving as the director of human relations, the director of elementary education, assistant to the superintendent and, finally, as assistant superintendent. As an African American female, on the cuff of the civil rights struggles and the women's movement, she provided inspiration, leadership and the opportunity to fully participate in the process of educating children. Her inclusive attitude has stayed with me. It does "take a village to raise a child."

At a time when African American female role models were in short supply in the Canton City School District, Mrs. Compton was my role model. She had a vision and she included you in that vision, as well as the children and parents. She was enthusiastic, and her enthusiasm was contagious. "Can't" was not in her vocabulary. Possibilities were.

Marie Jefferson Slaughter

By Stark County Alumnae Chapter
Delta Sigma Theta Sorority Inc.

Marie Jefferson Slaughter was born on November 20, 1910, in Staunton, Virginia, the daughter of Mary Emma Murray and Thomas Jefferson. She had one brother, Thomas Jefferson Jr. She graduated from West Virginia State College in 1932. While in college, she was initiated into the Delta Sigma Theta Sorority Inc. Among her sorority sisters were Mrs. Betty Dantzler, Mrs. Charlotte Lancaster, Mrs. Leo Johnson, Mrs. Edna Christian. In 1992, she was recipient of the sorority's National Great Teacher Award. She was a founding member of both the Akron and Stark County Alumni Chapters of the sorority. The Stark County Alumnae Chapter has dedicated a scholarship in her honor that is given annually to a deserving woman seeking to further her education.

In 1950, she came to Canton, Ohio, to visit her aunt Effie Lawson. Canton provided her with a husband and a job. She met and married Ludlow L. Slaughter, and they remained a devoted couple until his death. He was an active member of St. Paul A.M.E. Church. She became a member of the church and attended faithfully as long as she was physically able. She was a trustee and later trustee emeritus. In 1981, she paid to have the pipe organ moved from the previous church location on Thirteenth Street Southeast to the current location at East Tuscarawas Street. The church library has been named in her honor.

Education in itself is a treasure, but the educators named here are true treasures.

10

THE ATHLETES

Early Canton spawned a number of outstanding athletes; among them were Marion Motley, Ed "Peel" Coleman and Jim "Spike" Inman. Before McKinley athletes had the opportunity to play in college or the NFL or NBA, there were football and basketball standouts. Jim Inman is an example. Before graduating in 1941, Inman was a varsity member of both the football and basketball teams, but basketball was his game. Playing along with Ed "Peel" Coleman, the 1939–40 Bulldogs won twenty-two consecutive games before losing to New Philadelphia in the state finals. Inman played for a semipro team and enjoyed some time with the Harlem Globetrotters, but the need to take care of his mother kept him in Canton, employed at the Republic Steel Corporation for forty-two years. Many will remember the restaurant he owned and operated on Cherry Avenue Southeast known as SPIKE'S, although the official name of the restaurant was Spice of Life.

In 1947, the Canton Cushites, an all-black basketball team that featured Cleveland Browns star and future Football Hall of Fame member Marion Motley and Cleveland Indians star and future Baseball Hall of Fame member Larry Doby, almost signed basketball star Jackie Robinson. Reverend J.W. Inman was a key force with the Canton Cushites. Jim "Spike" Inman and Cleo Inman played for the Cushites. In 1945, Cleo was honorable mention all Ohio. The Cushites played against the Harlem Globetrotters. Spike had an offer to play with Globetrotters and played with them for a short period of time.

Marion Motley was one of the earliest African Americans to play professional football. Four players, including Motley, integrated the National Football League. With Bill Willis and two others, Motley signed to play with the Cleveland Browns in 1946, one year before Jackie Robinson signed with baseball's Brooklyn Dodgers. Although not born in Canton, Motley played high school football for the McKinley Bulldogs. After going to South Carolina State College and the University of Nevada at Reno, Motley entered the service and played for Coach Paul Brown with the Great Lakes Naval Training Station team that beat Notre Dame 39–7 in 1945.

Motley rejoined Brown with the Cleveland Browns of the newly formed All-America Football Conference in 1946, becoming a cornerstone in the Browns' powerful offense. Motley was also an excellent linebacker during his first two seasons. The Browns joined the NFL in 1950, and Motley led the league with 810 yards on 140 carries. Knee injuries limited his playing time during the next three years. After missing the entire 1954 season, he returned in 1955 with the Pittsburgh Steelers, who used him mostly at linebacker. Motley retired after carrying the ball just twice that season. He played for nine professional seasons and was inducted into the Pro Football Hall of Fame in 1968. Motley's bruising running style and exceptional blocking ability marked him as one of the sport's greatest players.

RONNIE HARRIS

Ronnie W. "Mazel" Harris was born in Canton. He is a former American boxer and won a gold medal in the lightweight division at the 1968 Summer Olympics after a unanimous decision over the defending champ. Harris was twenty years old when he won the medal. This was the same Olympic competition in which U.S. sprinters John Carlos and Tommie Smith stood barefoot, stared at the ground and thrust black-gloved fists into the air during the national anthem after winning bronze and gold in the two hundred meters.

Harris had an outstanding amateur career, winning the 1966, 1967 and 1968 National AAU Lightweight championship. He turned pro in 1971 and was undefeated until 1978. In 1978, he took on WBC and WBA middleweight title holder Hugo Pastor Corro but lost a decision. He retired in 1982. Ronnie Harris is one of only three Cantonians to win a gold medal at the Olympic Games and the first African American from Canton.

Harris began boxing when he was ten years old. It wasn't his sport of choice. He went out for baseball, football and basketball. But he was too light for the gridiron, too short for hoops. In the dugout, there always seems to be another catcher whose dad was also the coach. His career started in the basement of his parents' Canton home on Penn Place Northeast. His father, Willie, was his first trainer.

Some Cantonians will remember Harris's return to Canton after his victory at the Olympics. As the guest of Vice President Hubert H. Humphrey, he was greeted at the airport. Later, the two took the stage at Malone College; Harris, in his red Olympic blazer, received a five-minute standing ovation. Applause for the vice president lasted thirty seconds according to news reports. In 1971, Harris turned pro and boxed as a middleweight before retiring in the early 1980s, having won more than thirty fights but never a professional championship.

Nick Weatherspoon

Nick "Spoon" Weatherspoon was a basketball big shot for the McKinley Bulldogs and the Fighting Illini. He spent nine seasons in the NBA scoring records at McKinley High and the University of Illinois. He was an All-American at Illinois and still holds Illini records for the highest career scoring and rebounding averages. When Weatherspoon died on October 17, 2008, after an illness that had plagued him since he was in his thirties, he left behind a basketball legacy that took thirty-seven years to break as the leading scorer in McKinley High history. Only fifty-eight when he died, Weatherspoon was on the Washington Bullets team that played in the 1975 NBA finals. Prior to his death, Weatherspoon operated the Weatherspoon Insurance Agency for twenty-five years.

Raymar Morgan

Raymar Morgan was a six-foot-seven forward for the McKinley High Bulldogs. Morgan led his team to state titles in 2005 and 2006. Morgan was named a *Parade Magazine* All-American and the *Repository*'s Stark County Boys Basketball Player of the Decade. He finished high school as McKinley's

career scoring leader, breaking Nick Weatherspoon's thirty-seven-year-old record. Morgan went on to be four-year starter at Michigan State, playing in two Final Fours.

CLEVE BRYANT

Cleve Bryant is the associate athletics director of football operations at the University of Texas. A native of Canton, Bryant was a star quarterback at Ohio University. He earned All-Mid-American Conference honors in 1967 and MAC Player of the Year accolades in 1968 while leading the Bobcats to back-to-back league titles. He was selected by the Denver Broncos in the 1969 NFL draft. After college, he embarked on a brief career as a financial consultant but returned to athletics in the mid-1970s, coaching cross country, basketball and track and field at Glenoak High School (Canton, Ohio) in 1976.

KENNY PETERSON

James Kenneth Peterson was born on November 21, 1978, in Canton. He is an American football defensive end for the Denver Broncos. He was originally drafted by the Green Bay Packers in the third round of the 2003 NFL Draft. He played college football at Ohio State.

Peterson played high school football at McKinley High. While there, he helped his team win the Ohio Division I title in 1997. During his senior year, he was honored as an All-American after posting 101 tackles and 15 sacks. Peterson also was a star basketball player, achieving all-city selection as a senior. In 2018, Peterson opened a franchise bakery, Nothing Bundt Cake, in Canton.

PHIL HUBBARD

Philip "Phil" Gregory Hubbard was born on December 13, 1956, in Canton. Hubbard, a McKinley High graduate, led the team to its second straight appearance in Columbus while earning Class AAA of the Year honors in

1975. Hubbard was an All-American at Michigan and a standout on the gold-medal Olympic and World Games teams. He played for the Detroit Pistons and Cleveland Cavaliers from 1979 to 1989 and now serves as an assistant coach of the Washington Wizards.

PERCY AND ERIC SNOW

Born on April 24, 1973, in Canton, Eric Snow began his basketball career at McKinley High, where he was MVP for three straight seasons. Snow played alongside classmate and future NBA player Michael Hawkins. A member of the National Honor Society, Snow continued his playing career at Michigan State University, where he earned Big 10 Defensive Player of the Year and All-Big Ten honors, graduating in 1995. Most recently, Snow pledged $1 million to the YMCA to build the Eric Snow YMCA in downtown Canton.

In 2013, Percy Snow joined Alan Page as an inductee into the College Football Hall of Fame. The two are the only African Americans from Stark County to attain this distinction. Percy graduated from McKinley High and played for Michigan State. Snow was the first player to win the Butkus Award as the nation's top linebacker and the Lombardi Trophy as the top linemen or linebacker as a senior with Michigan State in 1989. He also won Rose Bowl MVP honors as a sophomore. Percy played in the NFL for four seasons with Kansas City and Chicago.

ERRICK AND C.J. McCOLLUM

Errick McCollum attended GlenOak High School, in Canton, Ohio, from 2002 to 2006, where he played with current NBA center and former Ohio State Buckeye Kosta Koufos. In 2006, McCollum was joined on the team's varsity squad by his younger brother, then a freshman, C.J. McCollum. McCollum has also competed with Overseas Elite in the Basketball Tournament. He was a point guard on the 2015, 2016, 2017 and 2018 teams that all won the championship game of the winner-take-all tournament. In 2017, McCollum averaged 13.7 PPG during the tournament.

McCollum played six games. He averaged 13.2 PPG, 2.8 assists per game and 2.7 rebounds per game. Overseas Elite reached the championship game and

played Eberlein Drive, winning 70–58 for their fourth consecutive TBT Title. McCollum was then named a member of TBT's 2018 All-Tournament Team. McCollum's younger brother, C.J. McCollum, is a professional basketball player for the Portland Trail Blazers of the NBA. During his third year in the league, Christian James "C.J." McCollum (born September 19, 1991) was named the NBA Most Improved Player.

AMERYST ALSTON

Ameryst Alston is a graduate of McKinley High and The Ohio State University. Alston was Stark County's career scoring leader at McKinley High School and was a two-time Ohio Ms. Basketball. Ameryst Alston became the sixth player in Ohio State women's basketball history to top two thousand points in her career. She has signed a contract to play for the WNBA.

KIERSTAN BELL

Canton McKinley High School junior Kierstan Bell was named Ohio Ms. Basketball by a statewide media panel. Bell became the fifth three-time winner in Ohio history in 2018. Six-foot-one, Bell averaged 33.3 points, 9.6 rebounds, 5.0 steals, 3.9 assists and 2.5 blocks per game while shooting 52.7 percent from the floor for the Pups (23-2). She set McKinley records for points in a game (53), season (833) and career (2,104). Kierstan has signed a letter to attend The Ohio State University.

GARY GRANT

The Gary Grant Award is given annually at the McKinley High School Football banquet. The award goes to the player selected as the team's best defensive player. Grant left McKinley to pursue successful careers at the University of Michigan and in the NBA. Grant led McKinley to its first state championship in 1984.

MIKE DOSS

Mike Doss led McKinley to back-to-back state titles before going on to The Ohio State University, where he became a three-time All-American. First drafted by the Indianapolis Colts in the second round of the 2003 draft, the five-foot-ten, 207-pound Doss was a member of the Colts when they won Super Bowl XLI in 2007, even though he did not play in the game due to injuries. He played for the Vikings in 2007 and the Cincinnati Bengals in 2008. He was the recipient of the Distinguished Service Award from the Canton Jaycees in 2010.

TIANA JONES

Tiana Jones is in the beginning of her career as a professional golfer. A native of Alliance, Ohio, Jones attended St. Thomas Aquinas, Marlington and Alliance High Schools. At Alliance, Jones practiced with the boys' golf team, since Alliance did not have a girls' team. As a young golfer, Jones played with the First Tee of Canton and won many amateur titles. In her senior year, Jones captured a state title by one stroke.

HENRY ARMSTEAD

Armstead served for many years as an official at local and state athletic competitions. His excellence as an official was celebrated with his induction into the Ohio High School Athletic Association Officials Hall of Fame in 2018.

JOHN RAMOS SR.

Athletes, no matter how good they are, are nothing without fans and supporters. A major supporter of Canton McKinley boys' and girls' sports teams was John Ramos Sr. He was a season ticket holder for over twenty years in both basketball and football. Ramos died in September 2005. In honor of his character, community service and dedication to McKinley sports, an annual award is given to a McKinley player in Ramos's honor.

SHAKEER ABDULLAH

Shakeer Abdullah is a former McKinley linebacker who achieved success on the football field and in the classroom. Abdullah graduated from McKinley High in 1995 and went on to earn degrees from Wittenberg University and The Ohio State University and a doctorate in administration with higher education from Auburn. In addition to being the director of Auburn University's Multicultural Center, Abdullah is an adjunct professor of higher education at Columbus State University in Columbus, Georgia.

SILAS CARTER

Carter was the first undefeated state placer for McKinley High. He went 8-0 in the first year of Bulldogs wrestling, 1958. Carter finished fourth in Ohio at 112 pounds in 1959. He finished 24-2 in his high school career. Carter was a Golden Gloves boxing champion. He was inducted into the Canton Negro OldTimers Athletic Association in May 2003 and the Stark County High School Wrestling Hall of Fame in 2009.

WAYNE FONTES

Fontes grew up in Canton and played football at McKinley High. He attended Michigan State University and graduated in 1962. Taken in the ninth round of the 1961 NFL Draft by the Philadelphia Eagles, Fontes played one year for the New York Titans of the American Football League. After thirteen seasons as an assistant in the NFL, Fontes took over the Detroit Lions as interim head coach in mid-season of 1988 after head coach Darryl Rogers was fired.

As THE HOME OF the Pro Football Hall of Fame, Canton, Ohio has produced many fine athletes. Only a few of them are included here.

11

THE BUSINESSES

To quote E.T. Heald,

> *A survey of Negro life in Canton, made by the National Urban League organization in the fall of 1952, found six Negro restaurants, seven retail stores (one confectionery, one grocery, one pharmacy, one record shop, one record rack, and two filling stations), one insurance company, and nine service establishment (one hotel, two beauty shops, two barber and beauty shops, one cleaner, one laundry and dry cleaner, one cab company and one automobile repair company).*[21]

This list does not include the night spots, the Main Event, the Pathfinder Skating Rink and Dance Hall or the restaurant operated by Z.A. Hunter for over twenty years on Cherry Street, known all over the country as Mable's Chicken Shack.

W.R. Smallwood was manager of the Flory Chain Store on Thirteenth Street Southeast from 1920 until the business was sold. He later became the first black sheriff's deputy. When he died, his son, Lewis, was named in his place and served for over sixteen years.

To state that the Southeast was a city within a city is not an overstatement. Every service or supply one could ask for could be found within the twelve blocks surrounding Cherry Avenue Southeast.

Among the earliest entrepreneurs in the African American community were the barbershop and beauty shop owners and operators. Ohio requires

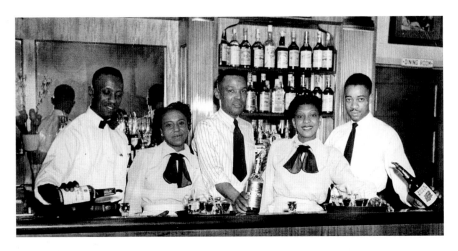

Believed to be the Main Event Nightclub. *Courtesy of Ella Green.*

licenses for beauticians to practice their profession even though most early beauticians operated shops within their homes. Shop owners were involved in their communities and churches by participating in local fundraisers and hosting talent and style shows. Beauticians like Elizabeth Carmichael, Betty Archer, Katy Larkins, Wilma Lipkins, Florene Tindell, Sharon Johnson Irene Paige, Vivian Pender, Rosemary Powell, Ruby Adams, Gloria Dave, Selma Boyd, Shirley Boyd, Cheryl Lee, Mable "Tootie" Gordon, Nancy Card, Mabel Butler, Carrie Fields, Lois (Evergreen) Williams, Chris Smith, Dee Mack, Ethel Fisher Goshay, Helen Hampton, Jamie Kindell, Caralisa Walker, London Williams, Diane Washington, Hazel Campbell, Bobbie Thompson, Madea Jenkins, Mary Claybourne, Lisa Allen and Simone Kirshinde are all licensed hair stylists. Most have operated their own business and joined the local professional stylist association. Many volunteer their time at local nursing homes, rehab facilities and funeral homes.

Unlike the beauticians, few barbers located their shops in the home. Early barbers of the city were Carl Adams, Roland Johnson, Ben Thompson and, later, Amelia Adams, who worked at Modernistic Barbershop located at 1957 Third Street Northeast. Oliver Bush, Michael Bush and Vernon Johnson are barbers at Priority Barber Shop located on Cherry Street North. Wilber Faulkner, another early barber, worked with Booker Reid Richard McIntyre, Preston Young, John and James Perry, George Lewis, Reverend Williams and Mike Jones at Esquire Barbershop on East Tuscarawas before opening his own shop at 1821 East Tuscarawas Street. James Ladson, Mike and Rob Lewis and Adrian Culler are shop owners who are still operating in the city.

THE POWELL FAMILY BUSINESSES

The Powell Grocery Store on the corner of Lafayette and Eighth Street Southeast was owned by Henry Powell Sr., the father of former Canton City Board of Education member Virginia Powell Jeffries, and his brother Rayfield Powell.

Virginia Jeffries recalls visiting her father's store. She described her father and his brothers as early entrepreneurs. Mose Powell owned the Douglas Club on Cherry, a social club and bar where many went to drink and dance

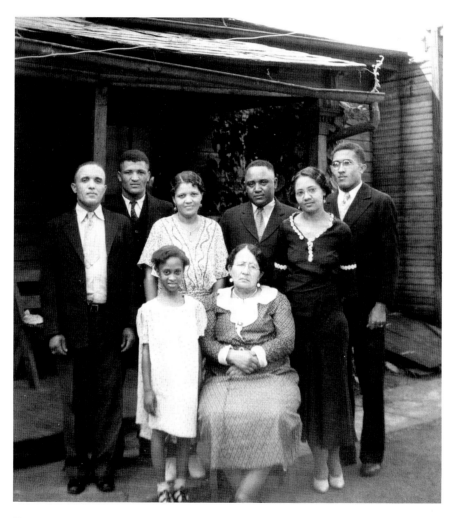

The Virginia Powell family.

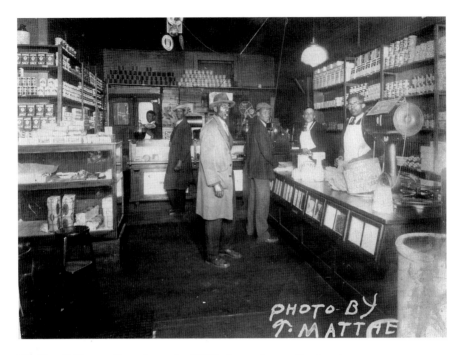

The Powell Grocery Store, located at 800 Lafayette Avenue Southeast.

on the weekends. The Douglas Club was on the second floor, but this did not stop the many regulars who patronized the club.

The restaurant, club and the shoeshine shop were all housed in the same building. Rayfield Powell owned a restaurant on the first floor beneath the Douglas Club. Timothy Powell owned the shoeshine shop adjacent to the Douglas Club and the restaurant. Henry Powell later owned and operated the Vahepa Hotel in Massillon. The hotel was named after his three children, Virginia, Henry and Patricia. It may have been this entrepreneurial spirit that led to the closing of the store. As the other businesses grew, interest in keeping the store may have waned, according to Henry's daughter, Virginia.

WILLIE PAUL MILAN, FASHION DESIGNER

Willie Paul Milan was born in Canton on October 6, 1928, and left this world on September 1, 2008, a much better place than he found it. Paul, as he was affectionately known, claims to have lived in only three residences his entire

Colleen Curtis Smith (*left*), Willie
Paul Milan and Marian Crenshaw.

life: 1928 Rex Avenue Southeast, 1111 Cherry Avenue Southeast and 2516
Tuscarawas Street. He was the son of Elise (Sullivan) and Bonner Milan
Sr. and the stepson of Eli Sullivan. Paul was a 1947 graduate of McKinley
High. Paul joined Antioch Baptist Church when he was nine. He was one of
the original founders of the Ohio Republican Council (ORC). That was an
easy decision Paul told this writer, "Because my parents and a lot of other
parents were Republicans and we just followed in their footsteps."

Paul said that his interest in fashion design began when he was student
at Market Elementary School. He watched how his teachers dressed and
began sketching designs in his notebook. However, his teachers at McKinley
encouraged his singing, not his designs. He attended the Art Institute of
Pittsburgh for two years and got an associate's degree in fashion design. He
attained a bachelor's degree in fashion and millinery design from the Art
Institute of Chicago.

His mother, Elise; maternal aunt Alberta McDonald Chenault; and
friends Agnes Wyatt and Irene Page began to sew his designs. Rosie Johnson
encouraged him, saying that he "had the flair" for designing. Paul enjoyed
both the sketching and the sewing.

In 1957, Paul débuted the first of what would become an annual social
affair for everybody. At the annual beautician style show, held at the Elks
Club on Walnut Street, Paul placed two hats and one outfit. Those who
viewed his designs encouraged him to "do your own show."

The WILLIE PAUL MILAN annual style show was something to behold. With
Milan's designs, often sewn by the models themselves, the runway exploded
in flair, fashion and color. Colleen Carmichael Curtis Smith was one of
Paul's regular models. Others were Geri Sommerville, Gloria Tuck, Gerri
Madison, Willadean Madison, Barbara Massey Holston, Mary Hailey and
Carolyn Williams Terry, who started with Paul when she was only sixteen

Carolyn Williams Terry.

Colleen Curtis Smith.

years old. Paul encouraged many other aspiring fashion designers, such as Kavetta Mathis Freese and Curtis Strickland.

Three things happened that changed the style show forever. First, Taylor Matthews began taking photos of all of the models, and many of those photos are preserved. The second involved Paul's commentator, Liz Powers from Chicago. Because of a snowstorm, Powers was unable to come to Canton. Paul asked his first cousin, Janet Chenault Williams, to commentate. Janet was only sixteen at the time, but she and her sisters had watched Powers and often practiced imitating her voice and style. Janet rose to the occasion, and Janet's commentary and Paul's style show became synonymous. The final change was the introduction of men into the style show. "The men got jealous and wanted to model, so I let them," Paul said.

"I remember the first style show like it was yesterday," Paul said from his bed in the McKinley Health Care Center, "it was held at the CIO Hall and there were so many people there. So many people came."

Willie Paul Milan's funeral services were held on Monday, September 8, 2008, at Antioch Baptist Church, where he was a lifelong member.

Mr. G's

Who will ever forget the chicken wings, barbecue ribs and fried catfish sandwiches from the kitchen of Mr. G, George K. Smith? Although he was only fifty-three when he died, he owned and operated a successful restaurant business for over twenty-three years. Located on the corner of Hartford Avenue Southeast and East Tusc, Mr. G's was more than a restaurant. It was a social gathering place where residents young and old congregated on the deck to play chess, a game Smith loved and taught many children how to play. He also sponsored many softball teams and charitable events and was named a friend of the library by the Stark County Library DeHoff Memorial Branch.

According to his obituary, the idea of naming Dr. Martin Luther King Jr. Memorial Corridor of Canton originated with Smith. Our community lost Smith on November 1, 2010. But his legacy continues on in the memory of his family, church and friends.

New businesses, such as Joe's Chicken, located in the former Mr. G's building, and new entrepreneurs are building their place in the African American history of Canton. Unlike Smith, the Bobbitts were not native-born Cantonians, but the entrepreneurial spirit drew them to Canton and the establishment of their restaurants.

Terr-Paul, McDonald's Franchisee

Robert and Hortense Bobbitt were owners of multiple McDonald's restaurants in the area before retiring. Robert Bobbitt, president and owner of McDonald's franchisee Terr-Paul, went into the restaurant business after more than twenty years with PepsiCo and Coca-Cola. He had a bachelor's degree from Texas Southern University and a master's degree in business administration from Central Michigan University. The Bobbitts built their first McDonald's restaurant on Portage Road Northwest and I-77. This store was built from the ground up by the Bobbitts and was the first of five franchises they would eventually own. Hortense Bobbitt is a licensed dietitian with a bachelor's degree from Texas Southern University and a master's degree in healthcare management from the University of Michigan.

Unfortunately, our community lost Bob on September 29, 2008. Hortense and Bob would have celebrated their fiftieth wedding anniversary in 2009.

SMITH HEALTHCARE CENTER

Smith Healthcare Center, formerly known as Smith Nursing Home, was founded in 1961. Astoundingly enough, it became the first and only black-owned nursing home in Canton, although the Jean Carol Nursing Home, located on East Tuscarawas Street, accepted African Americans. Unfortunately, Smith Healthcare Center was forced to close in June 2008 after losing federal funding.

Smith Healthcare Center was founded by Eugene and Olar Smith because they felt that healthcare needs for African Americans were not being met. To Olar Smith's knowledge at that time, African Americans were not admitted to nursing homes; they all had to go to the county home in Nimishillen Township. Smith, who was a licensed practical nurse for a white-owned nursing home, felt she knew enough about the business to start her own home.

After receiving a license from state examiners and securing a mortgage, they purchased a ten-room house at 717 Carnahan Avenue Northeast. The nursing home was opened with five residents but without employees. They did not have enough money to hire employees, so they spent many nights taking turns sleeping on the floor to be available for nightly care. Smith worked her other nursing home job for a short period while getting her operation underway, while her husband maintained his employment at the Timken Company, from which he later retired with thirty-four years of service. He remembered many times taking his whole check to pay off expenses at the home. In 2002, Smith Healthcare Center changed its name from Smith Nursing Home to Smith Healthcare Center for Nursing and Rehabilitation to eliminate the words *nursing home*.

DEION CASH CENTER FOR CHANGE

The Deion Cash Center for Change is named for the organization's former executive director, Deion Cash, who died in 2007. Cash also served as board president of the Stark Area Regional Transit Authority from 2001 to 2005. Chandra Bryant, Cash's daughter, said her mother bought the Tuscarawas Street East property and turned it over to the organization to be used as office space. The facility has added seventy-four beds available to men transitioning from prison back into the community. Formerly, the original property housed the Jean Carroll Nursing Home.

CLEARVIEW GOLF CLUB

Perhaps the most widely known entrepreneurs are William and Marcella Powell, whose story is told throughout the United States and the world. Both within and outside of the professional and amateur golf world, Clearview Golf Course is considered a unique historical achievement created by a visionary, committed African American man and his family.

The Clearview Golf Club located in East Canton is the first/only golf course in the world designed, owned and operated by an African American. Powell bought the land, designed the course, planted the fairways/greens and opened the course in 1946.

The course still operates in fine fashion today, with some of the best-maintained greens in the nation. His daughter Renee, one of only three African American LPGA professionals, is the course PGA pro, and his son, Larry, is the overall course superintendent. This course has remained a family owned and operated business.

Clearview Golf Course celebrated its sixtieth anniversary with various events throughout 2006. Clearview was placed in the National Register of Historic Places by the Department of the Interior in 2001 and was honored with a special marker by the Ohio Historical Society.

THE FUNERAL HOMES

The first black funeral director was W.S. Baker, who came to Canton around 1925 and established a funeral home on South Market Avenue. More memorable as a funeral director was Douglas A. Matthews, the second black funeral director. He established Matthews Funeral Home in 1932. Eventually, the home was moved to 1521 East Tuscarawas Street. Many remember Gladys Matthews, his widow, who continued operating after her husband's death. Matthews was the forerunner of the Jones Funeral Home, formerly located on East Tuscarawas Street. Other funeral directors, who were also licensed embalmers, were George Webster, who began in 1938, and Robert March, who established the March Funeral Home in 1945.

Cuff Brogdon established Brogdon (later Brogdon and Son) Funeral Home. The original home at 442 Thirteenth Street Southeast was relocated as a result of urban renewal, and a new home was built at Third

Street Northeast. This business was recently purchased by Sommerville Funeral Services, owned and operated by Marco Sommerville and family. The sale did not produce a viable business, and it virtually never opened. Unfortunately, our community lost another beloved pioneer upon the passing Ruby D. Brogdon. Ruby Doris Gee Brogdon, seventy-nine, died on May 11, 2013, at her home. She was born on December 11, 1933, in Carthage, Mississippi, the daughter of Booker T. and Mary Emma Battle Gee. Ruby worked at Brogdon and Son Funeral Home supporting her husband and son.

Another of the funeral homes to locate in Canton is the Rhoden Funeral Home, located on Cherry Avenue Northeast. The family owns and operates three funeral homes. The Canton home is located at 729 Cherry Avenue Northeast. Rhoden has been at that address for over twenty years. Other locations include homes in Akron and Youngstown.

BLACK BUSINESSES CONTINUE TO grow and establish a presence in Canton. Examples of new businesses include the following:

The Lenzy Family Institute has been owned and operated by Elizabeth Lenzy since 2005. The behavioral health provider provides treatment, prevention, recovery and support services serving children, adolescents, adults and senior citizens. Plans are to open the HART Center, a thirty-two-bed residential rehabilitation and detoxification facility in the former Smith Healthcare Center.

Founded by Kenneth Hill, a graduate of Timken High School and the College of Wooster, Integrity Accounting Service has provided a wide range of accounting services for the past twenty years. Hill began his apprenticeship under his mother and performed contractual work with the late Robert Fisher.

Marques Restaurant was located at 111 Cleveland Avenue Southwest and specialized in southern and Cajun food. Owned and operated by Marcus Harris, the restaurant was in business for three years. Marques's business philosophy was to deliver food and catering services with the highest possible quality and to always operate with integrity. Unfortunately, this business closed its doors in 2018

Along with Marques, several other food establishments have recently opened. Cork & Canvas on Third (CCO3) is also located downtown. Owned by Lisa Sims, CCO3 is a wine bar that provides good food and great

entertainment. Todd Brown is the owner of the new Plain Township sports bar and restaurant, Toddy B's. The restaurant has twenty-one television screens and an eclectic menu, making it a favorite destination for many.

Although it is not a new business, City Flooring and Design Center, owned and operated by Leonard and Brenda Stevens for over twenty-one years, deserves mention. Located in downtown Canton, the center provides all types of flooring and other home design assistance.

More information about African American businesses can be obtained from the Stark County Minority Business Association.

Canton Treasures

The Johnson Hotel

By Don Johnson

The John Earl Hotel became the Johnson Hotel in 1949. Located on Second Street Southeast, it was the only black hotel in Canton. Owned by my grandfather, Parker Johnson and my dad, Raymond Johnson, the hotel got all the black business, including entertainers, military boys going to war, railroad workers and some leftovers from the white hotels. Blacks were not welcome or permitted to stay in the white hotels, only to work there. Entertainers from the State Burlesque Theatre and musicians appearing at the Baby Grand and other popular night spots all stayed at the Johnson Hotel.

Johnson Hotel had three levels. On the second floor, or the upper level, there were twelve to fourteen rooms and the same on the third floor. Visitors could obtain a night's stay for around four or five dollars per room. I don't remember if the rooms had bathrooms or not. But the lower level had a ballroom on the main floor with a kitchen.

My father remembered the time the hotel was robbed. It was night, and three robbers entered the hotel; one of them had a gun and held it on my dad. The robbery made headlines in the *Canton Repository*. The story on the street was that the three men suspected someone in the hotel had drugs and therefore drug money. The Johnson Hotel went out of business in 1955 because the white hotels started accepting black patrons…another death by integration.

Jones Funeral Service

By Mabel Christine Jones

In January 1991, an agreement was reached with Gladys T. Matthews to occupy her former funeral home facility on East Tuscarawas Street. It took two months of hard work and prayers, and on April 27, 1991, we had our open house.

In honor of Mrs. Matthews, I was given the privilege of renaming the funeral home as the Matthews-Jones Memorial Funeral Home for one year. In 1992, the name was changed to Jones Memorial Funeral Home. In 1999, there was a fire that all but destroyed the structure. In 2000, we changed our name to Jones Funeral Service and moved into the Simchak Funeral Home at 2257 Mahoning Road Northeast, with intentions of purchasing that facility.

The owner-director is Mabel C. (Torrence) Jones, a licensed embalmer and a funeral director in Ohio, West Virginia (1994) and Pennsylvania. Jones is a lifetime resident of Canton, a graduate of the former Timken Vocational High School, Kent State University and Pittsburgh Institute of Mortuary Science. She has been married to Andrew Jones since August 1967. She is the only African American female funeral home director in the city. The funeral home is now at 4626 Cleveland Avenue Northwest.

My Life History with My Fairs

By Helen McKinley Potillo

I would like to give you some history of how I started my business. In 1961, we started making fudge in my kitchen and graduated to the basement of my home on Housel Street, in Canton, Ohio. My first two fairs in the area were in Dover and Ashland County. I thought at the time they were great fairs, but lo and behold I had no ideal of what was to come. Today, my sons and I have thirty-six fairs a year. I remember writing letters and spending a lot of time in telephone conversations with fair promoters trying to acquire a vender slot for selling my fudge. You can imagine how difficult it was for African American women to have their own businesses in 1961 during the civil rights era.

There are a few people that I would like to recognize for their encouragement and support. In Illinois, there was Don Miller, Don Bart

and Keith. Here in Canton, there was Cuff Brogdon, Judge Clay Hunter, Otis Efford and C.A. Lightbourn.

I was the first African American woman to tour the fair circuit. I became a successful female entrepreneur and have sold my fudge in almost every state in the United States. For more than forty-eight years, the fudge is still in demand and I continue to make and sell it while continuing to make more friends each year.

After leaving Canton, Ohio, for twelve years, I was united in marriage to Sam Potillo of Hellertown, Pennsylvania. There, I was affiliated with St. Paul Baptist Church. I was on the boards of the YWCA, Historical Society, Women Club and vice president of Church Women United.

Upon my return to Canton, I reunited with my home church, Mt. Calvary Second Missionary Baptist Church under the auspices of the late Reverend Lightbourn. I resumed my love for volunteering in my community. Catherine Claybourne and I were the first to serve as the Southeast United Way Campaign volunteers. I organized the now Holiday Parade of Homes, which benefit the Greater Canton Martin Luther King Jr. Scholarship.

George Lemon Jr.

By Gerry Radcliffe

George has three sons, Rodney, Michael and Shawn (all pastors), and one daughter, Nicole. George's wife, Kaleen, is also actively involved in the Canton community.

George was born in New Smyrna Beach, Florida. At the age of three, his parents relocated to Massillon in search of a better life. He graduated from Massillon Washington High School. George was one of Stark State College's earliest graduates; he received his degree in electrical engineering technology. For graduate studies, George attended Malone University.

George was employed for twenty-five years by AMETEK, as manager of the commercial marketing group, director of quality assurance and vice president of sales. In 1991, George, Gerry and Dale Radcliffe (sister and brother-in-law) and sister Sarrah Johnson were owner-operators of the Dele Center Inc., located on Sherrick Road Southeast. The Convenient Store, gas station, restaurant and laundromat provided jobs for twenty-two

George Lemon Jr.

employees. They brokered gas for Head Start, area churches and Stark County Reginal Transit Authority. The business was sold in 1995. In 1997, George founded and served as president of Technical Products Group Inc. He retired in 2007.

George served on United Way's executive board of directors. The United Way of Stark County credits George with the leadership push behind the successful merger of the Massillon and Canton Urban League organizations. In 2003, George was honored by Stark State College as "Alumnus of the Year." In 2009–10, while serving as chairman of the board of directors for Goodwill Industries of Greater Cleveland and East Central Ohio, he was instrumental in helping to develop the $5 million Community Campus at Goodwill in Canton.

In 2010, George received the Ohio Association of Community Colleges Distinguished Alumnus Award. In 2011, George was the first African American chairman of the board of directors of the Canton Regional Chamber of Commerce. He played an influencing role in bringing diversity to the boardroom and the chamber staff. George is the immediate past president of Stark State College Foundation. As of this writing, he is a member of the Aultman Health Foundation and Aultman Orrville Hospital Boards of Directors. George was the general chairman of the Pro Football Hall of Fame Enshrinement Festival (2015–16). George cites Joseph Smith, past executive director of the Canton Urban League, as the most inspiring person in his life. Most recently, George donated his Corvette, valued at over $100,000, to Aultman Hospital to support the new Aultman Cancer Center.

THE SOCIAL CLUBS, ORGANIZATIONS, LODGES, FRATERNITIES AND SORORITIES

*M*any girls and boys have been encouraged and inspired by the generosity of the various social and fraternal organizations in Canton. Two of the oldest that are no longer operating are BBB Club and the Penguins Club.

Many Cantonians remember the BBB formals, the Penguins Club Annual Dinner Dance and, of course, the Jane Hunter Pink Ball. How excited Cantonians were upon receiving that formal invitation. Following the dance, which did not end until 2:00 a.m. guests were treated to breakfast at the home of their hosts. It was an all-night affair, literally.

The Penguins Club was a premier social group consisting of men only. Among other activities, the Penguins sponsored an annual formal dinner dance for their guests. Women and men were always ready to put on their finest and enjoy an evening of camaraderie and dancing.

HIRAM ABIFF LODGE

Canton was the home of an African American Masonic Lodge known as the Hiram Abiff Lodge No. 72 AF&AM. This unit was started in 1950 under William Banks. The first lodge was called Simpson Lodge, but because of the somewhat secretive nature of the Masons, the location of this lodge is not identified.

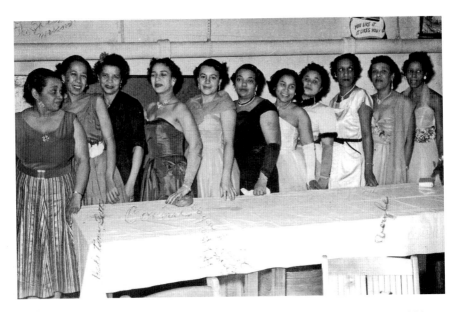

Pictured here are members of Alpha Kappa Omega Club (AKO) social club (*left to right*) Edna Christian, Betty Lewis Pollard, Corinne Dickerson, Agnes Wyatt, Cordelia Royal, Charlotte Lancaster, Elizabeth Dantzler, Myrtle Redmond White, Gaye Faye Hughes, Veryl Johnson and Ethel Harrison.

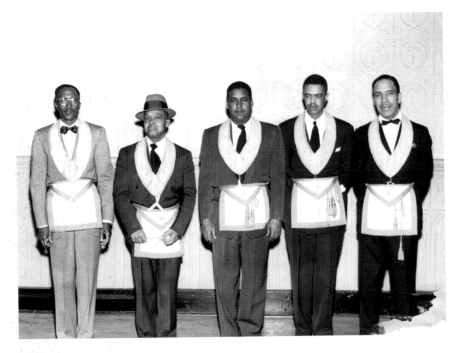

Hiram Abiff Lodge members.

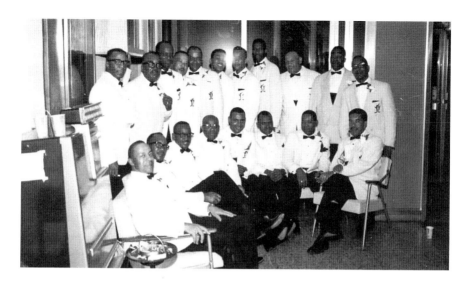

Above: The Penguins Club: Among the men pictured here are Norman Austin (*first row left*) and Jasper Harris (*first row third from left*).

Right: Ready for the ball are (*left to right*) Mabel Williams, Coralee McDonald, Elizabeth Tharp and Cathleen Tharp.

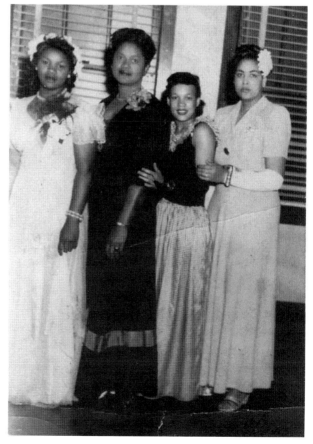

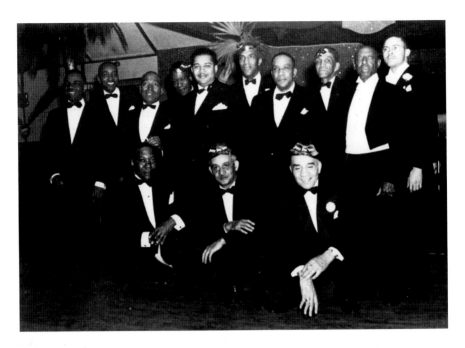

BBB Club.

Not to be left out, the Eastern Stars, sisterhood to the Masons and known as the International Free and Accepted Modern Masons, established a chapter.

THE JANE HUNTER CIVIC CLUB

On October 13, 1942, Catherine Summerville invited a number of civic- and social-minded women to her home to render services to less fortunate families. Summerville was the first president of the Jane Hunter Civic Club, named in honor of Jane Edna Hunter, founder of the national Phillis Wheatley Foundation Association.

The club "adopted" a family of a mother and five children and supplied them with necessary items and clothing, and at Christmastime, they were given Christmas treats.

The club was the first to donate television sets to the patients at Molly Stark TB Hospital. It was also the first club in Canton to purchase a lifetime membership in the NAACP. Club members worked on many projects,

such as running the mobile TB unit, making door-to-door calls for voter registration, helping with the local United Fund Campaign and organizing blood donor campaigns.

The Jane Hunter club was the first to sponsor a Broadway play in the city. In 1962, the club was responsible for bringing *Extravaganza* to Canton. The club had the first junior federated club in Canton, the Junior Janeys. This club was under the supervision of Elizabeth Carmichael. The juniors purchased a seeing-eye dog for a blind lady.

Three of the club members were the first blacks to be honored by the local newspaper in a column, titled "People you Should Know." They were Elizabeth Carmichael, Norma Marcere and Flora (Spence) Thomas. Membership in the club was limited to twenty-five women. Federated in 1945, it is the oldest federated club in Canton. The club continues to give scholarships and contributes to the United Negro College Fund. The club's state motto is "Deeds Not Words," and the national motto is "Lifting as We Climb."

This history was compiled by Willa Webb, past president and secretary. Webb received the club's President's Service Award for her work on the program planning committee of the YWCA and organizing a teen club there with over sixty-two members.

The Canton Negro Oldtimers Athletic Association

Perhaps no other organization of African Americans in Canton's history has reached the heights of the Canton Negro Oldtimers Athletic Association. William "Bill" Lacy served as the association's president from 1973 to 1980.

In 1960, James "Casey" Stokes, Milt Williams, Donald Martin, Robert L. Garrett, William Lacy, Sam Lipkins, Pete Fontes, Ernie Parks, Russell Allen and several others conceived of the idea to host a match game to determine who was the best. In 1962, the Oldtimers held the first public banquet. In 1963, the Christmas basket program was initiated, with the members paying out of their pockets for eighteen baskets. In 1969, the Canton Negro Hall of Fame was dedicated at that banquet with its first inductees. In 1975, the Ladies Auxiliary was organized and accepted by the parent body.

During 1975–76, the organization purchased a building at 1844 Eleventh Street Northeast. After a fire destroyed the building, the group moved to 1749 Tenth Street Northeast, continuing their record of community service from that location. The Oldtimers spearheaded an effort to have a portion of Eleventh Street Northeast from Mahoning Road and east to Belden Avenue renamed in honor of the late Judge Ira Turpin. By 2004, they had proudly moved into their new $2 million facility at 1844 Ira Turpin Way Northeast.

The Oldtimers Activity Center was not able to survive the downturn in the economy. Like many other black businesses before them, the group faced bank foreclosure and eventually lost the building. The building was purchased by Antioch Missionary Baptist Church, and congregants still hold services there.

Like the phoenix, the Oldtimers continue to rise. They took over the management of the former Chili's Lounge on Twelfth Street Northeast and continued many of their charitable activities.

CANTON FRONTIERS AND THE CANTON FRONTIERS WOMEN'S AUXILIARY

The club's principle of "advancement through service" has as a prime role the mission of harnessing the cooperative influence of community and directing that influence toward solutions to major issues that are civic, social and racial. In addition to involvement in numerous community-related projects, the club fully supports the Frontiers International Foundation Inc. The foundation was established as the successor to National Vitiligo Foundation.

In 2011, the Canton Frontiers Club officers were Randy Bond, president; Robert Collier, vice-president; Carlton Sanders, treasurer; Scott Barwick, secretary; Henry Edwards, sergeant-at-arms; James Dickerson; and Jim Motley. Other members include Theodore Johnson, Ben Armstead, Jacqueline Barnes-Holmes, Raymond McCloude, William Pollard and Preston Young. Pollard was a founder of the Canton chapter and one of its most ardent supporters.

Annually, the club sponsors a pancake breakfast, and the auxiliary sponsors the annual Yokettes Cotillion. The first Yokettes Cotillion was held on August 24, 1974, at the Onesto Hetel Ballroom.

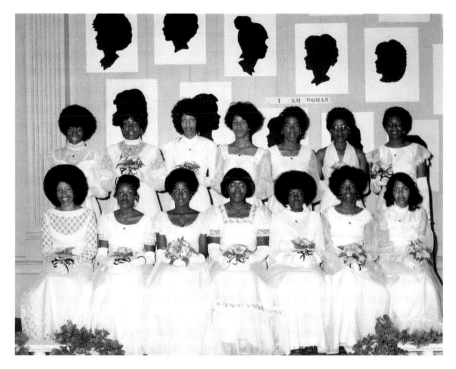

Debutantes making their debut at First Yokettes Cotillion: (*seated, left to right*) Theresa Golden, Maurica Donald, Audrey Merrell, Annabella Williams, Carrilyn E. Stevens, Vanessa Tuck and Gina Hunt; (*standing, left to right*) Shevawn Gibson, Delores May, Theresa Snow, Robin Hurd, Audrey Melton, Marcia Ford and Willie Mae Davenport. Photo by Bill Mannheim.

BLACK FLOWER PRODUCTIONS

For over twelve years, the members of Black Flower Production—Yvonne Wallace, John Maske, Kaleen C. Wheat, Mike Ward, Hundlean Maske, Dennis A. Milan and Cynthia A. Dunivant—sponsored an annual Miss Black History Month Pageant. Black History Month Queens include Valerie Lynn Rice (1980), Jacqueline Lee Ulmer (1982), Tonya Strong (1983), Antoinette Perry (1985), Monique Williams (1987) and Lillian Lancaster (1989).

KAPPA TAU CHAPTER, OMEGA PSI PHI FRATERNITY, INCORPORATED

The Kappa Tau Chapter of the Omega Psi Phi Fraternity Inc. was founded and chartered in June 1959. The founding meeting was held at the Canton Urban League, then located at 819 Liberty Street Southeast. Bro. Leonard Holland of Columbus, Ohio District Representative officiated the induction, invitation and installation of the following officers: Basileus, Bro. Bill Pollard; Keeper of Finance, Bro. Arthur Beeler; Keeper of Peace, Bro. Oliver Miller; and Chaplain, Bro. Art Malone.

Fred Johnson, Percy Malone of Alliance and Oliver Miller were present during the chartering of the chapter. Kappa Tau Brothers are actively involved in the leadership of Canton City Schools and Stark Metropolitan Housing Authority, as well as ABCD, Canton Urban League, Pro Football Hall of Fame, Massillon Rotary Club, Kent State University, the University of Akron, Mount Union College and other organizations within the city. Our membership includes entrepreneurs, educators, corporate executives and professionals, representing a plethora of industries. In the past ten years, the Brothers of the Kappa Tau Chapter have awarded nearly $50,000 in scholarships to area high school seniors to assist with their college educations. The fraternity celebrated fifty years of service in 2009.

STARK COUNTY ALUMNAE CHAPTER, DELTA SIGMA THETA SORORITY INC.

At the inception of Delta Sigma Theta in 1913 at Howard University, the founders envisioned an organization of college women pledged to serious endeavor and community service. Their ideas of scholarship and service have withstood the test of time; today, Delta Sigma Theta is a public service sorority, dedicated to a program of sharing membership skills and organizational services in the public interest.

In 1929, Delta Sigma Theta was incorporated as a national organization. The first public service act performed by the Delta founders involved their participation in the Women's Suffrage March in Washington, D.C., in March 1913.

The membership, which includes graduate and undergraduate chapters, has over 190,000 predominately African American college-educated

women. It currently claims 900-plus chapters in the United States, Japan, Germany, Bermuda, Haiti, Liberia, the Grand Bahamas, the Republic of Korea and the Virgin Islands. The Stark County Alumnae Chapter is proud to be among these impressive numbers. There was a consensus among the Stark County sorors that a chapter in Stark County was needed. The charter members of the Stark County chapter were Marian Crenshaw, Elizabeth Dantzler, Cora J. Davis, Elayne Dunlap, Margaret Hawkins, Sydney Lancaster, Paulette R. Lenzy, Cleo A. Lucas, Michelle M. Martin, Jeaneen J. (McIlwain) McDaniels, Mozelle R. Meacham, Ina Patterson, Marie J. Slaughter, Pamela D. (Thompson) Hill, Roberta E. Meacham, Deborah Ward and Debra J. West. This research and work resulted in the receipt of a charter from the Grand Chapter on Sunday, June 26, 1988.

Our chapter cherishes the memory of our beloved sorors who are now members of our Omega Omega Chapter: Marian Crenshaw, Mozelle R. Meacham, Sylvia Myricks, Marie Slaughter, Jacqueline Russell, and Elizabeth Dantzler, Sylvia Ramos and Cora Davis Hawthorne.

Juneites Club

In 1973, Jesse Byrd and Mose Garret discussed holding a birthday party each year for people born in the month of June who were considered either a Gemini or a Cancer. Membership was open to anyone willing to pay twenty dollars toward supplies for the party. Members for the first party were Lee Royster, Mose Garrett, Jesse Byrd, Patricia Byrd, John Warr, Charles Tarver, Jake Hailey, Mildred Austin and Ruby Mason. Robert Tate, Thelma Walker, Ann Hailey, Robert Lamarr, Eugene Mastin, Irene Parks, James Reeves, Fannie Wilson, Marie Justice, Constance Lamarr and Robert Johnson joined for the second party.

After the second party, the Juneites decided to change from a birthday group to a dues-paying organization and have a purpose other than having parties. In 1988, the club purchased a house on Carnahan from Reverend Finest D. Bryant with intentions of turning it into a club meeting place. After a code inspection, members found it would cost too much to bring the house up to code, so they had the house torn down. In 1989, a house at 874 Mahoning Road Northeast was purchased for the club meetings.

One of the Juneites honorees is Colleen Curtis-Smith, daughter of Mary Elizabeth Carmichael. Curtis-Smith is a native of Canton, Ohio, and a

graduate of McKinley High School. She attended Spelman College and graduated from Howard University. She earned her master's degree while working for the National Security Agency in Washington, D.C. Upon returning to Canton, she began working for the Canton Urban League as the youth director. After two years with the Urban League, she attended Kent State University and The Ohio State University to obtain her teaching certificate.

CANTON TREASURES

WATOES Outreach Programs

By Kathy Baylock

Founded in 1982, We Are Troubled On Every Side Out Reach Programs (WATOES) is derived from II Corinthians 4:8, 9. The acronym WATOES was thought of by Beth Renner, a former Canton City Schools teacher. The organization started with married couples meeting and sharing marital experiences concerning their families.

WATOES expanded to other programs that included the whole family, concentrating on Afrocentric ideas with Christian values. WATOES's focus has been the development of the family. Since families represent the simplest structure in society, they also represent the most important piece in our collective society. WATOES believes that all families are not the same. Culturally, they are all different, with different beliefs and values.

In 1992, WATOES encountered its biggest project, promoting a series of dramatic plays about African American history in Canton, Ohio. Directors and writers for the plays were Bruce Allison and Edwin Baylock. Nelson Polk served as the stage manager for all scheduled productions. In a small way, WATOES attempted to add to the Black History Month celebrations.

Menelick Cultural Federated Women's Club

By Gwen Singleterry

The Menelick Cultural Club existed in Canton in the early 30s and 40s. Their focus was centered on helping students in the elementary schools obtain the necessary school supplies and extras they needed. They also kept

close contact with the schools, seeking out students with family problems where the club might offer some assistance.

My mom, Edna Umbles, was the secretary of the club for many years. My mom worked at Bon Marché, a women's clothing store in downtown Canton, as a part-time elevator operator, which was considered a prestigious job back in those days because you did not get dirty and could wear "church clothes and shoes" six days per week. Other members that I remember were Gladys Matthews, owner of the Matthews Funeral home (I called her Aunt Gladys); Mary Hunter, wife of Judge Clay Hunter; Phoebe Ross, wife of Dr. Peterz M. Ross; and Pearl Williams, wife of Dr. Mantel B. Williams.

The event I looked forward to every year was Menelick's annual event for the elementary schools. It was a picnic called the Passing Party, held in Nimisilla Park. The zoo was there, too. Each student would bring their report cards to show that they passed to the next grade. A $50 reward was given to the student with the highest grade point average.

The Junior Jane Hunter Civic Club

By Gwen Singleterry

The Junior Janies was formed by members of the Senior Jane Hunter Federated Club of Colored Women in the 1950s. The Junior Janies were high school students. You had to be unanimously voted into the club. Elizabeth Carmichael was the advisor. Her assistants were Edna Jenkins and Dorothy Parker, who now lives in California.

Carmichael was a special woman, civic-minded. She also owned her own beauty salon, and she was a wonderful seamstress. She received many honors for her public speaking. She was a mentor and an inspiration to all of us.

Mary Elizabeth Carmichael was born in 1914 in Donora, Pennsylvania. She came to Canton in 1929 and attended McKinley High School. In 1935, she opened the first licensed black-operated beauty salon in Canton, after graduating from the Louise Miller School of Millinery. For more than thirty-five years, her salon operated as a successful business.

She won a first prize trophy in 1953 for hair styling. Former governor Michael B. DiSalle appointed her to the state board of cosmetology in 1963. She studied cosmetology at Madame Washington in Cleveland, Ohio, and in Paris, France. Her life took another career path, and she retired in 1982 as a banking auditor with the Canton Income Tax Department. In 1948, she

led a successful sit-in at the Stark Dry Goods Department Store because the store did not permit black people to eat in its restaurant.

Carmichael received a Mayor's Citation for her dedication and faithful service to the citizens of Canton and for her assistance on many projects. She organized and was the supervisor of ten troop leaders for black Girl Scouts. She organized the annual political luncheon of Black Club Women at the Onesto Hotel, sponsored by the late Congressman Frank T. Bow. She was a member of the Canton Urban League Board and served as membership chairperson. She appeared on programs throughout Ohio, including Dorothy Fuldheim's television show. Truly,

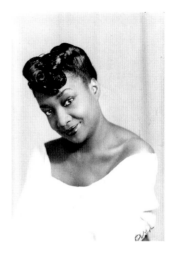

Elizabeth Carmichael.

Carmichael epitomized the active black woman upon whose shoulders many of us stand. Friendships have lasted over the years because of our close-knit groups. On March 31, 1984, we had our first reunion and we celebrated Carmichael's seventieth birthday. She was proud of our endeavors. I know she would be so pleased to see the fruits of her labor and love.

The demise of many of the mentoring groups has left young people in Canton without the structure and adult supervision needed to learn about their heritage, culture and responsibilities. It is time for history to repeat itself.

THE NEIGHBORHOODS AND FAMILY

Most would agree that Canton is a good place to live; despite documented incidents of overt racism, memories of growing up in Canton are generally positive, particularly memories of the neighborhoods where we lived.

IT TAKES A VILLAGE

By Nadine McIlwain

If you believe in the African proverb "It takes a whole village to raise a child," then choosing one inspirational person is impossible. I spent my early years living in Northwest Canton, at a time in Canton's history when most black people lived either on the Southeast or Northeast parts of town. As the story was told to me, my father's mother, Cora Lee Ricks Williams, married Harrison McDonald and, together with the help of other family members, moved our entire family to a small house at 2797 Harrison Avenue Northwest. My grandfather's sister and her husband, William and Lola Tharp, and their four children lived in the house next door. Across the street was my great-grandmother Della Bonner Scott, and in the apartment beneath her were my uncle and aunt Louis and Helen McDonald. My grandfather's brother, Garland Lee "Tet" McDonald, built a small ranch-

style white house on the top of the hill above Harrison Avenue. Another cousin, Elizabeth Tharp Tyrus Sullivan, eventually purchased a house approximately one-half block down the street. In all, our family owned and occupied five homes in that neighborhood. As students, all of the children, including me, attended Edgefield Elementary School (now the Stark County Educational Service Center) and Glenwood (now Glenoak Middle School). The year Plain Local opened Glenwood High School in 1955, there were two African American students, my sister Dona and me, among the seventh through twelfth grade students.

Although few in number, other black families in this neighborhood included Dave and Myrtle Arbogast; Reverend and Mrs. J.R. McDonald, the pastor of Antioch Baptist Church at the time; Mr. and Mrs. Don Marshall, who built another home next to the green house they occupied; and their nephew Junior Marshall, who later moved into the home. Effie and Bill Edmondson and Pauline Spencer Cundiff and family were also neighbors. Families from Alliance (Cunduffs) and from Massillon (Gilmers) and from Florida (Bryants) moved into the neighborhood. Cleve Bryant, a Glenwood football standout and later college football coach, was an early Glenwood High School graduate. Joyce and Daniel Sankey and their two girls moved into the neighborhood about the time I was fourteen years old. With such sadness, the entire Canton community mourned the death of their great-granddaughter, two-year-old Harmoney Sankey, who became one of the youngest victims of gun violence in Stark County.

White families, mostly middle class, surrounded our neighborhood on the north, south, east, west and middle, but there were a few poor white families, who, like us, did not have running water or inside toilets until the early 1950s.

Although school was not a pleasant experience, I loved going to Antioch Baptist Church, then located on Ninth Street Southeast, later on Gibbs and Seventh Street Northeast and now in the former Oldtimers Activity Center on Ira Turpin Way. I went to church three and sometimes four times a week because it was my chance to be among people like myself. Even though I had selfish motives, I gained so much spiritually and otherwise through the Antioch adults who watched over and taught us.

Although Sunday was the official church day, I spent every Saturday in the home of Susie Burkes. Burkes, along with Margaret Henderson, wife of Reverend W.C. Henderson, were the church ladies who gave up their Saturday to serve as volunteer organizers of the Sunshine Band, young children who wore yellow capes and sang as one of the church's choir. We traveled the county going to black Baptist churches in Massillon, Malvern,

Waynesburg and Alliance. Unlike my music teachers at school, it didn't matter if we could sing or not to these ladies. Helen McKinley Potillo was another of the Antioch ladies who watched over us. As we got a little older, we would go to Potillo's house. I don't remember exactly what we did at her house, but I loved going there.

Bible reading was a daily habit of my grandmother's. I asked her how she learned to read since she quit school after the third grade, and she said, "Back then, you knew how to read by the time you left the third grade." She left school because she refused to get a smallpox vaccination. "Somthin' happened to the colored kids' arms that got those shots." It didn't happen to the white kids was her explanation for quitting school. I'm not sure if I believed that, but I know she was still the smartest woman I ever knew.

Sometimes, my grandparents would allow me to skip the evening service and go to the Pathfinder Skating Rink, the Canton Urban League or the Phillis Wheatley building. I remember Sue Holloway from the Phillis Wheatley building. I didn't know it then, but she was the sister of Lillian Barnes, one of the first African American female teachers I ever met. Sue Holloway was a lady, and she made sure we knew how to act, talk, dress, eat and dance like ladies.

At the Canton Urban League, I enjoyed the street dances in the summer and the Friday night dances after school started. That was fun, but the learning took place in the after-school leadership classes. C.A. Thomas, the executive director, was the first black man I knew who wore a suit to work every day, except for the pastors who wore suits Sunday through Saturday. Mr. Thomas commanded respect, but Arthur Beeler, the youth director, brought us out of the dark—and I do mean dark—ages. During those youth meetings, he would tell us that we were as good as anybody else and that we deserved everything our brains and talents could obtain for us.

I will never forget the time when he took us to the Stark County Fairgrounds Roller Skating Rink to challenge their "no Negroes allowed" rule. The owners of the rink turned the busload of us away. The next day, Art Beeler or somebody sued the owners. "This is taxpayer land. Black people pay taxes. And black kids have a right to skate here," he said. So the busload of us went to court. Some of us had to testify; although I wasn't one of them, I wanted to be. Art Beeler said we won the case. Once again, we boarded the bus and road out to the fairgrounds. They let us in, and we skated with a lot of whistle-blowing, literally. That skating rink closed soon after that and, sadly, so did the Pathfinder.

At the Urban League, I also met the man who would change my life. I was sixteen and he was twenty-three. When he was thirty and I was twenty-three, we married. Albert H. McIlwain was not only my husband, but without hesitation I consider him one of the most inspirational persons in my life. When we met, I was a junior at McKinley High School and Al was a student working his way through college. Two years later, he came to my graduation from high school, and four years later, I went to his graduation from Malone College. The group we hung out with in the early years called him "Honest Al," like Honest Abe. Al epitomized honesty in every sense of the word.

It's strange how life reinvents itself. One of Al's students from Lathrop Elementary, Don Johnson, had two daughters, Tracy and Lesley. Lesley married our son, Randy McIlwain, and they have blessed the family with J. Pressley Reese McIlwain. Al left teaching to become the deputy director of the Stark Metropolitan Housing Authority, where he was serving as executive director when he died on Father's Day, June 18, 1989.

Ralph Armour was an American history and German teacher at McKinley High School and my first African American teacher. When I received the highest grade in his class, that sealed it for me—I was going to be a history teacher. Like most black children, my dreams were larger than my parents' bank account. But Al said I could do just what he had done: catch the bus to Malone, study hard, work and eventually get that teaching degree I wanted. I asked Gerry Radcliffe to be one of my bridesmaids when Al and I married. I met Gerry and her husband, Dale, at Antioch Baptist Church. Gerry is on my list in this inspirational village. I literally cannot think of anyone in the medical profession who has had more influence on the general health of black Cantonians than Gerry. A nurse by profession, she started early organizing and training church nurses. Even today, she continues to inform and coerce black people into taking care of themselves. Personally, she helped me through the health problems that plagued Al.

I nearly forgot to mention that circle of black professionals I used to babysit for in the fifties and early sixties. There were Kitty and Chuck Dowdy (teacher and engineer), Dorothy (first black teacher hired by Canton City Schools) and Buster Miller, Al Pringle, director of the Northeast YMCA. Others in that group who didn't have children but hung out with this group were Bill (educator and the first African American principal of McKinley High School) and Pat Hunter. I loved watching them gather at Chuck and Kitty's apartment prior to going to a BBB or Penguins affair. They were black professionals, college-educated, successful, well dressed and well spoken. Even if I was only an afterthought in their conversations, they never

failed to ask me about school, what were my grades like, where was I going to college, what did I want to be. I learned quickly that they favored the historically black colleges they attended, like Central State, Tennessee State, Fisk or Howard. I had to look these places up, since we never talked about these things on Berger Place Northeast, where I lived at the time.

If you look up Berger Place today, you will see one house still standing. But back then...well you know, it was happening. Esther M. Archer was responsible for our relocation from Berger to 1804 Second Street Southeast. My mother worked with Mrs. Archer at the Timken Company, so I remember hearing her name a lot. My mother always said her first and last name together, Esther Archer, and I believe that's what everyone called her. A Timken Company employee, one of the first black, female elected office holders in the United States and a real estate agent, she assisted my mother with purchasing her first and only home at 1804 Second Street Southeast. In her quiet way, Esther Archer helped so many people achieve a piece of their dreams. Ask me why I chose Esther Archer to swear me in when I finally won a seat on Canton City Council and you have your answer.

Esther Archer was not the only political influence in my life. Robert Fisher was one of my husband's best friends and my political mentor. It was Bobby who finally got Al and me together. It was Bobby who encouraged me to run for Canton City Council. It was Bobby who asked me, told me, I had to run for the Canton City Schools Board of Education. I have no idea what he wanted me to do next. My thoughts of Bobby, although deceased at the time, led me to lead the 100 in 100 fundraiser for the Urban League. I was pleased when he told me he was happy about my marriage to William P. Massey. So am I.

Although she wasn't in Canton long, Dr. Rosemary Johnson's educational credentials were impressive enough that she was appointed the superintendent of Canton Local Schools. Unfortunately, her untimely death prevented her from serving, and she died within two weeks after assuming her position. Rosemary said, "Always do something that makes you feel good." I played my first nine holes of golf with Rosemary. She would be proud of my golf game today. In addition to Rosemary, there are two others to whom I owe my love of learning and teaching. First, my father, Willie J. Williams, who took education seriously—so seriously that he stopped speaking to my aunt for one year because she quit school. There is too much about my father to be included here, but a story I wrote about him appears in the 2004 publication *My Soul to His Spirit*, edited by Melda Potts Beaty, and in the 2006 edition of *Chicken Soup for the African American Woman's Soul*.

I am forever inspired by Paralee Watkins Compton and her belief in the learning potential of all children, her respect for teachers and her encouragement to seek the higher ground. Paralee's advice to teachers was, "You can affect thirty students if you stay in the classroom, but if you want to affect the lives of five hundred children, you have to become a principal."

There are others in this village in whose debt I remain. I can never repay Linda, Ravene and Tina Smith and their mother and father, Goldy and James Smith and Pauline Singleton, for the love and nurturing she gave to my children, Jeaneen and Randy. Pauline was my children's caregiver (that's the new term, we called her our babysitter), and she was always there when Al and I could not be.

I should have written a book and not an essay because the life of everyone mentioned in this piece deserves a book.

WILL DENT

I was born in Eutaw, Alabama, and came to Canton when I was four years old. I can recall my first party when I was eight and remember the Barnes girls and Shirley Inman—they were and still are so beautiful. The same year, we moved to Northeast Canton, where I met Roy Yancy, Dick Seymour, Wayne Graves, Jim Parrish and Ed Smith, to name a few. The following are some memories of growing up in Canton that I will always cherish.

At the age of ten, I played on the Northeast Senators Mighty Mite Baseball Team, and we beat a team from the Northwest led by the Beldens and won the Ohio State championship; the coaches were Babe Sirgo and Zeke Bianci.

I won the school spelling bee and represented Washington Elementary School at the city spelling bee. I was extremely nervous and misspelled "science" in the first round.

During that same year, we won the city football championship, and I first met Bob Evans, coach, teacher and principal of Hartford Junior High School, who became a major influence on my life. I can recall him writing the word DESIRE on the board and from that he listed DETERMINATION, EFFORT, STRENGTH, INSPIRATION, RESPONSIBILITY AND ENTHUSIASM. These words became a frame of reference throughout my life.

We were the first class to attend Roosevelt School as eighth graders and won the city championship, and I met another outstanding coach and

teacher in Ralph Krabill. I also met longtime friends Walter Coleman and Leon Gupton.

I got my first job working in Hartville, where you crawled on your knees for miles picking weeds. You worked ten hours a day at sixty-five cents per hour. If you were lucky, you could earn more money by picking onions and potatoes. When I got a job shining shoes at Lucky's, I thought I was in heaven.

I attended McKinley High School and have many fond memories of the time I spent there. I wanted to be "cool" so I quit the team my junior year and I was miserable all during football season.

Will Dent. *Courtesy of Mark Bigsbee.*

I made up my mind that I had to play football again at McKinley. My senior year saw the arrival of Pete Ankney, perhaps one of the greatest coaches ever…a man who was ahead of his time. Well, I went out for football my senior year. Since I had quit the year before, they placed me on the last team, which was known as "winky dinks"—your shoes, helmet and pants were too big and you had to go up against the first team. I was determined to play and remembered the word *desire* that I learned from Mr. Evans. I began to hit so hard that few people wanted to face me on the tackling drills. On opening day, I was starting on offense, defense and all special teams—I found out then that if you want to achieve something bad enough you can. One of Coach Ankeny's favorite slogans was "A WINNER NEVER QUITS AND A QUITTER NEVER WINS."

I went to Wilmington College thinking that I had a football scholarship only to find out that it was a work-study program, whereby you work full-time in a factory three days and went to class three days. It was tough working eight hours and coming to football practice, but I made it through and earned four varsity football and track letters as well as earning a bachelor of science degree majoring in psychology. It was at Wilmington that I was first introduced to the civil rights movement. At Wilmington, there were freedom buses taking students to the South and such speakers as Stokely Carmichael. I can recall one occasion when I ran short on funds and Obie Bender sent me a check and when I went to repay him he told me to keep the money as a wedding gift.

My first job after graduation was in Lima, Ohio, at Bradfield Community Center, where I served as assistant executive director and athletic director. Frank and Estella Cooper, Ted and Laverne Wilson and Richard and Shirley Turner all adopted me and provided the support that I needed. One highlight during my employment there was a band named Big Tip and the Thin Men—one of the thin men was Mike Ward, whom I encouraged to go to college and major in music. The next time I saw Mike, he was the new band director of McKinley High School. A second highlight of my time as athletic director was winning the regional women's fast pitch championship without having a fast pitcher. Even though I liked Lima, I had a burning desire to return to home to Canton.

I returned to Canton when C.A. Thomas hired me to be the director of Housing and Community Services for the Canton Urban League. While employed at the Urban League, I met Joe Smith and Bill Hunter and worked with Rosalyn Taylor Averette, Marilyn Pender and Pat Byrd Kennard. I became involved with a group initially called the Southeast Improvement Association (SCIA), which later became known as the Society for Cooperative Improvement of Africans and was led by Gilbert Carter. It was through

Avid supporters of ABCD, Jacqueline Barnes Holmes (*left*) and Attorney Judith Barnes Lancaster with their father, Owen Barnes.

SCIA that I became orientated to Cultural and Revolutionary Nationalism and became known as Mwalimu Salih Mshauri. I served as the chief of staff and minister of economics. I was also instrumental in the organization of the Stark County Welfare Rights Organization. Working with such people as Jerrel "Tee" Shipman, the group reshaped the welfare system.

I met Reverend George Short, pastor of Turner Chapel United Methodist Church, and his wife, Elizabeth, both of whom are now deceased. It was Reverend Short who introduced me to the United Methodist Church and the black community developers program out of which ABCD, INC. was born. The first training event in Hendersonville, North Carolina, and my first meeting of the National Black Methodist for Church Renewal provided the foundation that resulted in the development and growth of ABCD. It was at the training session where I met Negail Riley, who founded the community developers program; John Coleman, the first national director; and Walter Bremond, the founder of the Black United Fund movement and one of the greatest community organizers of all time. It was with Walter's assistance that we were able to organize the first Black United Fund Chapter inside Ohio. I also became a member of Turner Chapel and later the James S. Thomas U.M.C, which was named after our bishop at that time, James S. Thomas. The development of this church was spearheaded by Reverend Gregory Palmer, who became active on ABCD's board as well as the total community. Greg became the youngest person to be elected bishop in the United Methodist Church and was recently elected president of the Council of Bishops.

Another significant event in my life was joining the OMEGA PSI PHI fraternity in 1988, being elected to serve as the Midwest representative on the National Congress for Community Development, Board of Directors.

THE NORTHEAST END

By S.J. Boyd-Coleman

I was lucky to have grown up in a unique neighborhood on the Northeast side of Canton, Ohio. We lived in a white-framed house on a red-bricked street. The thoroughfare was named Ross Avenue, and it ran between and parallel to Mahoning Road (now The O'Jays Parkway) and Carnahan Avenue (now Marion Motley Avenue) Northeast.

That particular vicinity was quite diverse. My community consisted of descendants from Africa, Greece, Spain, Romania and Italy, so it was an international neighborhood. Surnames like Fontes, Perry, Fernandes, Lazares and Mendes were as common as Williams, Norwood or Smith in our neighborhood. That is why I can appreciate the flavors of soul food, meat pies dipped in yogurt and stuffed grape leaves. Our Brownie scout leader was from Mexico, and at one of our meetings, she served tamales! There was nothing better than a rib sandwich that was cooked tender with two slices of bread, hot buns, soaked in a sweet and spicy blood-red sauce, and it was not necessary to travel to the Southeast community to have one. We had it all right on Carnahan Avenue. Black people, who sold the rib sandwiches and chicken dinners, prepared them on a grill that was made from one of those shiny steel barrels that I used to see my dad burn trash in. Every now and then, you can smell that mouthwatering aroma of grilled pork ribs and see the white smoke wafting from one of the barrels on the few street corners throughout the city.

I considered Carnahan Avenue the Cherry Street of the Northeast end. It was lined with barbershops, restaurants, family-owned stores, a shoe repair shop and a few bars that catered to each of the particular clientele in the neighborhood. It always surprised me that women were not allowed in the Greek bars or coffee houses where the old Greek men seem to just sit around and play cards all day long. Around the comer was an African American–owned funeral home called March's Funeral Home, owned and operated by Robert March.

The Northeast YMCA was also located on Carnahan. I remember having to go there at a young age to get a polio vaccine, and how I said that "I wasn't going to take any shot." I took my little fist and tried to beat the arm of the nurse who dragged me into the section of the clinic where the hypodermic injection was to take place with the longest, sharpest needle that I ever saw. The Y was not just a house of pain. There were a lot of activities sponsored for the youth by this recreation center. The O'Jays, who were the mascots then, often sang there. We also attended the Vacation Bible School that was held there, which lasted from about two weeks after school was out until about two weeks before school was back in session. We all got along fairly well. Every once and a while, there might have been an altercation, but everyone left there alive and in one piece.

Almost everyone in our surrounding area had some kind of a garden. Sometimes, it would be a vegetable garden, a flower garden or both. The house next door had a flat roof, and grapevines grew there. My parents

had a vegetable garden and a flower garden. I liked to help my dad in the vegetable garden because there was always some kind of interesting-looking fat, green worm or a weird bug, grasshoppers and praying mantises waiting to be captured.

Apple, pear and peach trees were also in great abundance, as were weeping willow and fir trees. We had three fir trees that were in front of our home. There was a lady who lived in a silver and gray trailer on some land that had at least twenty apple trees. On some evenings, the children would go to her yard because she had a guitar, and she would play and sing songs while we ate some of those apples. The fruit would have small holes in them at times and we talked about whether there were any worms in them, but we laughed and ate them anyway.

Miss Dory had a guitar, Sylvia played a mandolin and we listened to Sam Cook and to Mr. Magyar play jazz on his baby grand piano from his living room window. The African Americans living in that area were exposed to a lot of different kinds of music. When it was summer and the little holiness church around the corner had revival services well into the night, I would lie in my bed listening while they sang, played drums and tambourines. On the same street but on the opposite end sat two Greek churches (one had a silver cross, the other had a gold one) that were so close to each other that there were only three houses that separated them. They played the most beautiful bell chimes on Sunday mornings or when they had special services.

The Southeast had Jackson Pool, but the Northeast had Cook Pool and Nimisilla Park, which housed the zoo, and Crystal Park, which had a baseball diamond. There were night games played there. My uncle, Peel Coleman, would often be the umpire at some of those games. There were not too many African American umpires in the 1950s when I was a little girl.

On the Sundays that we did not attend church, my dad always took us to the zoo. We would just walk there, and he would take us a different way every time. No matter how many times he took us there, we were never tired of going into that smelly old monkey house observing those angry primates. I now understand their feelings of extreme hostility, and I even liked seeing that scraggly-looking lion, named Frank, which had a roar that didn't resemble any roar that I'd heard on one of those nature shows.

I had an aunt, uncle and cousins who lived on the Southeast side of Canton. My family also attended church there. It is not as if I have no knowledge of that area. I have played in and I have swum in Jackson Pool, and I have eaten rib sandwiches from Mabel's Chicken Shack, and I've attended the Elks parade, but my roots are planted in the Northeast. For

that, I won't apologize. I'm glad I was raised where I was. I have lived in other areas in my adulthood. Now, I am living on the Northeast again and I couldn't be happier about it. Most of those places that I have written about are no longer in existence, except within my being and that of others from this multicultural neighborhood.

THE WHOLE VILLAGE

Mari-Alisitne Victoria Thompson Moss

They say it takes a village to raise a child. If that is true, then I was blessed with a village full of individuals who not only inspired me and enriched my life in priceless ways but also touched many others of this community. These people have been mentors, blessings, pillars of strength and powerhouses that extend farther then the eye could see, and they have helped inspire me and innumerable people in our community and beyond, more than they probably know.

Every person in this community that has contributed to my life has a common connection to one person, my mother, Darleen Moss. I think she is the most talented, intelligent, beautiful and strong woman I could ever know. A young Angela Davis type (Afro and all), she told me of times she could recall being discriminated against at a lunch counter, and another occasion when she was taunted by a young boy for eating chocolate ice cream where the young man shouted out to her from his bike, "Chocolate ice cream for chocolate girls!"

She is the only person I know who can go anywhere in the world and make friends with complete strangers! It didn't even matter if they spoke English, because she is fluent in French and Spanish. I wanted to be just like her. She always carried herself with such class and joyfulness, bringing a smile to everyone with whom she came into contact. As a teacher, she poured out her heart to many people, especially young people in the community. Many of them who were my friends would talk about how much they also admired her and how she helped them "turn on their potential."

She helped advise a group of children she called "TOPS." She would tell us to remember to "Stay On Top!" She encourages me to bypass mediocrity and only expect my very best. She put me into a program called Project for Academic Excellence, or "PAX" (begun by Dr. Norma Marcere), where the

slogan was "Aim High in everything you do, Aim to excel for what is worth doing is worth doing well." Then as co-leader of NAACP youth, she taught me leadership skills and exposed a group of us to excellence outside of Canton through ACT-SO (the Academic Technological Scientific Olympics) sponsored by the NAACP.

My grandfather Adam Benjamin Thompson was the head of the Thompson clan. He showed me a special love that filled a void in my life. Throughout my life, my grandfather and my uncle, Terry, instilled in me wisdom and encouraged me to do what was right. He worked all his life as a construction worker. He shared with me the times when he had to deal with racism and managed to overcome every obstacle with strength and dignity. Because of his complexion, bluish-gray eyes and fine wavy hair, he would often confuse white people. They would ask him openly "What are you?" Back in those days, blacks who looked like him were called "Guinea Niggers" and sometime "Mulattoes." He gave his children every option in life to make it, whether they wanted to go to college like my mother or start a business like the corner store he and my grandmother used to own, which my uncle, Terry, began to manage and eventually own. He ended up owning multiple properties in his neighborhood.

My mother married Reverend Walter S. Moss, a former Mr. McKinleyite, who has taught me so much in my life, particularly how to be compassionate. No matter how many times in my life I would make mistakes, he always found a way to love me out of the situation and taught me how with grace and dignity. He taught me to have the character to stand up for what I believed in, to have the strength to back it up and stand firm and to have the compassion to love those who need to be loved the most.

When I talked my parents into letting me attend Allen School, they understood why I wanted to go there, since both of them had attended Allen. When I came to Allen, I was leaving a predominately white school, which had caused me some hardship just because I was black. I felt like I stuck out like a sore thumb at times just because of my color. Furthermore, the only black history I encountered was slavery and Martin Luther King. At Allen, with Stephanie Patrick as principal, I learned more about my heritage than I could have ever learned in a black history class in college. I felt so much pride learning about people who were black like me who made great accomplishments. Their portraits were so big and beautiful on display along the walls of the school, and I felt such a sense of pride whenever I walked past or stared at them.

All of the sudden, I went from Cs to straight As with teachers like Ora Strain pushing me to excel in my academics. I will never forget Gloria Dunivant making math class cool. Rap was popular then, and she knew we were all bummed out about math, and she came in and said, "YO! DIS YOUR MATH CLASS!" Then she made a pose like RUN DMC. We knew right then and there that we were going to have some fun learning about math. At Allen, you gained more than just an education, you gained insight and a sense of pride about who you were. You learned to walk with your head up and believe that you can make it through any obstacle. Your talents were enhanced and polished. At Allen, I felt free; I was able to express myself and learned how to really sing and dance through Miss Crenshaw and Myra Watkins, who still has a dance troupe today. Patrick gave me a sense of dignity and pride for who I was, which developed my confidence. Myra Watkins taught me the gift of dance and being bold and confident in expressing myself artistically. Dunivant helped me to love the toughest of classes and develop other talents like acting. Ora Strain helped me to excel in my work and reach my full potential academically. I attended Allen School for one year, but I retain knowledge and values that I can use for a lifetime.

Surrounding my mother were a bevy of first-class friends and mentors who are all successful today—many of whom became my mentors and friends today: Dr. Laura C. McIntyre, Nadine McIlwain, Paralee Compton, Virgina Jeffries, Minnie Hopkins, Ruby Foster, Sylvia Myricks, Steve Tyson, George Lemon, Nate Cooks, Sandy Womack, Kay Averette, Michael T. Brown, Thomas West, Curtis A. "Cap III" Perry and more.

Dr. Laura C. McIntyre was co-director of the NAACP ACT-SO youth group with my mother, but she was a resource for youth way before that. Her home was a haven for many young people to come and learn things and be encouraged. She became like family to me, and I remember when she taught me how to cook spaghetti. I was fourteen and was going to use the Chef Boyardee, but she whipped out some real tomatoes and added some soul and that was the best spaghetti anyone has ever tasted!

Nadine McIlwain is one of the pioneers of educational advancement for African Americans in our area. She had a well-respected mentor in Paralee Compton. I grew up watching McIlwain grow to higher heights in leaps and bounds. I remember when she became a principal, and now she is the president of the Canton City Schools Board of Education. She has helped pave the way for many African American educators and has excelled in many other areas of the community with involvement in various aspects of

the arts and youth development. Just as Paralee took her under her wing, she has done the same for others.

Paralee Compton is a phenomenal woman so respected in the community she has a school named after her! As a young girl, wherever I would go sing, recite a poem or be involved in a program she was heading up, she would offer the greatest words of encouragement to me. She always held herself with such dignity and esteem, and many others admired her for the obstacles she overcame in the educational system in Canton.

Virginia Jeffries was on the board of education. I remember nights when my mother would collaborate with her on projects that would invest in the lives of the youth of this community.

Minnie Hopkins touched the hearts of many. Her legacy of love lives on to this day. She was an extraordinary woman whose daughters Pat and Cynthia continue doing great things in our community.

Ruby Foster made sure that everyone under her watch took his or her education seriously through programs she created. Although she was "retired" and had only one hand, she would put the fear of God in someone in a heartbeat. Sylvia Myricks was a wonderful educator who really cared for her students but wouldn't be taken for granted. Teachers could take a page from her life today. She would smack someone in the head with a Nerf ball if they fell asleep in her class! She would also struggle with a student through a lesson until they truly got it.

Steve Tyson, of the Urban League, was the one who encouraged me to stop moping and actually do something about the tenth friend/associate in my life who died from violence. He showed me that I could accomplish things that without his encouragement, I may have never known, because I wouldn't have tried.

George Lemon is an example of how you can touch someone's life and never know it. George Lemon sat on a prominent board that gave money to fund projects such as the one I had developed. The following week, Mr. Lemon came in to personally inform the organization that not only had we gotten the grant but also he was so blown away by my presentation that he was going to personally give them a donation of $1,000! You cannot imagine how that felt! It touched me deeply, and I will be forever moved by that experience.

I will never forget the first time I met Kelly Zachary. She had the winning bubbly personality, but you also realized she possesses an intelligent mind and she was determined to achieve her goals.

Nate Cooks and Sandy Womack go hand in hand because they are friends and both are remarkable men. Nate Cooks is the former director of the S.E.

Community Center, and Sandy Womack is the eloquent speaker/remarkable principal of Paralee Compton Elementary School and now Hartford Middle School. In the community, they have served as father figures to many who had no father and have been encouragements to the youth and peers in their age groups.

Curtis Perry III is one of the great movers and shakers in this community. He started the African American radio station we have today, but he didn't just stop there! He has been doing special things for individuals in this community and touching lives for years. He blew everyone away when he made his own JoyFest a hot commodity force to be reckoned with during the Hall of Fame weekend. Over twenty thousand people joined in on a weekend that was so special to this community.

Thomas West is focused upon reaching his goal. When I was in high school, Mr. West gave me some experience in a program he started at Child and Adolescent Services. From that job, he then went on to produce his own programs and became a public servant in a more major and meaningful way as councilman of the Second Ward and state representative.

They say it takes a village to raise a child—and I am blessed to have known and learned from the people of this village. For every inspiration, for every word of encouragement, for every person who believed in me, and touched my life, for every obstacle they overcame, for every vision they fulfilled, I will in return continue and pass it on to others so that they too can benefit from the love from the people of this village.

CANTON TREASURES

Kathy Mitchell

By Lois DiGiacomo

The second person who has inspired me is Kathy Mitchell, the first actress to portray Norma in *The Fences Between* in 1994. Kathy has been by my side ever since. While Norma Marcere was the inspiration for the Rainbow Repertory Company, Kathy was a co-founder and is now Rainbow's artistic director. She was introduced to me by a Players Guild director in 1992, who said, "Kathy is a joy to work with, she will give you anything you want!" This is the highest recommendation any theater director could give or get.

Indeed, Kathy has given to those blessed to know her not only what they want, but what they need—without ever being asked. Kathy has shown me the value of a well-balanced life in her devotion serving her church, honoring her parents and caring for her grandchildren while working at two jobs, one in the social service world at ABCD Inc. and one at United Parcel Service.

Kathy's theatrical talents have extended to countless projects: writing and directing the story of Fredricka Stewart, *Good Girl Trying to Be Bad*, and *A Sweeter Way*, a play about diabetes; directing *Mahalia*, the story of Mahalia Jackson, and *For Colored Girls Who Have Considered Suicide/When the Rainbow Is Enuf*; and creating many programs for social service agencies.

I was born into a family of two brothers…blessed with a family that includes a beautiful sister-in-Christ, Kathy Mitchell.

Black History, Then, Now, Tomorrow

By Brooklyn MaShell McDaniels

Brooklyn is a 2018 cum laude graduate of The Ohio State University. She was a student at Oakwood Middle School when she submitted this article.

When I think of Black History, I think 365 Black because I am an African American every day of my life. Then I put it in perspective of THEN, NOW AND TOMORROW, that leads me to think of two truly significant and interrelated items. The first is the number 29 and the second is education. Why is 29 significant to me?

My Grandmother, Nadine McIlwain was born on July 29th. My Grandmother has a Bachelor's degree and TWO Master's degrees. Although no longer teaching, she is now serving as a member of the Canton City Schools Board of education. She has been about education all of her life. She was the first educator in Stark County to receive the Milken National Educator Award better known as the Academy Awards of teaching. To me, She represents the "then."

My mother, Jeaneen McIlwain McDaniels was born on March 29th. She has a Doctorate of Law degree from the University of Akron which she obtained after graduating Summa Cum Laude from Central State University in Wilberforce Ohio. She passed the bar exam the fist time she took it. She is now employed at the Timken Company. My mom is the first

8

African-American female born in Canton to practice law in the city. To me, she represents the "now."

And I, Brooklyn MaShell McDaniels, was born on June 29th. I hope I am considered a positive representation of our City's tomorrow. I am a sixth grade student at Oakwood Middle School and my goal is to continue maintaining my 4.0 average so my accomplishments will not only match my grandmother's and my mother's but will even surpass them. My vision is to one day become an actress. I want to play the roles of attorneys and judges. And, I want my acting career to be supplemented and substantiated by a law degree which I plan to obtain first.

My Grandmother is Black History then, my mom is Black History now and I am Black history tomorrow—together, we are all alive and here to celebrate the past, give praises for the present and contribute to the future.

Marilyn Thomas Jones, My Mother, My Mentor, My Hero!

By Elizabeth-Burton Jones

Elizabeth-Burton Jones was a senior at Canton Central Catholic High School when she submitted her article about her mother. Currently, she is a graduate of John Carroll University and has a master's degree from Georgetown University. Elizabeth was inducted into the Stark County Women's Hall of Fame as the teen representative in 2008. In 2007, Jones represented the First Tee of Canton at the National Life Skills &Leadership Academy at Kansas State. She is employed as a press aide in the U.S. House of Representatives.

Marilyn Thomas Jones is a native Cantonian; she was born in Aultman hospital on May 15, 1950. Her first address was 1313 Hunt Court SE, Canton, Ohio 44707—the original orange brick Jackson-Sherrick Projects. She is my Mother, my mentor and my hero!

My maternal Grandmother, Alice Elizabeth Hayes Thomas came to Canton, Ohio from Camden, South Carolina in 1942 when she got married. My grandmother and her brothers and sister attended Mather Academy, a private boarding school for colored children in Camden for grades 1 through 12 and South Carolina State University. Mather Academy and the woman who was the head of the school when my grandmother attended are mentioned in the book, Our Kind of People. Her signature is on my

grandmother's diploma from Mather. The diploma is on display in our house. My grandmother told my mother and me many stories about growing up in the segregated South. The most important lesson from all of the stories is always the importance of a good education. When my mother's mother got divorced in the 1950's she raised her three children with a focus on getting the best education possible.

My mother has lived in and worked in every quadrant of the city of Canton and currently is a homeowner in Canton's Northwest area. My Mother is proud of Canton, Ohio! Our family has been in Canton since 1902 when my paternal Great-grandmother, Lula Lucie Perkins Alexander came here from Ottumwa, Iowa. My Mother is a graduate of Ira M. Allen Elementary, Timken Vocational High and Walsh College having earned a Bachelor of Arts degree in Business. She is a graduate of the third class (1989-1990) of Leadership Canton.

A public speaker, she is a founding member of the Timken Company Toastmasters International Club. My Mother received special recognition for her speech in 1998 at Temple Israel as keynote speaker for their annual Martin Luther King Jr. Shabbat service and special recognition for her 1999 speech at the Mayor's Martin Luther King Jr. Commission. She has also given speeches to women in transition and shares her own experiences as a divorced mother. The Mary Church Terrell Federated Club honored her with a Beautiful People Award in 2002 for her contributions to her community, for her creativity in designing their club's major fundraiser in 1996. She is a founding member of Project Wheelbarrow, a youth mentorship program which she designed working with Mr. Bill Luntz who is the Founder of the group.

She is a member of the Women's Board of Aultman Hospital and serves on the Executive Committee as Chairman of the Program Committee, the Junior League of Canton, the Museum Guild of the Canton Museum of Art, is President of the Jane Hunter Civic Club of Canton, and the Ohio Association of Colored Women's Clubs. She volunteered many, many, hours to bring the Ebony Fashion Fair fashion show to Canton to the Palace Theatre on September 14, 2004.

My mother, Marilyn Thomas Jones is employed at the Stark Community Foundation. My Mother has told me many, many times that her most important and fulfilling commitment is that of being the mother of Elizabeth-Burton Jones, that's me! I love My Mother, my mentor, my hero, My Mother, Marilyn Thomas Jones.

GOD, Family and Friends

By Bruce Allison

I must start with my mother, Olivia, and my father, John Allison, both loving parents who reared six children after moving from the South to Canton, Ohio. My father, John Allison, who also inspired me to become a police officer, was the first black person ever to be hired by the Canton city school system as a custodian in early 1948. When Jesse Mason, then superintendent of the Canton City Schools, refused to hire him after he passed the civil service test, he had nowhere to turn. Enter Dr. Mantel Williams, the father of Marion Williams Crenshaw, who took my father to the board of education meeting and lobbied the board of education to hire my father based on his written score. The board agreed, and my father made history. Some twenty years earlier, Jesse Mason refused to hire Norma Marcere, Leila Green and many other well-qualified African American educators.

My mother, Olivia Allison, told me the story of how during World War II as an employee of the Timken Company, she and other black women were forced to use the outside segregated restrooms. One cold winter, after returning from the restroom outside, she led a group of ten black women to the foreman's office to demand use of the inside restrooms. She said when she arrived at the foreman's office, there were only two of them left, her and another lady. But God was with her. The foreman was so moved by my mother's resolve that, although they still had to use segregated restrooms, they no longer had to go outside.

Mr. Robert Fisher had a great impact on my career as a police officer. As a young patrolman coming on a police department in the 70s, it was a challenging and sometimes scary experience, especially for a young black man whose generation was set on justice and rights for all people. The fact that Mr. Fisher, as service director, was the most powerful black figure gave me the courage to fight many injustices from without and within the Canton Police Department (that's a book in itself). I knew that I could speak boldly because I knew they would not be able to fire me without just cause with Mr. Fisher in office. He also played a major role in integrating the police and fire departments. I, Ron Ponder, then president of the Stark County Chapter of the NAACP, Ray Strain and Sheila Barrino Tharp, city employees, were meeting in Mr. Fisher's office. When Mr. Fisher came from Mayor Cmich's office and told us that if the NAACP would file a lawsuit for discrimination of blacks and women in the Canton safety forces, the city would not admit

William L. Hunter.

fault but would consent to a decree to set goals and timetables for blacks and women. Thus began the 1981 consent decree *Early vs. City of Canton*. It truly was a historical moment for all of us.

Many boys and girls came under the influence of William Hunter, a young man on the playgrounds of Lathrop Elementary School. He worked as a playground supervisor while earning his master's degree and helped instill a high degree of character, honesty and discipline that gave us pride as young black children growing up in Southeast Canton. He always pushed us to go to greater heights. He would carry himself with confidence and spoke so properly that I thought he might be an "Uncle Tom." William Hunter was no Uncle Tom. He was a great man who never allowed us to use our race as an excuse for failure. He raised the bar.

Elder Robert Smith (clergy), my spiritual father, whom I met early in my career as a police officer, changed my life forever by being an example of the love of Jesus Christ. Before I became a Christian, I remember Mr. Smith wanting to give a birthday card to a slum landlord when we were working together in Highland Park (now Skyline Terrace Apartment). I was upset that he would give this man a birthday card when he knew the man was hurting our people. Mr. Smith made me more upset when he asked me to sign the card. Without wavering, he softly and plainly said, "The only way he [the landlord] will change is from within and we have to start by showing love to him." By the way, I never signed the card, but later I realized that that moment was much like Paul holding the coats of those who stoned Stephen. When it came time for me to call on the Lord, I remembered that moment.

BRUCE EDWARD ALLISON IS the first African American to rise to the rank of captain in the Canton Police Department. Bruce became a police officer in 1979 and served the Canton Police Department for twenty-nine years. He became a police officer in 1979. In 1984, he was named "Officer of the Year," and in 1989 Captain Allison was promoted to the rank of sergeant. On May 20, 2002, he became the first African American in the one-hundred-plus-year history of the Canton Police Department promoted to

the rank of lieutenant. On November 19, 2004, he became the first African American in the history of the Canton Police Department promoted to the rank of captain. Bruce retired on May 2, 2008.

George and Mary Lemon

By Gerry Radcliffe

In 1942, after moving his wife and three children from Florida, George Lemon Sr. settled in Massillon, Ohio, where he worked at Republic Steel and the Timken Roller Bearing Company. By 1950, the family had grown to include four daughters and two sons. The family thrived in Massillon, and even though pennies still had to be carefully counted, George and Mary pursued educational options for their children.

My mother, whom we called "Mother Dear," was determined to shape the future of her children. She told me that I was going to become a nurse knowing I had no interest in nursing. I had already applied for and was accepted into Kent State University to become a laboratory technologist. I wanted a college degree. I promised my mother I would come back to Massillon and work at the hospital but not as a nurse! You can imagine my surprise to find out my mother had enrolled me in Massillon Community Hospital School of Nursing. She had signed me up and had taken the proper steps for me to be admitted. There was one last requirement before I was accepted, and that was to take the entrance exam. While driving me to the test site, she told me how proud she was and how she had watched me nurturing and growing up caring for friends and family and she knew I should choose nursing, which she thought required a special gift and she recognized I had that special gift. "You can get a degree if you want, but we can only afford to pay ten dollars a month for Nursing School," she told me.

As a young girl growing up in small-town USA, I remembered hearing the mothers of our church talking about how proud they were of Ella Mae Mitchell and her sister Thelma, the first African American nurses to graduate from Massillon City Hospital School of Nursing. Geraldine Floyd, Dorothy Mercer, Herman Wesley, Stanford Stevens, Madelyn Burke and Roberta Bell would soon follow. Mother Dear wanted my name included on this list of successful black nurses. Needless to say, with role models like these early pioneers, how could I fail?

George and Mary Lemon.

My goal was to become the best nurse ever. I think I had accomplished my goal when asked years later to return as keynote speaker for the 1994 graduating class. Yes, I did go on to get a college education. Nursing was just a stepping stone.

Mary Lemon was smart beyond her years. There were many lessons to be learned from her. Mothers have a sense of the potential their children may have. Success in not easy; you must believe in yourself. We all need a strong foundation to build upon. There is always a means to an end. You can become whatever you want to be. Thrive to accomplish your dreams. These are my memories of lessons learned from Mother Dear, who nurtured, encouraged, supported and provided a firm foundation of education and words of wisdom to her family.

There are many personal heroes and people who have encouraged me and influenced my life and my nursing career: Perry Bomar, Naz Adams, Doris Wilson, Daisy Turner, Vivian Pender, my brothers George and Willie, sisters Sarrah, Rosemary and Linda; Nadine McIlwain, for her stimulating thought-provoking conversations during my graduate studies research;

Vickie Belloni; and even my college instructor who told me she "would never give me an A as long as I was in her class no matter how hard I worked." These words only made me work harder. Other supporters were Dr. Joseph Yut, noted otolaryngologist; and Dr. Robert Bird and Dr. Alvin Sojchet, both leading neurosurgeons in Stark County—all of whom I worked for as a private surgical nurse. I interviewed for three months before being hired as nursing director by the largest ambulatory group practice in the state, the North Canton Medical Foundation. Although extremely challenged, I had much support and encouragement from Dr. John Humphrey, Dr. John Schuster, Dr. William Fayen and Dr. R.T. Warburton. The person who has been the most inspirational and supportive of all my life endeavors is my husband, Dale Radcliffe.

GEORGE AND MARY'S SUCCESS story is typical of many African Americans who worked hard and through it all were able to prosper. As their children, we strove to make them as proud of us as we were of them. In April 2000, George and Mary moved into their retirement home in Jackson Township, Massillon, Ohio. Mary expired on November 11, 2005. George died on April 6. 2007.

Family

By Jeaneen (McIlwain) McDaniels

I don't know about others, but I for one, have been blessed with an amazing, spiritual, loving family. Here is just a sampling of the impact they have made on my life.

Edna McIlwain, my grandmother, my father's mother, affectionately known as Memaw, is the epitome of the strong and faithful African American matriarch. She possessed a Christian faith that never wavered. As she says, she is tested daily by the devil but will never give in to his ways. At the ripe young age of ninety-seven, she has lived to witness the deaths of two of her sons and her husband of sixty years. Her faith sustains her.

She could make any food taste heavenly without using a recipe, having learned her cooking skills from a white lady in the South. She sang the praises of the Lord while she prepared meals. It is my belief that you can never duplicate any of Memaw's recipes because you have to have her cast-

iron pans, her Bundt cake pans, and you have to sing her spirituals while you are preparing your meal. My grandmother says the advantage of growing older is that you can say whatever you want. The community celebrated her life at her home-going service held on Saturday, June 25, 2011, at Mount Olive Baptist Church.

Willie J. Williams, my grandfather, my mother's father, so impacted my mother's life that I feel his spirit through her. By the time this is printed, my grandfather's story will be immortalized in two publications written by my mother, titled *He Was Always There*, and that describes my grandfather. For his children and his grandchildren, he was always there.

Albert H. McIlwain, my father, began every morning and ended every night with prayer. I'm not talking about a two-second prayer. No, I mean a get down on bended knees, thank the Lord for the blessings, give me the strength to do Your Will prayer. I have never heard him cuss. I have never heard him speak badly of another person, I have never heard him disrespect his mother or his wife, and he only spanked me one time—and I deserved it.

There are not enough positive adjectives to describe Nadine Williams McIlwain, my mother, and my baby brother…nobody better ever mess with my baby brother, Randy.

Mabel White Williams, my grandmother, my mother's mother, provided me with the knowledge that faith is a personal belief and you do not need to prove that you have it. I recall those Sunday afternoons at my grandmother's home at 1804 Second Street Southeast behind what used to be the A&P grocery store. It went something like this…smell of fried chicken, football game on the ONE television that she had in her home—especially the Browns—and a Bible opened on the kitchen table.

I miss her so much. She died a victim of Alzheimer's in June 1996—two weeks before the birth of my first and only child. It is my hope that her quiet, faithful spirit was somehow transferred to her great-granddaughter, Brooklyn MaShell McDaniels, whom she never got to meet here on earth.

Jeffrey S. McDaniels—my husband; my hero; my true love.

Brooklyn MaShell McDaniels—I have never doubted that miracles and blessings are real. Brooklyn is my confirmation of both.

Marion Conner

By Marion and Emma Conner

Marion Conner, local boxing legend, was born Marion Conner Brown in Canton, Ohio, on October 11, 1940. When he was born, he was so small at two pounds, two ounces, the premature Marion required special care. By age seven, though, he was attending Roosevelt Elementary School. His older brothers, Raymond A. Brown and Chester E. Brown, mailed little Marion a book titled *How to Box*. This book changed Marion's life even though a football career at McKinley High School sidetracked his dream of boxing, but not for long.

Marion was on the McKinley High School 1955–56 state championship football team under legendary coach Wade Watts. His brother Raymond kept him focused on boxing by training with Marion at the Northeast YMCA on Carnahan Avenue. Often, the two brothers could be seen working out in the gym.

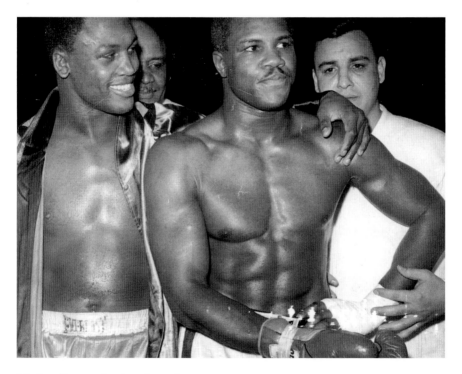

Marion Conner, boxing champion.

Marion won his first fight, a Pee Wee bout for eleven- and twelve-year-olds, in a gym on East Tuscarawas Street across the street from the State Burlesque Theatre. His prize was a mere fifty cents, which he received as two quarters.

By 1957, Marion had won the Stark County Golden Gloves Championship. He was rated the no. 4 contender by the WBA and received a picture in *Boxing Illustrated Magazine* in 1967. His earned the nickname Marion "KayO" Conner for his exploits in the ring. Today, he lives in East Canton with his wife, Emma.

Full Circle

By James E. Walton, PhD

My life came full circle last week. In late 1961, following graduation from Canton McKinley High in Canton, like my older brother one year before me, I went downtown, signed up with a navy recruiter, gave him my birth certificate, took the military test and received my date to ship out. Several weeks before I was scheduled to report, my pastor called me and asked if I would take his part in a play that the "white" church across town was putting on. I took the part, practiced on my own and prepared to participate in the play.

The play at the church was based on a missionary appeal. There were white youngsters dressed up as Chinese, Indians and members of other ethnic groups. For the part of the African, the play's director thought that she would enlist the assistance of the "real thing," or as real as could be had in early 1960s Canton, Ohio. I recall walking out on the stage, inhaling deeply and opening with, "Good evening. I am Tanya, from deepest Africa." Peering through the bright lights of the stage, I was able to make out a few faces in the audience, all pale, studying me intently, as I delivered the rest of my lines. Soon, it was over, and I was downstairs trying to arrange a ride home, when a smiling stranger approached me, extended his hand and said a few nice words about my performance. Then he asked, rather innocently, "How's school?" I told him that I had graduated. "Why aren't you in college, then?" he shot back, just as innocently. I had no ready answer to such an impossible thought.

"I think I can get you into the college that I attended, Andrews University. It's in Michigan. Ever heard of it? Tell your parents that I will be there in an hour. Can you be packed by then?"

On the heels of a huge snowstorm with snowdrifts a car high and temperatures in the single digits, we headed from Canton to Andrews University and Berrien Springs, Michigan. I learned that the stranger was Dr. Joseph Nozaki, a young physician in residence at the local hospital.

I had never applied to Andrews University, had never taken the ACT, SAT, XYZ or any college exam, for that matter. I spent my first night at Andrews University on someone's floor. Dr. Nozaki handed me a ten-dollar bill that next day, shook my hand and gave me some rather enigmatic words of advice in parting: "Jim, never put your trust in man. Man will let you down; only put your trust in the Lord." I saw Dr. Nozaki one time after that. He said that he had received all of my letters, but he was too busy to write back.

"Hello, Jim! How are you doing? So good to hear from you," a bubbling Dr. Nozaki gushed when he finally picked up the phone.

"I am going to have to drop out of school. Mr. Shaw in the business office said that my bill was getting too high, even though I've been working every day and during the summers. It's just getting too high. So, I am going to drop out and try to get a job for a semester—but I'll be back. I'll be back."

"Jim, you know," he began slowly, measuring his words, "it's been my experience...that when people drop out of school, they often do not come back," he offered at long last. "I tell you what," he concluded. "You go back to that business office and tell Shaw that Dr. Nozaki will take care of everything."

In the years that followed my eventual graduation from Kent State University, I taught high school at my alma mater, married, attended graduate school, became a professor of English at Mount Union College, a private institution in Alliance, for twenty years, spent time in Osaka, Japan, as an exchange professor and researcher and even taught Japanese literature before moving to Fresno, California.

Dr. Moores, a friend, told me that he had seen Dr. Nozaki earlier that day at a memorial service in Merced, approximately one hour north. Dr. Joseph Nozaki lived in Guam, I was told. He was practicing medicine at a clinic in Guam, but he was currently visiting the Fresno area.

We had not seen each other since 1963. During my second visit with him a few days later, Dr. Nozaki explained to me that while looking in the newspaper for a home in Fresno over twenty years ago, he noticed a church for sale. "I put in a bid and purchased it," he laughed. "I had no congregation or preacher in mind. I just purchased a church."

The man truly had made such a significant human difference in my life— and he did not want to receive any credit. Dr. Nozaki said that he clearly

remembered Canton, Ohio. "It was the Lord, it was the Lord," he kept saying over and over. "It was the Lord."

Euley Glenn
December 29, 1921–July 17, 2002

This interview of Mr. Glenn was conducted by Gerry Radcliffe on February 13, 1996

Euley Glenn was born on December 29, 1921, in Dothan, Alabama, to Euley and Pinkey Glenn. He attended Daniel Payne College in Birmingham, where he spent two years preparing for Morris Brown University.

In Birmingham, he met and married his first wife, Kate Edwards. Glenn worked for Eastern Airlines as a mail handler, and he also serviced planes. In May 1944, Euley moved his family to Canton, Ohio. He worked for the Hoover Company for forty years, until retiring in 1984. While employed by Hoover, he became a member of the board of directors of the Hoover Company Federal Credit Union and served for eighteen years. He served twelve years as a union steward and nine years as financial secretary of Local 1985 Electrical Workers. He is a lifetime member of the Brotherhood of Electrical Workers. Glenn was the first black president of the McKinley Booster Club.

> *I was told by Vera Snead that I was the first black man to get an FHA construction loan from Citizen Savings Bank. At the time, real estate companies had an agreement with banks not to give money to blacks. When I met with the bank, I said, "You have to do something about giving Negros loans." Richard Gilbert, VP of North Canton Citizen Bank, gave me that loan and I built my home in 1957.*
>
> *Dr. Ross, Dr. Malloy, and Bill Powell couldn't get loans; they had to go to Cleveland. I purchased a lot for cash, and three days later the money was returned to me. I was told as long as you are black, I will never sell this property to you!...*
>
> *There are too many black churches. They need to join together to solve some of our issues. There is nothing for kids [jobs] to get them to stay here after graduation and we need more blacks to get involved in the community.*
>
> —*Glenn, when asked about problems in the city.*

14

NATIONAL AND LOCAL RECOGNITION

*A*lthough he was not born in Canton, our city claims William McKinley, twenty-fifth president of the United States, as one of our own. The story has not ended there. Many Canton African Americans have achieved national attention and recognition.

Stephen A. Perry

Stephen A. Perry is retired from serving as the executive director of the Pro Football Hall of Fame. He was appointed the seventeenth administrator of the U.S. General Services Administration in 2001 by President George W. Bush. He is a former Canton senior business executive, who retired on March 31, 2001, as senior vice president—human resources, purchasing and communications at the Timken Company.

Perry began his career at Timken in 1964, progressing from an initial position as stockroom clerk to various accounting positions to director of accounting to director of purchasing to senior vice president. In 1991, then governor and later U.S. Senator George V. Voinovich appointed him to his cabinet as director of the Department of Administrative Services. After his success in state government, Mr. Perry returned to Timken in

1993, when he was elected by its board of directors as an officer of the company and named vice president. In 1997, he was promoted to senior vice president.

Prior to his appointment as administrator of GSA, Mr. Perry had been active for many years in diverse civic and professional associations. His most recent involvement with professional organizations includes serving as chairman of the Human Resources Council of the Manufacturers Alliance for Productivity and Innovation, serving on the Human Resources Policy Committee Steering Group of the National Association of Manufacturers and on the board of the Labor Policy Association.

Also, prior to his relocation to the Washington, D.C. area, his volunteer work in community and civic activities included his 1993 gubernatorial appointment to the Ohio Board of Regents, which oversees Ohio's institutions of higher education, and membership on the board of trustees of the Professional Football Hall of Fame. In 1999, he served as general chairman of the Football Hall of Fame Festival. He also served on the Management Improvement Commission, to which he had been appointed by Ohio governor Bob Taft.

A 1963 graduate of Timken High School in Canton, Perry earned his bachelor's degree in accounting at the University of Akron in Ohio, attended the University of Michigan Executive Development program and earned a master's degree in management from Stanford University in California. Mr. Perry and his wife, Sondra, have five adult children.

THE O'JAYS

The O'Jays is a R&B musical group inducted into the Rock and Roll Hall of Fame in 2005. The O'Jays formed in 1958 in Canton, where the five original members—Eddie Levert, Bill Isles, William Powell, Walter Williams and Bobby Massey—attended McKinley High. Eddie and Bill were inspired to start a group after seeing a performance by the Drifters at the Canton Auditorium. The O'Jays was first called the Emeralds, then the Triumphs and later the Mascots. The group settled on the name the O'Jays after Cleveland disc jockey Eddie O'Jay agreed to assist the group.

Eddie Levert and Walt Williams began their careers when they were high school students, singing gospel songs together on local radio. The O'Jays' first hit was "Lonely Drifter." The group scored its first gold record

in 1972 with "Backstabbers." They had more than three dozen top-10 hits. The O'Jays were at the forefront of a 1970s soul-music style known as "TSOP," or "The Sound of Philadelphia," a reference to the hometown of producers Kenny Gamble and Leon Huff. Group members Eddie Levert, Walter Williams, the late William Powell, Bobby Massey and Sammy Strain were enshrined in the Rock and Roll Hall of Fame in 2005. Powell died in 1977. Today, Eric Grant performs with Levert and Walt Williams. In 2005, the City of Canton renamed a portion of Mahoning Road as The O'Jays Parkway in honor of the group.

STEPHANIE SMITH HUGHLEY

Stephanie Smith Hughley, graduate of McKinley High, is executive producer and co-founder of the National Black Arts Festival in Atlanta, one of the most important African American arts festivals in the world. Hughley served as its artistic program director until 1992. She returned to Atlanta in 1999 to revive the failing and debt-stricken organization. Under her leadership, the festivals have expanded from a biennial summer arts festival to a yearly ten-day festival held during the month of July and a year-round African arts cultural teaching institution, which includes an annual curriculum for teachers and students. Hughley was born in Canton to Lillie Mae and Robert Lee Smith Sr. on October 16, 1948. Hughley managed and supervised the production of over twelve Broadway shows, including *Your Arms Are Too Short to Box with God, Ain't Misbehavin'* and *Bubbling Brown Sugar,* and toured the United States and Europe as the company manager of *For Colored Girls* in 1971.

DALE RAYMOND WRIGHT

Dale Raymond Wright, graduate of McKinley High, became an award-winning journalist. Born in Pennsylvania, Wright moved to Canton as a teen and graduated in 1941, later attending Howard University and graduating from The Ohio State University in 1950. Wright helped write a ten-article series on migrant farm workers along the Atlantic Seaboard. This work explored working conditions and exploitation by some produce growers and was a finalist for a Pulitzer Prize. The series was expanded in Wright's

book *They Harvest Despair: The Migrant Farm Worker*. Wright owned a public relations firm, Dale Wright Associates, which served black businesses in the New York area. Wright served as press secretary for New York City mayor Ed Koch and others.

MELVIN J. GRAVELY II, PhD

Melvin J. Gravely II, PhD, is a frequent guest on radio stations from Los Angeles to New York and has been featured in many national publications, including *Black Enterprise Magazine, Ebony Magazine, Entrepreneur Magazine* and *American City Business Journals*. After ten successful years working for a large corporation, he co-founded a civil engineering firm and grew it into a multimillion-dollar company. Dr. Gravely also is an author, speaker and entrepreneur. Dr. Gravely speaks and writes on various topics related to entrepreneurial thinking and minority business development. He is the author of five books, including *The Lost Art of Entrepreneurship*.

JEFF ROANE

Jeff Roane, a graduate of St. Thomas Aquinas High School and the University of Akron, is the inventor of the Control It All Remote. Roane figured out how to train a phone to be a remote control and wrote an Apple application for it. Then, he built a module to convert the phone's Bluetooth signals for DVD operations or changing TV channels. As a result of his invention, Roane founded MiCommand in 2010 to promote his invention. His company uses Amazon.com and the Apple App Store online to promote and sell his product.

MARLIA ELISHA FONTAINE

Marlia Elisha Fontaine, a 2000 graduate of Jackson High School, was crowned Miss Ohio in 2005. As Miss Ohio, she competed in the 2005 Miss America competition held in Las Vegas. Fontaine graduated magna cum

laude from the University of Akron with a bachelor's degree in sociology/ law enforcement. A talented opera singer, Fontaine did not win the Miss America title, but she won the hearts of all of Stark County.

MACY GRAY

Macy Gray (born Natalie Renee McIntyre on September 6, 1967, also credited as Natalie Hinds in her music) is an American R&B, soul, and neo soul singer-songwriter, record producer and actress, famed for her raspy voice and singing style. Gray has released five studio albums, one compilation album and one live album and has received five Grammy nominations, winning one. She has appeared in a number of films, including *Training Day*, *Spider-Man* and *Idlewild* and Tyler Perry's *For Colored Girls*. Gray is best known for her international hit single "I Try," taken from her multi-platinum debut album, *On How Life Is*. Gray is the daughter of Dr. Laura McIntyre and the late Richard McIntyre.

Macy Gray, a.k.a. Natalie McIntyre Hinds.

LOCAL RECOGNITION

Some people are recognized on a first name or first/last name basis. These are people whose deeds and services have made a difference in the lives of others. They serve as role models and inspirations to many young people. The entire community recognized the contributions of some individuals by naming buildings in their honor. Here is a list of some who have been so honored:

Paralee Compton
 Paralee Watkins Compton Learning Center
Walter Crenshaw
 Early College Academy at Crenshaw, formerly Crenshaw Middle School and Crenshaw Park
Nadine McIlwain
 Canton City Schools Nadine McIlwain Administrative Center
Albert H. McIlwain
 Stark Metropolitan Housing Authority Albert H. McIlwain Administrative Center
William Hunter
 William Hunter Family Development Center
Doris and William Wilson
 Wilson Pointe Apartments
Judith Lancaster
 Judith E. Barnes Lancaster Esq. Campus Gateway
Jack Calhoun
 Jack Calhoun Memorial Baseball Field
Judge Clay E. Hunter
 Hunter House
Cherrie Turner
 Cherrie Turner Towers
Edward "Peel" Coleman
 Edward "Peel" Coleman Southeast Community Center
Kimberlé Crenshaw
 Kimberlé Gardens
Minnie Hopkins
 Heartbeats of the City Minnie Hopkins Center

Buildings honoring Charles Ede and Dr. Rosemary Johnson are no longer standing, but these individuals were also honored. Recognition has been bestowed on deserving individuals by naming streets in their names. Canton is home to the Reverend Martin L. King Corridor, O'Jays Parkway, Ira Turpin Boulevard, Marion Motley Boulevard and Alan Page Drive. This list does not include the many alleys and small streets honoring local pastors and community activists.

Andrea Perry, a Canton native and graduate of Central Catholic High, is the first woman to serve as the director of public safety for the city. Appointed by Mayor William J. Healy, she was reappointed when the present mayor, Thomas M. Bernabei, was elected. As safety director, Perry is responsible for supervision of police and fire chiefs as well as the operations of both departments. Overseeing the traffic and building code departments of the city is also part of Perry's responsibilities.

Fonda Williams has worked in public service in several capacities. Williams served as a council member representing the Fourth Ward. He was appointed economic development director, community development director and chief of staff by Mayor Healy. Williams is responsible for overseeing the Fair Housing Assistance Program, MBE/WBE program, Equal Employment Opportunity (EEO) operations and safety forces' minority recruitment duties of the city.

Curtis A. Perry III is known as Cap III based on his initials and name. Born in Massillon, Perry is the owner of WINW Joy 1520 AM, which specializes in playing recorded gospel music. CAP III Production supports JoyFest Music Festival, one of Northeast Ohio's largest urban celebrations. Attendance at this amazing event is FREE and open to the public.

Prior to owning and broadcasting on his own radio show, Cap III worked as a promoter with such groups as the O'Jays.

DR. WILLIAM EDWARD WILSON

Dr. Wilson was born in Lebanon, Ohio, but spent most of his adult life in Canton. He was a member of the Alpha Phi Alpha fraternity and a graduate of Tennessee State University and Meharry Dental College in 1955. According to his obituary, "His entire life was about fighting for equal opportunities for all people—regardless of race, color, religion or ethnicity. In the 1980s he invested a large portion of his retirement savings to finance and pioneer

the concept of a two-chair mobile dental office that traveled with a professional staff throughout Ohio, providing dental services to residents of nursing homes, mental and correctional facilities and other clients in need of accessible dental health care."

Dr. William Wilson.

Dr. Wilson was a social activist and champion for the poor and the underprivileged and promoted equal access to housing, education and healthcare delivery through his leadership and involvement in many organizations and charities, including President of the Canton Urban League, Red Cross, March of Dimes and the Stark County Dental Society. He was appointed to the U.S. Committee on Civil Rights for Ohio and served as an adjunct professor of sociology at Malone College, now Malone University.

Named in his honor and that of his wife, Dr. Doris Ashworth Wilson, Wilson Pointe, a senior apartment building complex, sits on the corner of Sixth Street and McKinley Avenue Northwest.

William Hunter

The William Hunter Family Development Center represents the efforts of a community partnership between the U.S. Department of Health and Human Services, Administration for Children and Families (Head Start), City of Canton, Bank One, N.A. and the Stark County Community Action Agency. The center is named in honor of William Hunter, former Canton City School administrator. Hunter graduated cum laude from Central State University and obtained his master's degree from Kent State University. He served the Canton City School system as a teacher, guidance counselor and coach and principal of McKinley High School, director of human relations and director of personnel, ending his career as the executive director of personnel.

Hunter served as a member of the board of directors of the Canton Urban League for over thirty years and was elected to serve as a trustee for the National Urban League. He also served on the board of the United Way

of Central Stark County, the advisory board of the United Negro College Fund and was president of the Men's Fellowship of Faith United Christian Church in Canton.

In 1990, Hunter was selected to chair the Football Hall of Fame festival breakfast committee after serving for five years on the hall of fame's steering committee. Former Canton mayor Stanley Cmich also appointed him to the Canton Civil Service Commission.

Owen Barnes

Born on October 24, 1918, in Canton, Owen was the second-eldest of eleven children born to Frederick Dancy and Mary Barnes. After marriage and five children, Barnes served in the U.S. Army from 1944 to 1945 and was honorably discharged as staff sergeant.

In 1949, Owen and Lillian Barnes grabbed the spotlight, and even the floor of Congress, by going to college when they were both in their thirties and raising five children. They squeezed their studies in between cooking, cleaning, laundry and Owen's job as a paperhanger and later at Republic Steel.

In 1953, the two got their degrees, and a local congressman read their achievement into the congressional record. Owen Barnes became the first black teaching assistant at Kent State University as he pursued his master's in business administration, but he left his studies the next year to become a parole officer in Stark County, making him the first black resident Cantonian to hold the post.

About seven years later, his was one of the first black families to build a home in Perry Township.

Governor James A. Rhodes appointed Barnes to Ohio's Parole Board in 1979. After retiring in 1987, he returned to the board and served until 1993. Barnes accomplished another first by completing his thesis in 1998 at the age of seventy-nine, earning his master's degree and marching in the commencement ceremony with his grandson and fellow fraternity brother Lawrence Michael Tolson.

Beverly Mahone

Beverly Mahone is a veteran journalist, author, media coach and motivational speaker who writes about issues affecting middle-aged women

in her book *Whatever! A Baby Boomer's Journey into Middle Age*. The Ohio University graduate writes candidly about issues such as weight gain and menopause, dating after the age of forty and leaving corporate America at midlife.

After spending more than twenty-five years in the radio and television news business, Beverly traded it in to become a work-at-home mom. She is now using her media expertise as a consultant to train individuals how to market themselves to radio, television and newspapers professionals. She is also enjoying a lucrative speaking career in which she shares her life experiences with other baby boomer women.

Beverly, who has been classified as a baby boomer expert by the media, has appeared on numerous radio and talk programs, including WOR Radio in with Henican and White (New York City).

Geraldine Radcliffe, RN, BSN, MS

Gerry was voted the Outstanding Nurse of the Year on the state and local level by her peers. Gerry received her diploma from Massillon Community Hospital School of Nursing and a Bachelor of Science Nursing Degree (BSN) from Akron University. She received her master's of community health education from Kent State University.

Gerry was employed for twenty-three years by the North Canton Medical Foundation, a large Ambulatory Group Practice, as nursing director and nursing administrator. After a short retirement, Gerry returned to the workforce three months later, employed as cultural health initiatives manager and nurse educator for the American Heart Association. Currently, Gerry is on the adjunct faculty of Malone College. She is a community health consultant, grant writer and health educator.

Gerry is a graduate of Leadership Stark County and serves as a member of the Sisters of Charity Foundation of Canton Board of Directors and the Cultural Diversity Committee of Massillon Public Library, Stark Prescription Assistance Network and various other local services organizations. Gerry is a member of Stark County Alumnae Chapter of Delta Sigma Theta Sorority Inc. and Stark District Nursing Association, Ohio Nurses Association and the American Nurses Association.

RENEE POWELL

Renee Powell is the second of three African American women to play on the Ladies Professional Golf Association Tour. Renee entered her first tournament, the women's division of the Forest City Tournament at Seneca Golf Course in Broadview Heights, Ohio, at age twelve. She won her division and returned in 1988 to become head golf professional at Seneca.

Following graduation from Central Catholic High School, Renee attended Ohio University and was named captain of the women's golf team. She transferred to Ohio State University after her golf coach at OU decided she shouldn't go to the tournament in Jacksonville, Florida, due to the potential for racial tension. She was also named captain of the women's golf team at OSU and recognized as the top female amateur golfer in Ohio.

Renee turned pro in 1967. During her thirteen years on the tour, she participated in more than 250 tournaments. She won the Kelly Springfield Open in Brisbane, Australia, shooting a 67 in the final round to set a new course record.

She was chosen to represent the United States in the U.S. vs. Japan team matches during the 1970s. In each of Renee's four matches, her team won. Renee was invited to participate in King Hassan's Tournament in Morocco and was the only American golf professional to play in President Jawara's Tournament in Gambia.

In 1979, she became the first woman to be named head professional at a golf course in the United Kingdom. She left the LPGA Tour in 1980. She did not leave the world of golf.

During the fiftieth LPGA Anniversary Celebration, the LPGA honored Renee by nominating and selecting her to receive an honorary membership into the LPGA Teaching and Club Professional Division.

CHARITA M. GOSHAY

Charita M. Goshay is a native of Canton and a graduate of Timken Senior High and Kent State University, where she majored in communications. Charita has been employed with the Canton Repository since 1990. She currently is a nationally syndicated

Charita Goshay.

columnist for Gatehouse News Service and a member of the newspaper's editorial board. She is a nine-time Associated Press Best Columnist in Ohio Award winner and has earned recognition from the Stark County Bar Association, the Greater Canton Martin Luther King Jr. Commission, the Ohio legislature, Canton City Schools, the Boy Scouts of America, Buckeye Council and others. Charita is a founding board member of Habitat for Humanity East Central Ohio and a graduate of Leadership Stark County.

TONYA STRONG-CHARLES

Tonya Strong-Charles was a general assignment reporter for NewsChannel 5 and co-anchored several other programs, including the number one–rated *NBC Nightside*, a national overnight broadcast that also aired in the United Kingdom, the Middle East and Australia. She covered the 1996 Summer Olympics in Atlanta and the 1996 Democratic National Convention in Chicago. Tonya also served as a substitute anchor for *NBC News at Sunrise* and traveled around the country covering stories for the network.

She is a member of the Cleveland Association of Black Journalists. She is a graduate of McKinley High School and Purdue University in West Lafayette, Indiana. Presently, Strong-Charles is the director of media relations and communications for John Carroll University.

CHRIS SMITH

Chris Smith is serving as an elective member of Canton City Council representing Ward 4. Well respected by fellow council members, Smith was chosen to serve as the majority leader following her election in 2018. She was born in Montgomery, Alabama, in 1952, and was raised in nearby Troy. When she was thirteen, she and her family moved to Canton.

Smith is a graduate of McKinley High School. She earned a doctorate, master's degree and bachelor's degree from the National Institute of Cosmetology (Washington, D.C.).

Chris Smith, majority leader, Canton City Council. *Courtesy of Mark Bigsbee.*

VERNELIA MAY MOORE

Mr. and Mrs. Charles Moore were married for fifty-seven years. From their union were born five boys and three girls. Vernelia was recognized by the *Guinness Book of World Records* and *Ripley's Believe It or Not* for being the only woman in the world to have all three combinations of twins consecutively by the same parents. The twins are Linda and Lynn, Janine (Green) and Justina (Lorenzo) and Kirk and Kevin Moore.

FLOYD RANDALL MCILWAIN (RANDY MAC)

Randy McIlwain joined NBC5 in 2003 working as a general assignment reporter and a fill-in anchor for sports. Randy started his career in television journalism in 1990 as a photojournalist at WSEE-TV in Erie, Pennsylvania. In 1990, Randy was promoted to reporter and covered city hall, crime and politics. Randy was there for the political rise of former secretary of Homeland Security Tom Ridge, covering him through his terms as congressman and his run for governor. Some of his most memorable interviews from Erie included Muhammad Ali, President Bill and First Lady Hillary Clinton on numerous occasions while they were on the campaign trail.

In 1994, Randy moved to WHIO-TV in Dayton as the education reporter for two and a half years and broke many stories concerning Dayton schools and public education in Ohio. In 1997, Randy moved west to KOCO-TV in Oklahoma City, where he spent six years as an investigative and senior reporter.

He earned a bachelor's degree in speech communications from Edinboro University of Pennsylvania, where he attended college on a football scholarship. He is now a franchise reporter in Los Angeles and broadcasts under the tag "Randy Mac will get your money back."

JILL HOGAN

Jill Hogan began her career with Time Warner Cable in 2001 in the Northeast Ohio Division (NEO) Akron as a recruiter. She staffed for customer operations, technical operations, sales, administrative and management

positions throughout the nine systems within the NEO Division. In 2005, Jill was promoted to human resources manager for Time Warner Cable in Jackson, Mississippi. She was responsible for all facets of human resources, such as recruitment, AAP and employee relations. She successfully implemented a new hire orientation program, recruitment process training to hiring managers, management training on effective and positive tools for employee discipline documentation and change management training. Returning to Canton in 2011, Jill accepted the position of employment recruiter for VXI, an international company that opened a call center in Canton. She now serves as a senior recruiter at Shearer's Foods.

DeLores May Pressley

DeLores May Pressley, president of Born Successful Consulting, a professional speaker and trainer, was the host of the *DeLores Pressley Show*, an inspirational show heard on Joy 1520 am radio, and a television host of the *Born Successful Show* on Warner Cable Television in Canton. She cohosted *Wriggling in the Middle* on local radio station WHBC-AM. She is the author of *Clean Out the Closets of Your Life* and *Believe in the Power of You*. She has appeared on *Today* and *The Oprah Winfrey Show* and provided articles for numerous magazines, including *People*. DeLores has received numerous awards, including an honorary doctorate and induction into the YWCA Women's Hall of Fame. Recently, she launched She Elevates, an initiative designed to encourage young female entrepreneurs.

Betty Knight

Betty Knight, a graduate of Timken Vocational High, was selected as the first African American Hall of Fame Queen. Ms. Knight reigned over HOF festivities in 1981. Other African American queens include Therlanda Whitfield (1985), Chantel Gray (2000), Makaela Meacham (2008), Mariah Curtis (2014), Alleya Tavares (2016) and Imani Bush (2018).

Betty Knight.

COREY MINOR SMITH

Attorney Corey Minor Smith is employed as legal counsel for the Stark Metropolitan Housing Authority. In addition, she is an at-large member of Canton City Council and a former elected member of the Canton City Schools Board of Education.

PHILANTHROPISTS

Generally, the term *philanthropy* in Canton is associated with the names of Timken, Hoover or other wealthy whites. Black philanthropy is not thought of at all or seldom mentioned. In addition to money, goods and time are also indicators of philanthropic giving. Indeed, without the collection plates on Sundays and volunteers to serve the chicken dinners on Saturdays and to chair anniversaries, Women's Day, Men's Day and other special programs, many churches would cease to survive. Using all indicators of philanthropic giving, we have highlighted a few of the local black philanthropists.

Judith Barnes Lancaster, Esq.

Steve and Sondra Perry have contributed to many charitable causes, including the Stark Community Foundation, the Greater Stark County Urban League, the O'Jays Family Weekend, the Omega Psi Phi Scholarship Foundation and many other local and national charities. Perry's service includes serving on the Ohio Board of Regents, Pro Football Hall of Fame Board, Mercy Medical Center Board, Stark County District Library Board, United Way of Central Stark County Annual Campaign chairman and Pro Football Hall of Fame Festival general chairman.

Attorney Judith Barnes Lancaster is a major contributor to the Northeastern Ohio Universities College of Medicine (NEOUCOM) (known as the Northeast Ohio Medical University since 2011) and the Canton

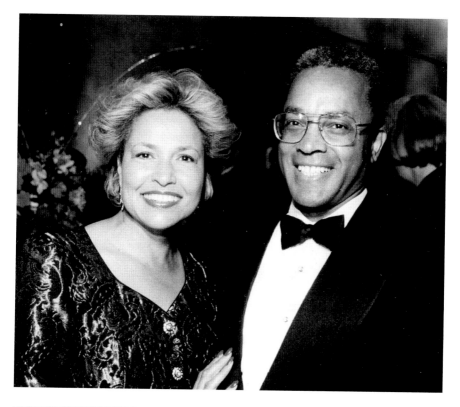

Above: Stephen and Sondra Perry.

Left: Robert Bobbitt.

Museum of Art. Most recently, she was appointed to the board of trustees of NEOUCOM by Ohio governor Ted Strickland. She was the major supporter of the Willis "Bing" Davis, Dean Mitchell, Woodrow Nash and Elijah Pierce exhibits at the Canton Museum of Art. As a patron of the arts, Lancaster's collection includes *Bongo Drummer*, by Dean Mitchell, and several of Woodrow Nash's clays. Lancaster is the recipient of an honorary doctorate from the Northeastern Ohio Universities College of Medicine.

Owners/operators of multiple McDonald's restaurants in the North Canton area, Robert and Hortense Bobbitt were active on many community boards, supporting worthwhile causes ranging from education to feeding the needy. Their charitable activities include the Greater Stark County Urban League, the Aultman Health Foundation Women's Board and the Wilderness Society. Hortense serves as a member of the board of directors of the National First Ladies Museum. Robert died on September 29, 2008. Hortense has since moved to the Detroit, Michigan area to be closer to her sons and grandchildren.

Eric Snow pledged $1 million to build a new YMCA in downtown Canton. The twenty-seven-thousand-square-foot facility at Second Street and McKinley Avenue Northwest is called the Eric Snow Family YMCA. It opened in January 2014.

Researching and reporting Canton's African American history is both challenging and rewarding. Writing the history that you are living is a challenge due to innate biases. It is also challenging because attempts to authenticate and critically examine history are often not without errors or omissions. We have tried to be as careful as possible in presenting our research. Your decision to purchase and read this book is our reward.

Thank you for helping us to uncover Canton's African American Treasures.

NOTES

1. Edward Thornton Heald, *The Stark County Story*, vol. 1 (Canton, OH: Stark County Historical Society, 1949), 76.
2. This note was found in the archives of the William McKinley Presidential Library and Museum.
3. David Gerber, *Black Ohio and the Color Line 1860–1915* (Urbana: University of Illinois Press, 1976), 4.
4. Ibid., 11.
5. Heald, *Stark County Story*, vol. 4, part 1, 453.
6. Ibid.
7. Gerber, *Black Ohio*, 61.
8. Heald, *Stark County Story*, vol. 4, part 1, 453.
9. Gerber, *Black Ohio*, 91.
10. *Leslie's Weekly*, September 21, 1901. *Frank Leslie's Weekly*, later often known as *Leslie's Weekly*, actually began life as *Frank Leslie's Illustrated Newspaper*. Founded in 1852 and continued until 1922, it was an American illustrated literary and news publication, one of several started by publisher and illustrator Frank Leslie.
11. Heald, *Stark County Story*, vol. 4, part 1, 453.
12. Ibid.
13. David Levering Lewis and Deborah Willis Ryan, *Harlem Renaissance Art of Black America: The Studio Museum in Harlem* (New York: Harry N. Abrams Inc., 1987).
14. Norma Marcere, *'Round the Dining Room Table* (Canton, OH: Daring Books, 1985), 20.

15. Mary Peebles, *Repository*, November 24, 1968.

16. Gretchen Adams Bagley, *Repository*, March 17, 2002.

17. Gary Brown, *Repository*, February 25, 1991.

18. Heald, *Stark County Story*, vol. 4, part 1, 464–65.

19. Ibid., 164.

20. Canton Black History Week Committee, *Canton Black Book* (Canton, OH: Canton Black United Fund, 1977), XV.

21. Heald, *Stark County Story*, vol. 4, part 1, 360.

ABOUT THE EDITORS

NADINE MCILWAIN is a former Ohio public school educator and has received numerous awards for excellence in the classroom, including the prestigious National Educator Award from the Milken Family Foundation. She has coauthored two biographies, *From Ghetto to God: The Incredible Journey of NFL Star Reggie Rucker* with Reggie Rucker, published in 2001; and *My Father's Child* with Fredricka Stewart, published in 2006. Another article, "Macy Gray: On How Writing Lyrics Is," appeared in the 1999 edition of *Ohio Writer*. Written as a tribute to her father, her essay "He Was Always There" appears in *My Soul to His Spirit*, 2003, a compilation of stories written by African American women about their fathers and edited by Melda Beaty. "The Twenty Dollar Education," a brief memoir, was published in *Chicken Soup for the African American Woman's Soul* (2005). Nadine is a member of Stark County Alumnae Chapter of Delta Sigma Theta Sorority.

GERRY RADCLIFFE is a registered nurse and has served the Stark County community as nurse manager, consultant, health educator, grant writer and local African American amateur history buff. Gerry enjoys providing programs to faith-based organizations spreading the word

of good health. She has certified many of our local church nurses. As a health educator who makes a difference through her programs, she is able to initiate change and influence others to "Take Control of Their Health." Currently, Gerry has retired from her part-time employment with the American Heart Association as cultural health initiatives manager and Malone College as a communicable disease instructor. Gerry is a member of Stark County Alumnae Chapter of Delta Sigma Theta Sorority.

LOIS DIGIACOMO founded the Rainbow Repertory Company in 1994 with an original biographical play about the life of Dr. Norma Marcere. Since then, she has written several plays for schools, social service agencies and businesses. Rainbow Repertory is currently developing a dinner theater for downtown Canton. Lois hosts a local arts-focused television show, *State of the Arts*, and serves or has served on the board of directors for Coming Together Stark County, Arts in Stark and Multi-Development Services of Stark County.